Magic Lantern Guides®

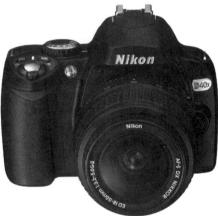

Simon Stafford

A Division of Sterling Publishing Co., Inc. New York / London Book Design and Layout: Michael Robertson Cover Design: Thom Gaines – Electron Graphics Associate Art Director: Lance Wille

Library of Congress Cataloging-in-Publication Data

Stafford, Simon.
Magic lantern guides : nikon D40x / Simon J. Stafford. -- 1st ed. p. cm.
Includes index.
ISBN-13: 978-1-60059-258-4 (pb-trade pbk. : alk. paper)
ISBN-10: 1-60059-258-9 (pb-trade pbk. : alk. paper)
Nikon camera--Handbooks, manuals, etc. I. Title.
TR263.N55732245 2007
7771.3'1--dc22

2007017910

10987654321

First Edition

Published by Lark Books, A Division of Sterling Publishing Co., Inc. 387 Park Avenue South, New York, N.Y. 10016

Text @ 2007, Simon J. Stafford Photography @ 2007, Simon J. Stafford unless otherwise specified

Distributed in Canada by Sterling Publishing, c/o Canadian Manda Group, 165 Dufferin Street Toronto, Ontario, Canada M6K 3H6

Distributed in the United Kingdom by GMC Distribution Services, Castle Place, 166 High Street, Lewes, East Sussex, England BN7 1XU

Distributed in Australia by Capricorn Link (Australia) Pty Ltd., P.O. Box 704, Windsor, NSW 2756 Australia

This book is not sponsored by Nikon Corp. The written instructions, photographs, designs, patterns, and projects in this volume are intended for the personal use of the reader and may be reproduced for that purpose only. Any other use, especially commercial use, is forbidden under law without written permission of the publisher. The works represented are the original creations of the contributing artists. All artists retain copyrights on their individual works, except as noted.

Nikon, Nikkor, Speedlight, and other Nikon product names or terminology are trademarks of Nikon Corp. Other trademarks are recognized as belonging to their respective owners.

Every effort has been made to ensure that all the information in this book is accurate. However, due to differing conditions, tools, and individual skills, the publisher cannot be responsible for any injuries, losses, and other damages that may result from the use of the information in this book. Because specifications may be changed by manufacturers without notice, the contents of this book may not necessarily agree with software and equipment changes made after publication.

If you have questions or comments about this book, please contact:

Lark Books 67 Broadway Asheville, NC 28801 (828) 253-0467

Manufactured in USA

All rights reserved

ISBN 13: 978-1-60059-258-4 ISBN 10: 1-60059-258-9

For information about custom editions, special sales, premium and corporate purchases, please contact Sterling Special Sales Department at 800-805-5489 or specialsales@sterlingpub.com.

Contents

Introduction	13
Production of the Nikon D40x	15
About this Book	15
Conventions Used in This Book	17
Introducing the Nikon D40x	19
Design	19
Power	24
Sensor	25
Low-Pass/Anti-Aliasing Filter	27
File Formats	
The Viewfinder	31
Shooting Information Display	
Automatic Focus	33
AUTO and Digital Vari-Program Modes	35
Exposure Modes	35
Metering Exposure	36
3D Color Matrix Metering II	38
Center-Weighted Metering	38
Spot Metering	38
White Balance	39
Optimizing Images	39
The Shutter	40
Shooting Modes	
Self-Timer	
Remote Release	
LCD Monitor	42
Menus	43
Built-In Speedlight (Flash)	43
External Ports	
Basic Camera Care	
Cleaning the Low-Pass Filter	46

Quick Start Guide	49
Getting Ready to Shoot	49
Charging/Inserting the Battery	49
Attaching the Camera Strap	50
Choosing a Language	50
Setting the Internal Clock	51
Lens Compatibility	53
Mounting a Lens	54
Adjusting Viewfinder Focus	55
Using Your SD Memory Card	56
Installing the Memory Card	56
Formatting the Memory Card	57
Removing the Memory Card	58
Holding the Camera	59
Point and Shoot with the D40x	60
Select a Digital Vari-Program	61
AUTO Mode – Default Settings	62
Composing, Focusing, and Shooting	63
AUTO and Digital Vari-Program Modes	64
AUTO	64
Auto (Flash Off)	65
Portrait	66
Landscape	68
Child	70
Sports	72
Close-Up	
Night Portrait	74
Common Settings in Digital Vari-Program Modes	76
Optimize Image Settings in	
Digital Vari-Program Modes	76
Basic Image Review	77
D40x Shooting Operations in Detail	79
Powering the D40x	79
Using the EN-EL9 Battery	81
EH-5 AC Adapter/ EP-5 Adapter Connector	82
Internal Clock/Calendar Battery	83
Battery Performance	83
Secure Digital (SD) Memory Cards	84
Secure Digital High Capacity (SDHC) Memory Cards .	86

Formatting	. 86
File Formats	. 87
JPEG Format	. 89
NEF (RAW)	. 90
Which Format?	
Image Quality and Size	. 93
Setting Image Quality and Size	. 94
White Balance	
White Balance Options	. 95
Selecting a White Balance Option	. 97
Fine-Tune Control of White Balance Value	. 99
White Balance Preset	101
Using the Preset Option	
Optimizing Images	
Normal	104
Softer	
Vivid	
More Vivid	105
Portrait	
Black-and-White	105
Custom	106
Settings Available in Custom-Optimize Image	107
ISO Sensitivity	
Setting Sensitivity	113
ISO Auto	114
TTL Metering	115
Matrix Metering	116
Center-Weighted Metering	
Spot Metering	119
Exposure Modes	
P–Programmed Auto	
A–Aperture-Priority Auto	
S–Shutter-Priority Áuto	121
Shutter Speed Considerations	
M–Manual	122
Autoexposure Lock	123
Exposure Compensation	124
Shutter Release	
Shooting Modes	
Single Frame Shooting Mode	

Continuous Shooting Mode	130
Self-Timer	130
Using a Remote Release	133
The Autofocus System	
Autofocusing Sensor	
Focusing Modes	136
AF-S vs. AF-C	137
Predictive Focus Tracking	138
Trap Focus	139
AF-Area Modes	140
AF Mode and AF-Area Mode Overview	141
Focus Lock	142
AF-Assist Illuminator	142
Limitations of the AF System	
Using Non CPU-Type Lenses	144
Depth of Field	144
Two-Button Reset	148
Image Playback Options	149
Image Review	149
Basic Single Image Playback	
Assessing the Histogram Display	152
Thumbnail Playback	156
Playback Zoom	156
Protecting Images	156
Deleting Images	157
Camera Menus	159
Access to Menus	
Setup Menu (Simple Option)	
CSM/Setup Menu	
Format Memory Card	162
Info Display Format	164
Auto Shooting Info	165
World Time	165
LCD Brightness	166
Video Mode	
Language	
Image Comment	168
USB	169
Setup Menu (Full Option)	171

Folders	171
File Number Sequence	172
Mirror Lock-Up	173
Firmware Version	175
Dust Off Ref Photo	175
Auto Image Rotation	176
Shooting Menu	
Optimize Image	177
Image Quality	
Image Size	
White Balance	177
ISO Sensitivity	
Noise Reduction	178
Nikon D40x – Noise issue	179
Retouch Menu	
Selecting Images	181
Image Quality	182
D-Lighting	182
Red-Eye Reduction	
Trim	
Monochrome	
Filter Effects	184
Small Picture	185
Image Overlay	
Custom Setting Menu	
Help Button	
(R) Custom Setting Reset	189
CS-01 Beep	190
CS-02 Focus Mode	190
CS-03-AF-Area Mode	191
CS-04 Shooting Mode	191
CS-05 Metering	192
CS-06 No Memory Card?	192
CS-07 Image Review	
CS-08 Flash Compensation	193
CS-09 AF-Assist	193
CS-10 ISO Auto	194
CS-11 Fn Button	195
CS-12 AE-L/AF-L	195
CS-13 AE Lock	196

CS-14 Built-in Flash	197
CS-15 Auto Off Timers	
CS-16 Self-Timer (Delay)	
CS-17 Remote On Duration	
Playback Menu	
Delete	
Playback Folder	
Rotate Tall	202
Slide Show Print Set (DPOF)	203
Print Set (DPOF)	203
Nikon Flash Photography	205
The Creative Lighting System	206
i-TTL Flash Exposure Control	206
Flash Output Assessment	209
The Built-In Speedlight	
External Speedlights	
SB-400	
SB-600 and SB-800	215
TTL Flash Modes	
Nikon Terminology	
Non-TTL Flash Modes	
Manual Flash Mode	
Flash Sync Modes	
Flash Sync in P, S, A, and M Modes	
Flash Sync with Digital Vari-Program Modes	
Additional Flash Features and Functions	
Flash Exposure Compensation	
Flash Color Information Communication	
Limitations of Using the Built-In Speedlight	
Aperture, Sensitivity (ISO), and Flash Range	
Lens Compatibility with the Built-In Speedlight	220
Using a Single Speedlight Off-Camera	220
with TTL Cord	220
	229
Nikon Lenses and Accessories	
DX-Format Sensor	
Choosing a Lens	235
Lens Compatibility	236
Using Non-CPU Lenses	

Incompatible Lenses and Accessories	238
Features of Nikon Lenses	
Filters	
Polarizing Filter	
Neutral Density Filters	
Graduated Neutral Density Filters	
General Nikon Accessories	244
Working Digitally	247
Workflow	
Using Memory Cards	251
Nikon Approved Memory Cards for D40x	251
Memory Card Capacity	252
Image Information	
DPOF	
PictBridge	
Exchangeable Image File Format (EXIF)	
International Press Telecommunications Council (IPTC)	
Camera Connections	
Connecting to a T.V	257
Connecting to a Computer	
Card Readers	258
Direct Printing	259
Linking the D40x with a Printer	259
Printing Pictures One at a Time	260
Printing Multiple Images	262
Selecting Images for Direct Printing	263
Nikon Firmware and Software	264
Picture Project	264
Nikon Capture NX	266
Nikon Camera Control Pro	266
Troubleshooting	269
Common Problems	
Error Messages and Displays	
Electrostatic Interference	275
Web Support	
Glossary	276
Index	

Introduction

The first Nikon 35mm film camera, the Nikon I, was introduced during 1948. This was the beginning of fifty years of production of leading models, such as the professionally specified F5, and highly popular F100, which represented the pinnacle of film camera design. Yet few would have predicted that just a few years later Nikon would cease production of all film cameras, with the exception of the F6. The effect of the explosive rise in the popularity of digital photography has changed the face of photography for both amateur and professional photographers.

However, the Nikon Corporation is not new to the business of building digital cameras, it has accrued many years of experience in this field. Its first efforts, during the early to mid 1990s, involved a collaboration that used sensors, developed by Kodak, in modified Nikon film camera bodies. The first wholly independent Nikon digital SLR camera, the D1, was launched during 1999, and followed by the D1X and D1H. These models broke new ground technically and made high-quality digital photography financially viable for many professional photographers. Subsequently, with advances in sensor technology, Nikon launched its thirdgeneration camera, the D100, during mid-2002. This camera pushed resolution beyond that of the earlier models. Its good technical specifications coupled with the fact it cost about half the price of a D1X tempted many non-professionals to take the digital plunge! Building on these solid foundations the company went on to introduce the professionally specified D2-series cameras, beginning with the D2H and most recently, the D2Xs, during mid-2006. As this branch of the Nikon evolutionary tree grew, other cameras such as the entry-level D50 camera, and the phenomenally successful

Building on proven technology, the D40x is designed for ease of use, portability, and high performance. It offers a degree of responsiveness unequalled by compact digital cameras.

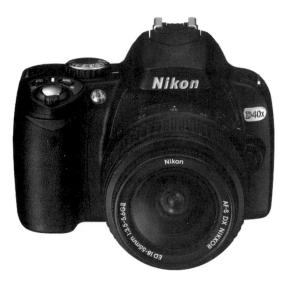

The D40x has a CCD sensor of 10.2 MP and can be purchased with the 18-55mm f/3.5-5.6G ED II AF-S DX Zoom-Nikkor lens.

D70-series models where introduced. It is from this heritage that Nikon has developed the D40x, the thirteenth digital SLR camera model to be launched by the company.

Nikon is not new to the business of building cameras with wide appeal for the beginning amateur photographer. Nikon was an early leader in the production of high-quality advanced compact digital cameras. As the digital camera market has evolved, the SLR, rather than compact models, now drives it, as users seek improved camera performance and handling. Models such as the Nikon D70 and D50 have helped Nikon to build a significant market share in this sector, which will no doubt grow, as the D40 and D40x models meet the ever-growing demands of consumers. The D40x is intended to appeal to users of high-end compact digital cameras who want to expand their level of creative camera control by upgrading to a camera with more responsive handling. Equally, it has been designed to provide higher resolution and performance for those Nikon D-SLR owners wishing to either upgrade or supplement their current model.

It is no coincidence that many of the core features and functions of the D40x can also be found in other recent, and highly successful Nikon camera models; for example, the D40x uses the same 10.2mp sensor as the D80. Rationalization of component parts works very much in Nikon's favor on two fronts. First, it allows a new model to reach the market far quicker, as design and development can concentrate on the use of existing tried and trusted parts, rather than the engineering and manufacture of new ones. Second, it permits the economies of scale to be exploited by using a higher volume of a single component with the consequent reduction in the unit cost of manufacture. Nikon has exploited the benefits of this approach to good effect in achieving their aim with the D40x.

Consequently, the D40x is a camera with the flexibility to be used either in a simple, fully automatic, point-and-shoot style, or with total control of all its features and functions. Innovation, which adds to its appeal, particularly to the beginner, or less experienced photographer, includes the use of "assist" reference images to guide the user when selecting the main functions of the camera, which also act as a prompt whenever settings are changed. Combined with the support offered by the immense array of lenses, flash units, and accessories within the Nikon system, the D40x represents a highly effective and efficient, state-of-the-art tool for digital SLR photography.

Production of the Nikon D40x

The D40x is assembled at Nikon's wholly owned production facility in Thailand, which employs about 8,000 staff. The D70 was produced there, as are, currently, the D40 and D80. It has been manufacturing precision equipment for over 15 years.

Offering a visual introduction to the camera and an overview of operating techniques, the Magic Lantern DVD Guides: Nikon D40/D40x is an ideal way to get quickly acquainted with camera basics.

However, a number of the D40x's core parts, such as its main printed-circuit board, viewfinder optics, and lens mount, are produced at the Nikon factory in Sendai, Japan and elsewhere.

About This Book

To get the most from your D40x, it is important to understand its features so you can make informed choices about how to use them with your style of photography. This *Magic Lantern Guide* is designed to help you achieve this objective. Besides explaining how all the core camera functions work, this book also provides useful tips on operating the D40x and maximizing its performance. It does not have to be read from cover to cover; you can move from section to section as required, study a complete chapter, or just check information about the principal features or functions you want to use. If you also want visual action tips and instructions on working with the camera to get you quickly acquainted with it, you may want to supplement this comprehensive guide with the *Magic Lantern® DVD Guides: Nikon D40x.*

The key to success, regardless of your level of experience, is to shoot a lot with your camera. You do not waste money on film and processing with a digital camera; once you have invested in a memory card it can be used over and over again. Therefore, you can shoot as many pictures as you like, review your results almost immediately, then delete your near misses, but save your successes—this trial and error method is a very effective way to learn!

Conventions Used In This Book

Unless otherwise stated, when the terms "left" and "right" are used to describe the location of a camera control, it is assumed the camera is being held to the photographer's eye in the shooting position.

When referring to a specific Custom Setting, it will often be mentioned in the abbreviated form "CS-xx", where xx is the identifying number of the function. In describing the functionality of lenses and external flash units, it is assumed that the appropriate Nikkor lenses, generally D or G-types, and Nikon Speedlight units are being used. Note that lenses and flash units made by independent manufacturers may have different functionality. If you use such products, refer to the manufacturer's instruction manual to check compatibility and operation.

When referring to Nikon's software, such as Nikon PictureProject (initial deliveries of the D40x are supplied with version 1.7.5), or the optional Nikon Capture NX, and Nikon Camera Control Pro, it is assumed that the most recent versions of each application are used to ensure full compatibility with D40x image files.

Simon Stafford Wiltshire, England

Introducing the Nikon D40x

Design

The compact D40x is designed to integrate ease of operation, high performance, and excellent image quality. It possesses a comprehensive set of features and a wide range of menu options that produce outstanding photographic results. Because of its compact size and high resolution the D40x makes an excellent pairing with my D200, especially when I need to carry two cameras for a day long shoot. It is a camera that has the ability to appeal to a wide range of photographers, from the complete beginner who seeks point-and-shoot convenience to the budget conscious professional who requires complete control of their camera. It offers complete automation of exposure and focusing, as well as full manual control of all its features and functions.

The D40x has an all-polycarbonate body that encases a fully mechanical, electronically timed shutter unit, which Nikon tests to perform at least 100,000 cycles. Providing a shutter speed range of 30 seconds to 1/4000 second, it is the same unit used in the Nikon D80. It has a 420-pixel RGB sensor for TTL metering and flash exposure control. The D40x uses the same Multi-CAM530 autofocus sensor as the D40 model. The D40x and D40 share the same physical dimensions making them the smallest cameras in the current Nikon D-SLR range due in part to the exclusion of a built-in autofocus motor and LCD control panel on the top of the camera.

Compact and lightweight, the D40x's portable design makes it ideal for landscape photography.

The innovation of the D40x is to use the LCD monitor to show the information that has formerly been displayed in the control panel of other models. In what Nikon calls the "Shooting Information Display," all relevant camera settings pertaining to exposure, flash, focus, TTL metering, ISO, white balance, battery status, and image quality are shown on the monitor. Nikon has even included three different display style options for the Shooting Information Display.

The approximate dimensions for the D40x (W x D x H) are $5.0 \times 2.5 \times 3.7$ inches (126 x 64 x 94 mm) and it weighs approximately 17 oz (495 g) without battery or memory card. It has a Nikon AF lens mount with the appropriate electrical contacts, however the camera does not have a built-in motor to drive the focusing mechanism of lenses that do not have their own built-in AF motor. Consequently the D40x will only support autofocus with AF-S and AF-I type Nikkor lenses, although many earlier Nikkor lenses can be mounted on the D40x.

Used with AF-D or AF-G type Nikkor lenses that do not have a built-in focusing motor, the D40x supports all functions except autofocus. Other AF Nikkor lenses and AI-P type manual-focus lenses can be used but provide a lower level of compatibility in terms of the camera's TTL metering system (i.e. standard color Matrix metering as opposed to 3D Color Matrix metering). If the D40x is set to the M (Manual) exposure mode, it is even possible to use a number of manual focus AI, AI-S, AI converted, and E-series Nikkor lenses, although the camera's autofocus system, TTL metering system (including TTL flash control), and electronic analog exposure display will not function, and lens aperture must be set via the aperture ring on the lens (see chart on page 53 for more information).

The D40x uses Secure Digital (SD) memory cards and is able to support the new generation of Secure Digital High Capacity (SDHC) cards based on SDA 2.00 specification as well, providing support for the latest 4GB SDHC memory cards and, in time, capacities of up to 32GB.

Nikon D40x—Front View

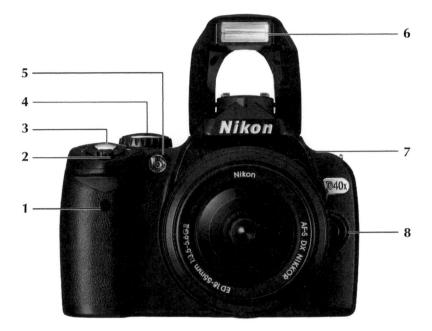

- 1. Infrared receiver for remote control
- 2. Power switch
- 3. Shutter release button
- 4. Mode dial
- 5. AF-assist illuminator Self-timer lamp Red-eye reduction lamp
- 6. Built-in Speedlight
- Flash mode button
 Flash compensation button
- 8. Lens release button

Nikon D40x—Back View

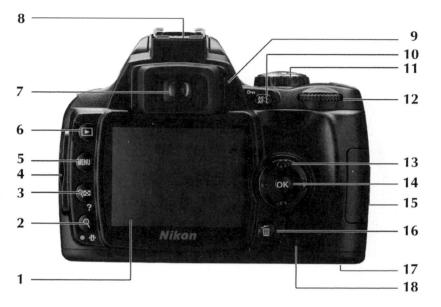

- 1. LCD Monitor
- 2. 9 Zoom button Setting button Reset button
- З. 923 Thumbnail/ Help button
- 4. Connector cover
- 5. NENU **MENU** button
- 6. 0 Playback button
- Viewfinder eyepiece
 Accessory hot shoe
- 9. Diopter adjustment control

- AE-L/AF-L button 10. (On) Protect button
- 11. Mode dial
- 12. Command dial
- 13. ۲ Multi selector
- 14. button OK
- 15. Memory card slot cover16. Delete button
- 17. Battery chamber (camera bottom)
- 18. Memory card access lamp

Nikon D40x—Top View

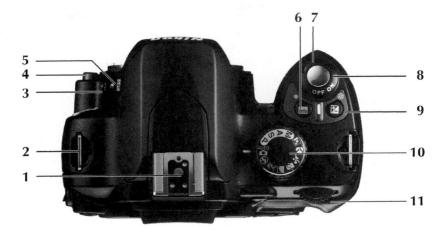

- Accessory hot shoe
 Eyelet for strap
 Self-timer button Fn (function) button
 Lens release button
- Flash mode button 5. Flash compensation button
- Shooting 6. information button Reset button
- 7. Power switch
- 8. Shutter release button
- 9. Description of the second se
- 10. Mode dial
- 11. Command dial

The D40x uses the EN-EL9, a rechargeable lithium-ion battery; it is the only internal power source available for the camera.

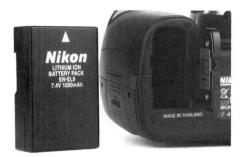

Power

The D40x is powered by a single Nikon EN-EL9 (7.4V, 1000 mAh) lithium-ion (Li-ion) battery that is approximately 1.8 oz. (51 g). It is an entirely new battery design, which at the time of writing is exclusive to the D40x-series models. There is no alternative power source for the D40x that can be fitted internally; the standard camera body cannot accept any other type of battery. And currently Nikon has no plans to introduce a separate battery pack/grip for the D40x, such as the MB-D80 that is available for the standard D80 body.

The camera's reset button is located between the video out terminal (above), and the USB terminal.

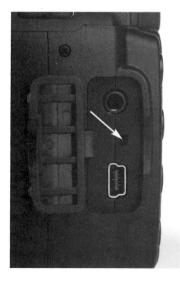

Battery performance depends on a number of factors, including condition of the battery, the camera functions and features used, and the ambient temperature. It powers up in just 0.18 seconds when the temperature is 68°F (20°C). It is possible to make many hundreds of exposures on a single fully charged EN-EL9. For extended periods of use, the Nikon EH-5 AC adapter can also be used to power the D40x via the EP-5 adapter cable.

Note: All electronically controlled cameras may occasionally function improperly due an electrostatic charge. To remedy, first switch the camera off, remove and replace the battery (or disconnect then reconnect the AC supply), then switch the camera on again. If this fails to clear the problem, press the reset button located between the video-out and USB terminals, beneath the connector cover on the left side of the camera. If you press this button, the camera's internal clock will need to be reset from the Setup menu.

Sensor

The Charge Coupled Device (CCD) sensor used in the D40x is the same sensor used in the Nikon D80 model; it is a modified version of the sensor in the Nikon D200 camera that uses a two-channel rather than four channel output. Produced by Sony (a fact not officially acknowledged by Nikon) it has a total of 10.75 million photosites (pixels) of which 10.2 million are effective image forming areas. Each photo site is just 5.9 microns square (1 micron = 1/1000 millimeter). This gives the camera a maximum resolution of 3872 x 2592 photosites (pixels), sufficient to produce a 16 x 11 inch (40 x 27.5 cm) print at 240ppi (pixel per inch) without interpolation (re-sizing) in software.

The imaging area is 0.66×0.93 inches ($15.6 \times 23.7 \text{ mm}$), which is smaller than a 35mm film frame (1×1.5 inches, or 24 x 36 mm), but retains the same 2:3 aspect ratio. Nikon calls this their DX-format (elsewhere referred to as APS-C format), and uses the same DX designation to identify those

The Fn button, located on the side of the left lens mount, is used in conjunction with the command dial to rapidly gain access to several important camera settings.

lenses that have been optimized for use with their DX-format digital SLR cameras. Because this format is smaller than that of 35mm film, the angle-of-view offered by any focal length is reduced compared with a lens of the same focal length used on a 35mm film camera. Consequently, the focal length of any lens you have used on a 35mm film camera should be multiplied by 1.5x (to be precise the factor is nearer to 1.52x) to provide an approximation of the field of view the same focal length provides on the D40x.

In a process adopted from Nikon's "flagship" D-SLRs (D2Xs, D200, and D80), the D40x performs "color independent analog pre-conditioning" before the analog signal sent by the sensor reaches the ADC (analog-to-digital converter). This signal will often have a different output level for each channel (i.e. the red, green, and blue channels). The gain is altered for each channel to make certain the signal is in the optimum condition prior to the conversion process that creates a digital signal, and thus as much of the original data as possible is preserved to ensure maximum image quality.

The D40x is capable of producing images with a high degree of sharpness in the details. The low-pass filter helps eliminate moiré and keep edges distinct.

Low-Pass/Anti-Aliasing Filter

Light passing through the camera to the sensor's surface encounters this filter with its array of layers first; each layer performs a specific purpose. Whenever you take a picture of a scene that contains very fine detail (e.g. the weave pattern in a piece of material) it is possible that the freguency of the detail nearly matches that of the photosites on the sensor. During the conversion of a signal from analog to digital, this can lead to moiré effects or color fringes appearing between two areas of different color or tone, or on either side of a distinct edge. In the analog-to-digital conversion process, most frequencies will be reproduced properly, but ones above a specific frequency known as the Nyquist frequency have an increased tendency to generate moiré and color fringing effects (also known as aliasing). The anti-aliasing filter of the D40x is designed to transmit frequencies below the Nyquist frequency; hence it is referred to as a "low-pass" filter.

Infrared Coating Layer: Although not visible to the human eye, infrared (IR) light can be detected by a CCD sensor. This is a problem in digital cameras because IR light can cause a perceived loss of image sharpness, reduced contrast, and other unwanted effects, such as color shifts. Therefore, the optical low-pass filter used in the D40x incorporates an anti-reflective IR layer to virtually eliminate the transmission of IR light to the sensor. Consequently, it is not possible to use the D40x practically for digital IR photography.

Micro-lens Layer: A CCD sensor is most efficient when the light striking it is perpendicular to its surface. Therefore, to help realign the light rays projected by the camera lens into the photosites (pixels) on the sensor, the filter array contains a layer of micro-lenses.

Bayer Pattern Filter: The pixel site on the CCD does not see in color-it can only detect a level of brightness. To impart color to the image, this layer has a series of minute red, green, and blue filters arranged in a Bayer pattern, named after the Kodak engineer who invented it. These filters are situated in an alternating pattern of red/green on the oddnumbered rows, and green/blue on the even-numbered rows. Thus final image data comprises information that is 50% green, 25% red, and 25% blue, and requires reconstruction by interpolating the values from each photosite (pixel), accordingly.

File Formats

The D40x can record images as compressed files using the JPEG standard, and as files saved in Nikon's proprietary RAW format: Nikon Electronic File (NEF). The NEF files can only be saved in a compressed form; the D40x provides no option to record uncompressed NEF files.

The files using the JPEG standard can be saved at three different sizes: Fine (low compression 1:4); Normal (medium compression 1:8); and Low (high compression 1:16). Note as

The NEF format allows scenes with a wide contrast range to be recorded faithfully.

the level of compression is increased there is a greater loss of original image file data. Furthermore, all JPEG compressed files are ultimately saved to an 8-bit depth in camera.

The highest potential for quality files comes from recording files using the NEF format: These contain the values direct from the sensor's photosites without modification and virtually no other in-camera processing, apart from information concerning camera settings. The compression applied to the 12-bit NEF files is "visually lossless" (which is not quite the same as saying "lossless"), a claim that is due to the method of compression used by the camera, which averages highlight data during the processing of the NEF file. To get the most out of NEF files you will need additional software such as Nikon Capture NX or a good quality third-party RAW file converter such as Adobe Camera RAW (see page 266 for details).

Viewfinder Display

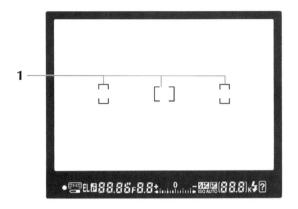

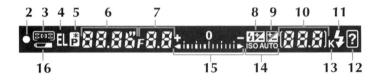

- 1. Focus areas (brackets)
- 2. Focus indicator
- 3. Focus area display AF-area mode
- 4. Autoexposure (AE) lock
- Flexible program indicator
 Shutter speed
- 7. Aperture (f/number)
- 8. Flash compensation indicator
- 9. Exposure compensation indicator

- 10. Number of exposures remaining Flash compensation value
- 11. Flash ready
- 12. Warning indicator
- 13. K = memory for 1000 or more exposures
- 14. ISO Auto indicator
- 15. Exposure display Exposure compensation level
- 16. Battery level

The Viewfinder

The D40x has a fixed, optical pentaprism, eye-level viewfinder that offers a 0.8x magnification and shows approximately 95% (vertical and horizontal) of the full-frame coverage. It has an eye-point of 0.7 inches (18 mm), which provides a reasonably good view of the focusing screen and viewfinder information for users who wear eye-glasses, plus there is a built-in diopter adjustment. To set the diopter adjustment, mount a lens on the camera and leave the focus set to infinity. Point the camera at a plain surface that fills the frame and move the diopter adjustment switch (located to the right of viewfinder eyepiece) until the AF sensor brackets appear sharp. It is essential to do this to ensure you see the sharpest view of the focusing screen.

Nikon also produces a range of stronger optional eyepiece correction lenses. These are attached by slotting them on to the eyepiece frame (the DK-16 rubber eyecup must be removed first). The viewfinder eyepiece does not have an internal shutter to prevent light entering when the D40x is used remotely, so the camera is supplied with the DK-5 eyepiece cap that can be similarly fitted whenever the camera is operated this way in any of the Digital Vari-Program, P, S, or A, exposure modes.

The viewfinder display includes essential information about exposure and focus (see viewfinder information callout). The focusing screen is marked with three pairs of square brackets to define the position of the autofocus sensing areas. The D40x employs conventional LED illumination for its focusing screen, so all three pairs of bracket markings are visible. To help distinguish the active focus area, its brackets are initially illuminated in red.

View of Shooting Information Display

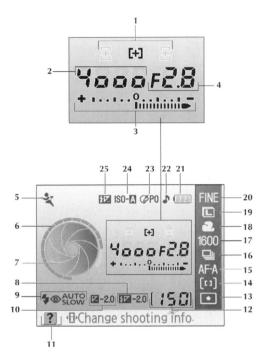

- 1. Focus area AF-area mode
- 2. Shutter speed
- 3. Exposure display Exposure compensation
- 4. Aperture (f/number)
- 5. Exposure mode
- 6. Shutter speed display
- 7. Aperture display
- 8. Flash compensation value
- 9. Flash sync mode
- 10. Exposure compensation value
- 11. Help
- 12. Number of exposures remaining Preset WB indicator

- 13. Metering mode
- 14. AF-area mode
- 15. Focus mode
- 16. Shooting (drive) mode
- 17. Sensitivity (ISO)
- 18. White balance setting
- 19. Image size
- 20. Image quality
- 21. Battery level
- 22. Beep indicator
- 23. Optimize image option
- 24. Auto ISO sensitivity
- 25. Manual flash control indicator Flash comp for optional Speedlight

Shooting Information Display

In a departure from previous designs, Nikon has chosen not to use a separate LCD display on the top of the D40x for showing the status of the principal camera controls. Instead, to reduce the overall size of the camera, the D40x displays camera settings on the LCD monitor on the back of the camera, a feature that Nikon calls the Shooting Information Display. This color monitor enables "assist images," which are small picture files shown as examples for many of the main functions to help guide you in making a selection or making an adjustment to the relevant setting. It is possible to choose one of three styles for the Shooting Information Display from the Setup menu: Classic, Graphic, and Wallpaper.

Note: If you already understand the relationship between shutter speed and lens aperture, together with the concept of the lens aperture and its values, I recommend using the Classic display since it replicates the display of the control panel LCD used in other Nikon cameras. The Graphic display is well intentioned but the scale of the information displayed is reduced. The Wallpaper option suffers similarly and the difficulty in reading some items can be compounded if the picture selected obscures part of the display.

Press the button to gain access to the Shooting Information Display. The LCD will show a wide range of camera control settings, including shutter speed, aperture, ISO, exposure and flash compensation, metering mode, shooting mode, active focus sensor and focus area mode, white balance, image quality and size, battery status, and audible warning.

Automatic Focus

The autofocus (AF) system is based on the new Multi-CAM 530 AF module (up to 530 individual points are assessed in the process of focus acquisition, depending on the AF-area mode selected). It features three sensing areas arranged in a

horizontal line across the viewfinder screen. The central sensor is a cross type that is sensitive to detail in both horizontal and vertical orientations, whereas the other two are single line sensors, sensitive to detail parallel to the long edge of the viewfinder frame.

The diagram shows the approximate coverage of the three autofocus sensing areas of the Multi-Cam 530 AF module used in the D40x. Only the central area is a cross type, which is sensitive to detail in both horizontal and vertical orientations.

The detection range of the AF system is -1 to +19EV at an ISO100. An AF-assist lamp used in low light levels has an effective range from 1.67 to 9.83 feet (0.5 m to 3 m). The system has three focusing modes: Auto-servo focus (AF-A-the default setting), Continuous-servo focus (AF-C), and Single-servo focus (AF-S). In AF-A mode, the camera will activate AF-S automatically if the AF system determines that the subject is stationary; if the AF system determines that the subject is moving, AF-C mode will be activated. In the AF-C mode, the camera will attempt to predict the position of the subject at the moment the shutter is released.

In addition, the D40x has three AF-area modes that not only determine which of the focus areas are used but also how the camera uses the selected focus area: Single area AF, Dynamic area AF, and Closest subject area AF. For more detailed information on autofocus, see pages 134-144.

AUTO and Digital Vari-Program Modes

The D40x is capable of operating in a fully automated way for point-and-shoot photography. The Auto option relinquishes all control to the camera, and does not allow the user to apply any influence or compensation to any of the settings selected by the camera pertaining to exposure or white balance. In additional to , there are seven Digital Vari-Program modes: Auto (Flash off) cancels the operation of the built-in Speedlight flash, plus six scene / subject specific modes that Nikon refers to as, Portrait , Landscape , Child , Sports , Close-up , and Night Portrait

For more detailed information on these programmed modes, see pages 64-76.

Exposure Modes

The D40x offers four exposure modes that are partially or fully controlled by the user to determine how the lens aperture and shutter speed values are set when the exposure is adjusted: Programmed auto (P), Aperture-priority (A), Shutter-priority (S), and Manual (M):

P-Programmed auto selects a combination of shutter speed and aperture automatically but the photographer can override this using the Flexible program feature.

A-Aperture-priority allows the photographer to select the lens aperture while the camera assigns an appropriate shutter speed.

S-Shutter-priority allows the photographer to select the shutter speed while the camera assigns an appropriate lens aperture.

M-Manual mode places selection of both the shutter speed and lens aperture in the hands of the photographer.

For more detailed information about these exposure modes, see pages 119-122.

Exposure compensation can be set over a range of -5 to +5 stops in increments of 1/3EV; however, the D40x does not have an exposure, or flash-exposure, bracketing feature. In P, S, A, and the automatic exposure modes, the exposure settings can be locked using the AE-L/AF-L button located on the rear of the camera.

The exposure mode is selected using the mode dial; here Aperture-priority (A) mode is set.

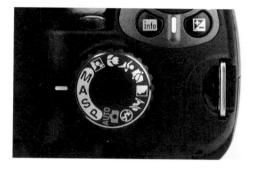

The D40x has a sensitivity range (ISO equivalent) between ISO 100 and ISO 1600 that can be set in steps of 1EV. Additionally, the sensitivity can be increased by 1EV above ISO 1600, again in a single step, to an equivalent ISO rating of 3200. The camera also has a noise reduction feature that can operate at sensitivities over ISO 400.

Metering Exposure

The D40x's offers three options within its TTL metering system enabling the camera to cope with a variety of different lighting situations.

The flexibility of the D40x's TTL metering options allows the camera to produce excellent results even in challenging lighting conditions.

3D Color Matrix Metering II

The D40x uses a 420-pixel RGB sensor (the same component as the D50 model, except the D40x has more advanced algorithms for data processing) located within the camera's viewfinder head to assess the brightness, color, and contrast of light. Additional information from compatible lenses (D-type or G-type Nikkor lenses) and the autofocusing system is also taken in to account. Based on the focused distance and which focus area is active, the camera assumes the likely position of the subject within the frame area. The D40x then uses a reference of over thirty thousand examples of photographed scenes, comparing these with the information from the metering system to provide a final suggestion for the exposure value.

Note: Standard Color Matrix Metering is performed if CPU lenses other than D or G-type are attached to the camera. If you attach a non-CPU type lens (i.e. Ai, Ai-modified, Ai-s, and E-series), the TTL metering system does not operate, although it is still possible to use Manual exposure mode (the shutter speed is set on the camera while the lens aperture is set via its aperture ring) and Manual focus.

Center-Weighted Metering

The camera meters from the entire frame area, but assigns a bias to a central, 0.31 inch (8 mm) diameter circle in a ratio of 75:25.

Spot Metering

The camera meters a 0.13 inch (3.5 mm) circle, which represents approximately 2.5% of the full frame area, centered on the selected (active) focus area brackets.

The 3D Matrix and Center-weighted metering systems have an Exposure Value (EV) range of 0 to 20EV, and 2 to 20EV for Spot metering (ISO 100, lens aperture of f/1.4, 68°F/20°C). For more detailed information about metering modes, see pages 115-119.

White Balance

The D40x offers several choices for white balance control, including a fully automatic option **AUTO** that uses the same 420-pixel RGB sensor in the viewfinder as the metering system. There are another six user selectable manual options for specific lighting conditions: Incandescent (for typical tungsten type lighting), Fluorescent <math>(for fluorescent lighting), Direct Sunlight <math>(for fluorescent for lighting by both the internal and external flash units), Cloudy (for daylight under an overcast sky), and Shade <math>(for daylight in deep shade). Each of these settings can be fine-tuned to impart a slightly warmer (red) or cooler (blue) color.

In addition, the D40x has the ability to set the white balance using a Preset **PRE** option that can be set by assessing the color temperature of the prevailing light reflected from an appropriate test target.

Note: Only one Preset white balance value can be stored in the camera and recalled as required; it is not possible to apply a fine-tuning white balance factor when using the Preset white balance option.

For more detailed information about white balance, see pages 95-104.

Optimizing Images

In the fully automated point and shoot An And Digital Vari-Program modes, values for image attributes of sharpening, tone (contrast), color mode, saturation, and hue are assigned automatically; the user has no level of control over the settings used by the camera.

In P, S, A, and M exposure modes, however, values for these image attributes are assigned by a number of options found by selecting Optimize Image in the Shooting menu,

This control allows an image to be processed by the

camera according to the type of subject/scene being photographed or to how the image will be used. The Optimize Image options include: Normal, Softer, Vivid, More Vivid, Portrait, Custom, or Black & White. The camera sets values automatically for all options, with the exception of the Custom option, which allows the user to define their own settings. See pages 104-112 for more detailed information about the Optimize Image options.

The Shutter

The D40x uses a fully mechanical, electronically timed shutter unit, which Nikon tests to withstand at least 100,000 cycles. Providing a shutter speed range of 30 seconds to 1/4000 second, it is the same unit used in the Nikon D80. The shutter release lag time is approximately 0.1 second, with a viewfinder (mirror) blackout time of approximately the same duration. Apparently, a fully mechanical shutter was chosen for the D40x (in preference to a mechanical/ CCD shutter type as used in the D40 model, where briefer shutter speeds beyond 1/90th second are emulated by switching the CCD sensor on and off), in order to maintain image quality because the sensor in the D40x has many more photosites (pixels).

The shutter speed range runs from 30 seconds to 1/4000 second and can be set in steps of 1/3EV. There is a *bulb* option for exposures beyond 30 seconds. The D40x has a noise reduction option in the Shooting menu that helps reduce the effects of electronic noise in exposures of 8 seconds or longer (however the recording time for each exposure is extended by up to 100% as the camera performs a dark frame exposure as part of the long exposure noise reduction process). The maximum flash sync speed when using either dedicated flash units with TTL flash output control, or non-dedicated flash units with non-TTL flash output control, is 1/200th second.

Shooting Modes

The shooting mode determines when the camera makes an exposure. In Single frame mode \bigcirc , the camera takes a single photograph each time the shutter release button is fully depressed. In Continuous mode \bigcirc , the camera shutter cycles up to a maximum rate of 3 frames per second (fps). However, the effective frame rate will be limited by a number of factors, including the camera functions that are active, the selected shutter speed, and the capacity of the remaining buffer memory.

Ů¹⁰^s Self-Timer

The Self-timer mode delays recording of the image after the shutter release button is depressed fully. It is useful for self-portraits and for reducing the loss of sharpness caused by the effect of vibrations generated by touching the camera, in particular the shutter release button, especially when shooting at a high magnification or using a very long focal length. The default delay is 10 seconds, but you can use CS-16 in the Custom Setting menu to change the delay to 2, 5, or 20 seconds.

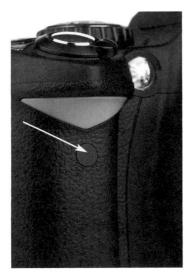

The shutter of the D40x can be released remotely using the ML-L3 release; the infrared receiver is located behind the small window on the front of the handgrip.

Remote Release

The shutter of the D40x can be released remotely using the ML-L3 infrared remote release, which allows the shutter release to be activated wirelessly. There are two options, immediate release $\mathbf{\bar{D}}$, or a delayed release that introduces a 2-second pause $\mathbf{\bar{D}}^{2s}$ between the signal being sent to the camera and the shutter being released, which is helpful if you are shooting a self-portrait (see page 133 for a more detailed description of this accessory).

LCD Monitor

The 2.5 inch, 230,000 pixel, color LCD monitor screen located on the back of the camera offers a viewing angle of 170 degrees shows virtually 100% of the image file when it is reviewed. Pictures can be played back for review either as single images or in multiples. When used to display a single image, the review function has a zoom facility that enlarges images by up to twenty-five times (large 3,872 x 2,592 pixel images only–lower magnifications are available for medium and small size images).

You can change camera settings or review information about recorded image files using the LCD monitor.

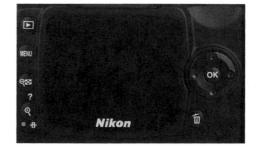

By using the multi selector include a page of basic information about any image of basic information, two pages of shooting data, one that displays a highlight warning (poten-

tially over exposed areas of the image will blink), and a page showing a composite histogram of the color channels (red, green, and blue). The sixth page, Retouch History, displays a history of the changes to any image created using the Retouch menu options, starting with the most recent change.

You have the option to delete your image files while they are still in the camera or protect them from unintentional erasure while reviewing them on the LCD monitor. Also use the LCD to view the Shooting Information Display as well as the various camera menus, from which you can activate or deactivate a wide range of camera features and functions. The brightness of the LCD monitor screen can be adjusted via the Setup menu.

Menus

Built-In Speedlight (Flash)

Nikon always refers to its flash units, built-in or external, as Speedlights. The D40x has a built-in Speedlight housed above the viewfinder. In Auto and in the Digital Vari-Programs for Portrait, Child, Close-up, and Night Portrait,

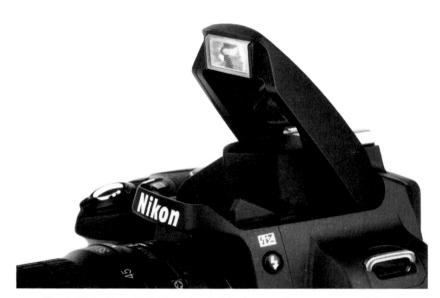

The built-in Speedlight is not only ideal as a primary source of illumination for a photo, it can also be a handy tool for fill-flash photography.

the built-in flash will raise automatically if the camera determines the light level is sufficiently low to require additional illumination from the flash. The built-in Speedlight will not pop up automatically in P, A, S, or M exposure modes, but must be activated manually by pressing the Speedlight flash mode button O on the front of the camera to the left of the viewfinder head.

At full output, the Guide Number (GN) of the built-in Speedlight is GN 39 feet (12 m) at ISO 100 when TTL control is used, and GN 42 feet (13 m) at ISO 100 with manual flash control. It is fully compatible with the latest i-TTL flash exposure control system for balanced fill-flash, but defaults to standard i-TTL flash when spot metering is selected. The D40x also supports the Advanced Wireless Lighting system when it is used with either an SB-800 (in Commander mode) Speedlight or SU-800 to control a number of remote flash units (SB-800, SB-600, or SB-R200). The built-in flash can be used with any CPU-type lens with a focal length of 18–300mm. The minimum distance at which the Speedlight can be used is 2 feet (0.6 m). However, with certain lenses the minimum distance must be greater due to the proximity of the flash tube to the central axis of the lens, otherwise light from the flash is prevented from illuminating the entire frame area (see pages 205-231 for full details on using the D40x for flash photography).

External Ports

On the left side of the D40x is a rubber cover that houses two ports, one for connecting the camera to a computer or printer (the D40x supports High-speed USB 2.0 for data transfer), and another for connecting the camera to a Video monitor for image playback. Located between these two ports is the camera's reset switch that is used to rectify problems that can occur due to the build up of static charge within the camera.

Basic Camera Care

Regardless of how scrupulous you are about keeping your camera clean, dust and dirt are sure to accumulate inside it eventually. Since prevention is better than cure, always keep body and lens caps in place when not using your equipment. Be sure to switch the D40x off before attaching or detaching a lens to prevent particles from being attracted to the low-pass filter by the electrical charge of the sensor. Hold the camera body with the lens mount facing downwards whenever you change lenses. You should also vacuum the interior of your camera bag periodically.

It is a good idea to put a basic cleaning kit together. It should consist of a soft 1/2 inch (12 mm) artist's paintbrush, a micro-fiber lens cloth, a micro-fiber towel (available from a good outdoors store) for absorbing moisture when working in damp conditions, and a rubber bulb blower (either from a

traditional blower brush or made specifically for use in cleaning lenses and the low-pass filter).

Always brush or blow material off equipment before wiping it with a cloth. For lens elements and filters, use a microfiber cloth and wipe surfaces in short strokes, not a sweeping circular motion, turning the cloth frequently. For residue that cannot be removed with a dry cloth, use a lens cleaning fluid suitable for photographic lenses. Apply the fluid sparingly to the cloth, *not* directly to the lens (it may seep inside and cause damage). Wipe the residue and buff with a dry cloth. Any lens cloth should be washed on a regular basis to keep it clean.

Cleaning the Low-Pass Filter

Dust and any other material that settle on the low-pass filter array in front of the CCD sensor will often appear as spots in your pictures. The exact nature of their appearance will depend on their size and the lens aperture you use. At large apertures (f/2.8) it is likely that most very small dust specks will not be visible. However, at small apertures (f/16) they will probably show up as well-defined black spots.

Nikon recommends the low-pass filter should be cleaned by an authorized service center. However, knowing this may be impractical for a variety of reasons, Nikon has provided the D40x with a function to help users clean the low-pass filter array.

First go to the Setup menu and scroll to *Mirror lock-up*. Then press the multi selector to the right to select *On* (high-lighted as the default). Press the multi selector to the right again. A dialog box will appear with the following instruction: "When shutter button is pressed, mirror lifts and shutter opens. To lower mirror, turn camera off."

Once the shutter is pressed, the mirror will lift and remain in its raised position. Keep the camera facing down so any debris falls away from the filter; look into the lens mount to inspect the low-pass filter surface (it is probably helpful to shine a light on to it), but remember that offending particles will be very small, making it unlikely you will be able to resolve them by eye.

Note: If the battery level of the camera drops too low, it will not be possible to access *Mirror lock-up* in the Setup menu. Also, if the battery power becomes too low while the mirror is locked-up, the camera will emit an audible alert and the AF-assist lamp will begin to flash, warning that the mirror will lower automatically in approximately two minutes.

Keep the camera facing down and use a rubber bulb blower to gently puff air towards the filter array surface. Take care that you do not enter any part of the blower into the camera. Under no circumstances should you touch or wipe the filter array. Never use an ordinary brush with bristles or compressed air to clean the filter array (they can leave residue or damage its surface). Once you have finished cleaning, switch the camera off to return the mirror to its down position. If the blower bulb method fails to remove stubborn material, I recommend you have the sensor cleaned professionally.

It must be stressed that you clean the low-pass filter array entirely at your own risk. It is *essential* that the camera's battery be fully charged before you attempt any of these procedures (preferably use the EH-5 AC adapter with the EP-5 adapter connector to ensure a continuous power supply). If the power supply fails during the cleaning process, the shutter will close and the mirror will return to its down position, with potentially dire consequences if you have any cleaning utensils in the camera!

Finally, if you have Nikon Capture NX software, you can use the Dust Reference Photo feature with NEF (Raw) files shot using the D40x to help remove the effects of dust particles on the low-pass filter by masking their shadows electronically.

Quick Start Guide

Getting Ready To Shoot

It is only natural to want to start using your new D40x camera as soon as you remove it from its box. However, there are a few basic steps that you should take before you start shooting your first pictures. Spend a little time with your new camera to acquaint yourself with the principal controls and functions.

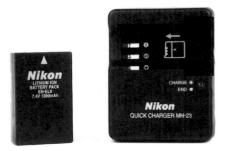

The EN-EL9 battery is charged in its dedicated AC charger, the MH-23.

Charging/Inserting the Battery

Since the D40x is entirely dependent on electrical power, it is essential to fully charge the EN-EL9 battery supplied with the camera (it is only partially charged when shipped). There is no need to pre-condition the battery, but for its first charge leave it connected to the MH-23 charger until it is cool to the touch. Do not be tempted to remove it as soon as the charge indicator lamp on the MH-23 has stopped flashing.

Learn the important controls and functions before going on a shoot to ensure you are ready whenever an interesting photo opportunity arises.

Make sure the camera's power switch is OFF. Slide the battery-chamber cover lock (on bottom of camera) toward the center of the D40x to open. Insert the battery so its three contacts enter first and face the battery-chamber cover. Close the chamber cover by pressing it down until it clicks into place to lock. Now turn the camera ON and check the battery-status indicator in the Shooting Information Display shown on the LCD monitor to confirm the battery is fully charged; **I** should be displayed.

Attaching the Camera Strap

The camera strap is not only useful to prevent the camera from being dropped accidentally, it also helps you brace the camera to reduce camera shake that can spoil your pictures. You can aid support of the camera if you adjust the strap to a length that is taut when wound around your arm.

To attach the strap, start by threading it from the outside of the left camera strap evelet and feed it back through the keeper-loop. Then pass it through the inside of the buckle, under the section of the strap that already passes through the buckle, before pulling it tight. Repeat this process with the other end of the strap, working it through the right strap eyelet. Finally adjust the strap to your preferred length.

Choosing a Language

Once you have inserted a fully charged battery it is time to turn the camera on by rotating the power switch set around the shutter release button.

After switching the camera on for the first time, the Language option from the Setup menu is displayed. Press the multi selector arrows (on back of camera (9)) up or down until the required language is highlighted, and press the

button to confirm and lock your selection.

Note: If you wish to change the language at any time, open the Setup menu and highlight the Language option, then repeat the procedure just described.

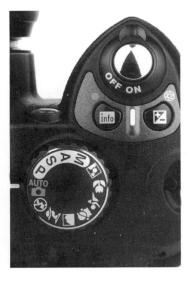

The main power switch to the D40x is located on a collar around the shutter release button.

Setting the Internal Clock

Once you have selected the language, the *Time Zone* option in the *World Time* menu will be displayed; press the multi selector to the left or right to highlight the appropriate local time zone, and press the button to confirm and lock your selection.

The Daylight Saving Time page will now open. Use the multi selector to highlight either On or Off as required for your local time zone, and press the button to confirm and lock. The last page to open is the Date page; press the multi selector to the left or right to highlighted each box and press it up or down to adjust the setting as required.

Once you have completed setting the date and time, press the button to confirm and lock your selections. The monitor will turn off and the camera is returned to the shooting mode.

To provide full compatibility with all its functions, including autofocus, the D40x requires AF-S or AF-I type Nikkor lenses.

Note: The D40x has an internal clock powered by an independent rechargeable battery that is charged from the camera's principal power source, either the main EN-EL9 battery or the EH-5 AC adapter with the EP-5 connector adapter. The clock battery is not accessible by the user. It requires approximately 72 hours of charging to power the clock for approximately one month. Should the clock battery become exhausted the "Clock not set" warning message is displayed on the monitor screen, and the clock is reset to a date and time of 2007.01.01 and 00:00:00 respectively. It will be necessary to reset the clock to the correct date and time should this occur.

Hint: The internal clock is not as accurate as many wristwatches and domestic clocks, so it is important to check it regularly, particularly if the camera has not been used for a few weeks.

Lens Compatibility

Either an AF-S or AF-I Nikkor lens is required to access all the functions and features of the D40x, including autofocus; other types of Nikkor lenses can only be used with manual focus and provide lesser degrees of compatibility (see table below).

Lens Type	Focus Mode		Exposure modes	Metering	
	AF	Manual	D V-P + P, S, and A modes	Matrix	C-W & Spot
AF-S, AF-I	ОК	OK	ОК	ОК	ОК
AF-D and AF-G (without AF-S)	-	ОК	ОК	ОК	OK
AF lenses	_	ОК	ОК	OK 1	ОК
AI-P	-	ОК	ОК	OK ¹	ОК
PC-Micro Nikkor 85mm f/2.8D ²	_	ОК	_	ОК	ОК
AI and AI-S compatible manual focus lenses ³	_	ОК	-	_	_

D40x Lens Compatibility Table

1. Color Matrix metering is used instead of 3D Color Matrix metering II

2. Exposure metering and flash control may not function properly when lens is shifted and/or tilted, or aperture is not at its maximum.

3. Non-CPU lenses (such as manual focus AI and AI-S type lenses) can be used but only in manual (M) exposure mode. Selecting another mode disables the shutter release. Aperture must be manually adjusted using the lens aperture ring; the autofocus system, exposure metering, electronic analog exposure display, and TTL flash control are not available. If another exposure mode is selected, the shutter release will be disabled and "F--" will appear in the display, blinking. The electronic rangefinder can be used with most lenses that have a maximum aperture of f/5.6 or faster (see page 238 for more details).

Mounting a Lens

Align the mounting index-mark (white dot) on the lens with the mounting index-mark (white dot) next to the bayonet ring of the camera's lens mount. Enter the lens bayonet into the camera and rotate the lens counter-clockwise until it locks into place with a positive click.

Hint: Whenever you attach or detach a CPU-type lens (these have a series of electrical contact pins set around the lens mount bayonet) from the D40x, ensure that the camera is turned off. If the camera is on while a lens being rotated, there is risk that the electrical contact pins on the lens mount could cause an improper connection with the contact plates in the camera, causing the electronics of the camera to malfunction.

Mounting a lens on the D40x requires alignment of the white index dots, one on the lens and another on the edge of the camera's lens mount flange.

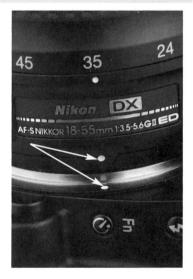

Apart from G-type lenses that lack a conventional aperture ring, it is necessary to set the aperture ring of all other CPU-type Nikkor lenses to the minimum aperture value (highest f/number), and I recommend you use the small locking switch to ensure the aperture ring is secured in this position.

It is essential to set the diopter adjustment control properly so the viewfinder image can be seen with clarity.

Hint: If you turn the camera on after mounting a lens and **FE E** blinks in the viewfinder, the lens has not been set to its minimum aperture (highest f/number). When this happens, the shutter release is disabled and the camera will not operate.

To remove a lens from the camera, press and hold the lens release button, then turn the lens clockwise until the white mounting index-mark on the lens is aligned with the mounting index-mark next to the bayonet ring of the camera's lens mount. Now lift the lens clear of the camera body. If you do not intend to mount another lens, always replace the BF-1A body cap to help prevent unwanted material from entering the camera.

Adjusting Viewfinder Focus

The viewfinder eyepiece lens has a diopter adjustment so that the camera can be used regardless of whether or not you normally wear eyeglasses. To check and set the viewfinder focus, turn the camera on with a lens attached and use the multi selector to select the central focus sensor area. Look through the viewfinder and slide the diopter control button up and down until the focus area brackets appear sharp. If the viewfinder display turns off as you make adjustments, press the shutter release button halfway to re-activate the displays.

The diopter adjustment is set by sliding the small button located to the right of the viewfinder eyepiece.

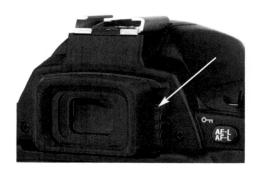

Note: It is usually easier to judge the viewfinder focus if the camera is pointed at a plain pale surface. To prevent the focusing system from hunting when pointed at a such a featureless subject, select manual focus by setting the focus mode switch on the lens to M (not A, or M/A). Alternatively, select *Focus mode* from the camera's Shooting Information Display and set it to *MF* (manual focus). Finally, set focus to the infinity mark on the lens distance scale (assuming the lens has one).

Using Your SD Memory Card

The D40x records pictures to Secure Digital (SD) memory cards, which use solid-state flash memory (i.e. no moving parts). The card slot of the D40x can accommodate one card at a time (a list of memory cards tested and approved by Nikon is shown on page 251).

Installing the Memory Card

Turn the camera OFF before opening the card slot cover by sliding it in the direction of the small arrow marked on the door. The door will swing open to reveal the memory card port. Insert the card with its contacts pointing toward the

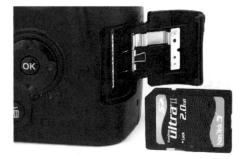

Slide the card slot cover until it swings open to reveal the memory card port; the memory card is shown in the correct orientation for installation.

cover; the small write-protect switch should be at the bottom with the main (top) label on the memory card facing you. The card will slide easily until you feel slight resistance, then keep pushing until it clicks in to place (the green memory card access lamp illuminates briefly as confirmation that the card is installed properly). Finally, close the cover.

Hint: Pay attention to the orientation of the memory card when you insert it in the D40x. The main (top) label of the card must face you (i.e. face toward the back of the camera), and the beveled corner should be to the top left as you look at the card.

Formatting the Memory Card

All new memory cards *must* be formatted before first use. To format a memory card, first ensure the write-protection switch on the card is not set to Lock, then install the card and turn the camera ON. Press the button, then navigate to the Setup menu and open it. Now high-light *Format memory card* and press the multi selector to the right. The next menu page carries the warning: *"All pictures on memory card will be deleted. OK?"* To proceed with the formatting process, highlight *Yes* and press the button (if you wish to cancel the formatting process highlight *No* and press the multi selector to the right).

During formatting, the message "Formatting memory card" appears on the monitor screen. Once formatting is finished, a further message, "Formatting complete" appears briefly on the monitor screen before the camera returns to the Setup menu display.

Note: You should never switch the camera OFF, interrupt the power supply to the camera, or remove the memory card during the formatting process.

Hint: It is good practice to format any memory card each time you install it, even if you have deleted its contents using a computer. If you do not get into the habit doing this, there is an increased risk of communication problems occurring between the card and the camera, particularly if the memory card is used in different camera bodies.

After formatting the memory card, check the Shooting Information Display on the LCD monitor to verify the number of exposures available in the frame counter. When the installed memory card reaches its capacity, the viewfinder display will change; the figure "0" will flash in the frame counter brackets of the viewfinder display and Ful will replace the shutter speed value. The camera cannot take more pictures until one or more files are deleted from the card or a different memory card is installed. However, it may be possible to take additional pictures if you reduce the image quality and size settings.

Removing the Memory Card

Before removing your memory card, make sure the green memory card access lamp has gone out. Then switch the camera OFF and open the card slot cover to push the exposed edge of the SD memory card gently towards the center of the camera, and then release it. The memory card will be partially ejected, and it can then be pulled out by hand.

Note: You should be aware that memory cards can become warm during use; this is normal and not an indication of a problem.

Despite its relatively small size for a D-SLR, the D40x has a comfortable handgrip that helps to support the camera when it is handheld.

If the D40x has no memory card inserted when a charged battery is installed, or it is connected to a AC supply via the EH-5 AC adapter and EP-5 connector, [-E-] appears in the exposure counter brackets within the Shooting Information Display on the monitor screen.

Holding The Camera

Proper hand-holding technique reduces the risk of camera shake, which is a principal cause of pictures that appear blurred. Regardless of whether you shoot with the camera held horizontally or vertically, it should be grasped firmly but not overly tight. The fingers of your right hand should wrap around the handgrip so that your index finger is free to operate the shutter release. Cup your left hand under the camera to cradle the camera and lens for support; your left thumb and index finger should be able to rotate either the focus or zoom ring of a lens. Keep you elbows tucked in towards your body while standing with your feet shoulderwidth apart with one foot half a pace in front of the other.

The D40x can be used as a point-and-shoot camera in the AUTO mode, plus it has a number of automatic subject-specfic exposure modes called Digital Vari-Programs.

Point and Shoot with the D40x

Though the Nikon D40x is a sophisticated digital SLR, it can also be used for straightforward "point-and-shoot" photography, in which the camera controls most of the settings according to the shooting conditions that prevail. As well as its fully automatic AUTO mode ******, there are six other scene-specific automatic modes in which the camera attempts to tailor its settings to suit the nature of the subject. Nikon calls these Digital Vari-Programs (you may be more familiar with the expression "scene modes"). Though they may appear tempting to less experienced photographers, it is important to remember a camera cannot think for itself–only photographers can do that! **Note:** There is also a Digital Vari-Program called Auto (Flash off), which cancels flash operation. See page 65 for more details.

By using one of these modes, you not only relinquish all exposure control to the camera, but you are also locked out of the ability to adjust several key functions, including white balance, metering mode, exposure compensation, and flash output compensation. In my opinion the Digital Vari-Program modes can be more of a hindrance than a help to photographers seeking to develop their photographic skills; you can never be sure what settings the camera is using. Still, Nikon has included these options because the D40x is designed with less experienced photographers in mind, many of whom will be content to rely on the automation offered by the camera.

Select a Digital Vari-Program

Once you are ready to take pictures, rotate the mode dial (on top left of camera) to $\overset{\text{wo}}{\longrightarrow}$, or choose one of the other Digital Vari-Programs by turning the mode dial so that the desired icon is aligned with the white index mark on the side of the viewfinder head.

Set the mode dial at AUTO for point-and-shoot photography.

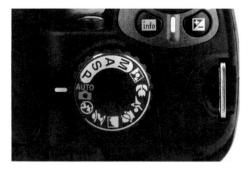

Hint: All the Digital Vari-Programs, including AUTO require a lens with a CPU to be fitted to the D40x. If you attach a non-CPU lens the shutter release will be disabled.

It's great to use the general purpose AUTO exposure mode for shooting quickly, but be aware that it imposes a number of limitations on camera control.

AUTO Mode - Default Settings

At the default settings for mode, the camera is set to the following:

- **Image Quality:** Normal–pictures are compressed (1:8) using the JPEG standard.
- Image size: Large (L)-images are 3,872 x 2,592 pixels in size.
- **Shooting mode:** Single frame-one exposure is made each time you press the shutter release.
- Flash sync mode: Auto-standard front curtain flash sync is performed
- Autofocus mode: AF-A-automatic selection of either single-servo or continuous servo modes.
- Autofocus-area mode: Closest subject all focus points selected, and camera will determine which one to use automatically.

• Sensitivity (ISO): ISO AUTO-the camera will adjust the sensitivity setting automatically if required to maintain a proper exposure.

Note: It is possible to change the default settings of mode, and regardless of whether you turn the camera off or switch to another mode and return to mode subsequently, most of the adjusted settings remain. To restore the mode default settings, use the two-button reset option by pressing and holding the button (top right of camera) together with the button (back lower left corner) for approximately two seconds (there is a small green dot beside each button as a reminder of this dual button function); to reset the options in the Custom menu to their default values you must select *Custom Setting R* (Reset).

Composing, Focusing, and Shooting

Since all three autofocus areas are active in Closest subject area mode (the default setting in AUTO mode), compose each shot so that the main subject is completely covered by one of the three bracket pairs on the focusing screen in the viewfinder. Press the shutter release halfway to activate the focusing system. If the camera can acquire focus, one or more of the autofocus sensing area bracket pairs illuminate and a beep will sound (assuming CS-01 is set to *On*). The in-focus indicator, a solid green dot, will appear in the viewfinder display.

If the in-focus indicator blinks, the camera has not been able to acquire sharp focus. Recompose and place the autofocus brackets over a different part of the subject and press the shutter release halfway again. If you still have difficulty focusing, try rotating the camera slightly toward a more vertical orientation and re-focus. Once acquired, the focus will lock at the current camera-to-subject distance.

Note: If the subject moves closer or farther from the camera before you release the shutter, and assuming the camera is set to the default AF-A autofocus mode (automatic selection of autofocus mode) the camera should select AF-C (continuous-servo autofocus mode) and begin tracking the moving subject.

Hint: The D40x shows approximately 95% of the full frame in its viewfinder. There is a narrow border around all sides that you cannot see but will be included in the final picture.

AUTO and Digital Vari-Program Modes

ΔΤΟΑ Αυτο

The mode is designed as a universal point-and-shoot mode. The camera attempts to select a combination of shutter speed and aperture that will be appropriate for the current scene. It does this by using information from the through-the-lens (TTL) metering system in the camera, which assesses the overall level of illumination, contrast, and color quality of the prevailing light, together with information from the autofocus system used to estimate the location of the subject in the frame area and its distance from the camera. This mode is most effective for general-purpose snapshot photography, such as family events or vacations.

In this mode the D40x uses its 3D Color Matrix Metering II system with D-type or G-type lenses. Using an AF-S or AF-I type lens, the camera's default AF settings are Closest subject im for AF-area mode (the camera will focus on the subject it determines to be closest) and AF-A (Auto-servo AF) for focus mode; the latter option cannot be overridden. Using any other type of lens will cause the camera to select Manual focusing, with the central AF sensing area supporting the electronic rangefinder to assist focusing (only with compatible lenses; see pages 53 and 237).

Note: If you alter the default setting for the AF-area mode, the selected AF-area option is only retained while the camera remains in mode. If you turn the mode dial to an alternative Digital Vari-Program mode, the default settings for autofocus operation (AF-area mode & AF mode) are restored.

The built-in Speedlight will activate automatically if the camera determines that additional illumination is required. The camera automatically selects standard front curtain flash

sync mode **4 AUTO** and an appropriate shutter speed between 1/60 and 1/200 second. Alternatively, you can select Auto flash with red-eye reduction **4 O AUTO**, or Auto (flash off) **3**; other flash modes are not available.

Hint: It is important to make sure your subject is within the shooting range of the flash. The built-in Speedlight has a Guide Number (GN) of 39 feet (12 m) at ISO 100. At an aperture of f/5.6 and the D40x's base sensitivity, which is equivalent to ISO 100, the maximum effective range of the flash unit is approximately 7 feet (2.1 m). If the flash symbol in the viewfinder blinks for approximately three seconds after the flash has fired, it indicates that the flash discharged at its maximum output; therefore the shot may be underexposed. In this case, either set a higher sensitivity, select a wider aperture (lower f/number), or move closer to the subject.

Auto (Flash off)

This mode is essentially the same as the mode, with the exception that the built-in flash is turned off and will not operate regardless of the level of ambient illumination, even if it is very low.

(c) is a new feature, first introduced on the D40 that is useful in situations where the use of flash is undesirable; for example when shooting in a museum where flash may be prohibited, or in natural low-light conditions where you don't want to spoil the atmosphere by using flash. Although the operation of the built-in flash is cancelled, the AF-assist illuminator lamp will still function to assist autofocus operation in poor lighting conditions.

In this mode the D40x uses its 3D Color Matrix Metering II system with D-type or G-type lenses. Using an AF-S or AF-I type lens, the camera's default AF settings are Closest subject in for AF-area mode (the camera will focus on the subject it determines to be closest) and AF-A (Auto-servo AF) for focus mode; the latter option cannot be overridden. Using any other type of lens will cause the camera to select Manual focusing, with the central AF sensing area supporting the electronic rangefinder to assist focusing (only with compatible lenses; see pages 53 and 237).

Note: If you alter the default setting for the AF-area mode, the selected AF-area option is only retained while the camera remains in O mode. If you turn the mode dial to an alternative Digital Vari-Program mode, the default settings for autofocus operation (AF-area mode and AF mode) are restored.

Hint: Since the camera can set slow shutter speeds in this mode, always check the viewfinder information to ensure that the selected shutter speed will allow the camera to be held without risk of camera shake affecting the picture. At slow shutter speeds consider using a camera support, such as a tripod.

2 Portrait

The **1** mode is designed to select a wide aperture in order to produce a picture with a shallow depth-of-field. Generally this renders the background out-of-focus so it does not detract from the subject, although the effect is also dependent on the distance between the subject and the background, and the focal length of the lens used. This mode is most effective with telephoto focal lengths and when the subject is relatively far away from the background.

To select Portrait mode, simply rotate the mode dial until the icon is aligned with the white index mark.

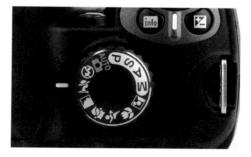

Again, in this mode the D40x uses its 3D Color Matrix Metering II system with D-type or G-type lenses. Using an AF-S or AF-I type lens, the camera's default AF settings are Closest subject **[**] for AF-area mode (the camera will focus on the subject it determines to be closest) and AF-A for focus mode; the latter option cannot be overridden. Using any other type of lens causes the camera to select manual focus and the central AF area (focus bracket), which supports the electronic rangefinder (only with compatible lenses) to assist focusing.

Note: If you alter the default setting for the AF-area mode, the selected AF-area option is only retained while the camera remains in **2** mode. If you turn the mode dial to an alternative Digital Vari-Program mode, the default settings for autofocus operation (AF-area mode & AF mode) are restored.

The built-in Speedlight will activate automatically if the camera determines that additional illumination is required. The camera automatically selects standard front curtain flash sync mode **\$** AUTO and an appropriate shutter speed between 1/60 and 1/200 second. Alternatively, you can select Auto flash with red-eye reduction **\$** O AUTO, or Auto (flash off) **\$**; other flash modes are not available.

Hint: The most successful portraits are often achieved when the subject nearly fills the frame. Since at the default setting selection of the autofocus area is fully automatic, there is no guarantee that the camera will focus on at least one of the subject's eyes. Therefore I strongly recommend that you override the default option and use Single area AF [^[1]] to choose an autofocus sensing area that covers one of the subject's eyes to ensure it is focused sharply. To select Single area AF, press the button to open the Shooting Information Display, then press the button; use the multi selector to highlight the AF-area mode option and press Use the multi selector to highlight [^[1]], and confirm the selection by pressing .

If using flash, it is important to make sure your subject is within the shooting range of the flash (see the Hint about Guide Number, page 65).

Landscape

The mode is designed to select a small aperture in order to produce a picture with an extended depth-of-field. Generally, this renders everything from the foreground to the horizon in-focus, although this will depend to some degree how close the lens is to the nearest subject. This mode is most effective with wide-angle or wide-angle zoom lenses, and when the scene is well lit.

Again, in this mode the D40x uses its 3D Color Matrix Metering II system with D-type or G-type lenses. Using an AF-S or AF-I type lens, the camera's default AF settings are Closest subject Im for AF-area mode (the camera will focus on the subject it determines to be closest) and AF-A for focus mode; the latter option cannot be overridden. Using any other type of lens will cause the camera to select Manual focusing, with the central AF sensing area supporting the electronic rangefinder to assist focusing (only with compatible lenses; see pages 53 and 237).

Note: If you alter the default setting for the AF-area mode, the selected AF-area option is only retained while the camera remains in a mode. If you turn the mode dial to an alternative Digital Vari-Program mode, the default settings for autofocus operation (AF-area mode & AF mode) are restored.

The Landscape exposure mode is optimized to provide extended depth of field, which can be particularly effective with a wide-angle lens.

Operation of the built-in Speedlight and AF-assist lamp is cancelled in mode; there are no flash modes available in the Landscape mode.

Hint: It is important to ensure the main area of interest in your composition is in sharp focus. Since selection of the focusing area is fully automatic at the default setting, the camera may not focus where you expect it to; in a mode you may prefer to override the default option by selecting Single area AF [1] to ensure you know which part of the scene the camera is focusing on. To do this, press the button to open the Shooting Information Display, then press the button; use the multi selector to highlight the AF-area mode option and press . Use the multi selector to highlight [1], and confirm the selection by pressing .

Hint: When using a wide-angle focal length (i.e. a focal length less than 35mm), try to include an element of interest in the foreground of the scene, as well as the middle distance, to help lead the viewer's eye into the picture.

🗳 Child

The formula mode sets a bias toward a wide aperture (low f/number) to reduce the depth of field; although the effect is also dependent on the distance between the subject and the background, together with the focal length of the lens used. This mode is most effective with telephoto focal lengths and when the subject is relatively far away from the background. Image processing in camera is designed to render soft, natural skin tones without affecting the vividness of other colors.

Once again, in this mode the D40x uses its 3D Color Matrix Metering II system with D-type or G-type lenses. Using an AF-S or AF-I type lens, the camera's default AF settings are Closest subject for AF-area mode (the camera will focus on the subject it determines to be closest) and AF-A for focus mode; the latter option cannot be overridden. Using any other type of lens will cause the camera to select Manual focusing, with the central AF sensing area supporting the electronic rangefinder to assist focusing (only with compatible lenses, see pages 53 and 237).

Note: If you alter the default setting for the AF-area mode, the selected AF-area option is only retained while the camera remains in a mode. If you turn the mode dial to an alternative Digital Vari-Program mode, the default settings for autofocus operation (AF-area mode & AF mode) are restored.

The built-in Speedlight will activate automatically if the camera determines that additional illumination is required. The camera automatically selects standard front curtain flash sync mode **\$** AUTO and an appropriate shutter speed between 1/60 and 1/200 second. Alternatively, you can select Auto flash with red-eye reduction **\$** O AUTO, or Auto (flash off) **\$**; other flash modes are not available.

Hint: Like shooting portraits, best results for pictures of children are often achieved when the subject nearly fills the frame. Since the autofocus area is set automatically at Closest subject, there is no guarantee that the camera will focus on at least one of the subject's eyes. Therefore I strongly recommend that you override the default option and use Single area AF [1], and choose a focus area that covers one of the subject's eyes to ensure it is focused sharply. To select Single area AF, press the button to open the Shooting Information Display, then press the button; use the multi selector to highlight the AF-area mode option and press to ensure it is focused sharply. [1], and confirm the selection by pressing

When photographing children it is often preferable to lower the camera so the lens is at the child's eye level because this helps to produce a more pleasing perspective. Using a focal length in the range of 70–105mm will allow you to maintain a comfortable working distance from your subject(s) reducing the risk of disturbing them and increasing the chances of capturing some candid moments. If using flash, it is important to make sure your subject is within the shooting range of the flash (see Hint about GN, page 65).

💐 Sports

The \checkmark mode is designed to select a wide aperture in order to maintain the highest possible shutter-speed to "freeze" motion in fast-paced action, such as sports or children on the go. It also has a beneficial side effect, since this combination produces a picture with a very shallow depth-offield that helps to isolate the subject from the background. This mode is most effective with telephoto or telephoto-zoom lenses, and when there are no obstructions between the camera and the subject that may cause the autofocus function to focus on something other than the subject.

In * mode the D40x uses its 3D Color Matrix Metering II system with D-type or G-type lenses. Using an AF-S or AF-I type lens, the camera's default AF-area setting is Dynamic area [13]. The camera will use the central focus area, but if the subject leaves the coverage of the central AF-area, the camera will continue to perform autofocus, tracking a moving subject using information from the two other focus areas, provided the shutter release button is kept half depressed. The focus mode is always set to AF-A and cannot be overridden. Using any other type of lens will cause the camera to select Manual focusing, with the central AF sensing area supporting the electronic rangefinder to assist focusing (only with compatible lenses; see pages 53 and 237).

Note: If you alter the default setting for the AF-area mode, the newly selected AF-area option will be retained while the camera remains in $\stackrel{\bullet}{\prec}$ mode. If you turn the mode dial to an alternative Digital Vari-Program mode, the default settings for autofocus operation (AF-area mode & AF mode) are restored.

Operation of the built-in Speedlight and AF-assist lamp is cancelled in $\stackrel{\bullet}{\stackrel{\bullet}{\xrightarrow}}$ mode; there are no flash modes available in the Sports mode.

Familiar objects in everyday surroundings offer an endless supply of subjects for close-up and macro photography.

Hint: There is always a slight delay between pressing the shutter release button and the shutter opening; therefore, it is important to anticipate the peak moment of the action and press the shutter just before it occurs. The decisive moment will be missed if you wait to see it in the viewfinder before pressing the shutter release.

Close-Up

The mode is for taking pictures at short shooting distances of subjects, such as flowers, insects, and other small objects. It is designed to select a small aperture in order to produce a picture with an extended depth-of-field. Generally depth-of-field is limited when working at very short focus distances, even when using small apertures (high f/numbers), so this program tries to render as much of the subject in focus as possible. The final effect will also be dependent on how close the camera is to the subject and the focal length of the lens used. This mode is most effective with lenses that have a close-focusing feature, or dedicated Micro-Nikkor lenses.

In this mode the D40x uses its 3D Color Matrix Metering II system with D-type or G-type lenses. Using an AF-S or AF-I type lens, the camera's default AF-area setting is Single area [1], using the central focus area to focus on the subject (either of the two other focus areas can be selected by pressing the multi selector). The focus mode is always set to AF-A, which you will not be able to override. Using any other type of lens will cause the camera to select Manual focusing, with the central AF sensing area supporting the electronic rangefinder to assist focusing (only with compatible lenses; see pages 53 and 237).

Note: If you alter the default setting for the AF-area mode, the selected AF-area option will be in effect while the camera remains in mode. If you turn the mode dial to an alternative Digital Vari-Program mode, the default settings for autofocus operation (AF-area mode & AF mode) are restored.

The built-in Speedlight will activate automatically if the camera determines that additional illumination is required. The camera selects standard front curtain flash sync mode **\$** AUTO and an appropriate shutter speed between 1/125 and 1/200 second. Alternatively, you can select Auto flash with red-eye reduction **\$** O AUTO, or Auto (flash off) **\$**; other flash modes are not available.

Hint: Due to the emphasis this mode places on using a small aperture, the shutter-speed can quite often be relatively slow. To prevent image blur caused by camera shake, use a tripod or some other form of camera support.

Night Portrait

The mode is designed to capture properly exposed pictures of people against a background that is dimly lit. It is useful when the photographer wants to include background detail, such as a cityscape or sunset, in the photo and is most effective when the background is in low-light, as opposed to near dark or totally dark, conditions. The built-in Speedlight will activate automatically in low-light; alternatively, an external Speedlight such as the SB-400, or SB-600, can be used to supplement the ambient light.

The camera automatically selects standard front curtain flash sync mode **4 AUTO** and an appropriate shutter speed between one second and 1/200 second. Alternatively, you can select Auto flash with red-eye reduction **4 O AUTO**, or Auto (flash off) **3** ; other flash modes are not available.

In this mode the D40x uses its 3D Color Matrix Metering II system with D-type or G-type lenses. Using an AF-S or AF-I type lens, the camera's default AF settings are Closest subject **I** for AF-area mode (the camera will focus on the subject it determines to be closest) and AF-A for focus mode; the latter option cannot be overridden. Using any other type of lens will cause the camera to select Manual focusing, with the central AF sensing area supporting the electronic rangefinder to assist focusing (only with compatible lenses; see pages 53 and 237).

Note: If you alter the default setting for the AF-area mode, the selected AF-area option is only retained while the camera remains in mode. If you turn the mode dial to an alternative Digital Vari-Program mode, the default settings for autofocus operation (AF-area mode & AF mode) are restored.

Hint: It is important to ensure the main area of interest in your composition is in sharp focus.

Since focus area selection is fully automatic at the default setting, there is no guarantee that the camera will focus where you expect it to in \square mode. Therefore I strongly recommend that you override the default option. Use Single area AF [1], and choose a focus area that covers one of

the subject's eyes to ensure it is focused sharply. To select Single area AF, press the button to open the Shooting Information Display, then press the button; use the multi selector to highlight the AF-area mode option and press Son . Use the multi selector to highlight [1], and confirm the selection by pressing Son .

Commons Settings in Digital Vari-Program Modes

The following are shared between and all Digital Vari-Program Modes:

- All photographs are recorded in the sRGB color space.
- All shooting modes (Single, Continuous, Self-timer, Remote, and Remote-delay) can be used.
- If the light levels exceed the sensitivity of the TTL metering system in the D40x, H i will be displayed in the viewfinder if the overall level of illumination is too bright, or i o will be displayed if the overall illumination is too low.

Optimize Image Settings in Digital Vari-Program Modes

The D40x applies the values in the following table when either AUTO or one of the Digital Vari-program modes is selected. The user has no control over these settings, which are applied automatically by the camera.

	Sharpening	Tone	Color Mode /Space	Saturation	Hue
AUTO	Auto	Auto	IIIa/sRGB	Auto	0
Auto (Flash off)	Auto	Auto	IIIa/sRGB	Auto	0
Portrait	Auto	Auto	la/sRGB	Auto	0
Landscape	Auto	Auto	IIIa/sRGB	Auto	0
Child	Auto	Auto	la/sRGB	Auto	0
Sport	Auto	Auto	IIIa/sRGB	Auto	0
Close-up	Auto	Auto	IIIa/sRGB	Auto	0
Night Portrait	Auto	Auto	la/sRGB	Auto	0

Basic Image Review

Assuming CS-07 is set to its default setting of *On*, a photograph will be displayed on the LCD monitor almost as soon as the exposure is made. If no picture is displayed, the most recent picture recorded by the D40x can be displayed by pressing the button (located on back upper left of camera). To review other pictures, use the multi selector to scroll through the pictures stored on the memory card. To return to the shooting mode at any time, simply press the shutter release button halfway.

If you want to delete the displayed picture, press the button (located on back lower right of camera). A message will be shown over the displayed picture asking for confirmation of the delete action, with an option to cancel. Press the button again to proceed and delete the picture. To stop the delete operation, either press , or press the shutter release button halfway.

To protect an image from accidental deletion, display it on the monitor screen by pressing and press the button (on back of camera to right of viewfinder eyepiece). A key icon will appear in the top left corner of the displayed image to indicate its protected status. To remove the protection, display the image and press the button again; the key icon will disappear.

Note: Never be in too much of a hurry to delete pictures unless they are obvious failures; it is better to leave the editing process to a later stage, as your opinions about a particular picture can, and often do, change. Also, any image file marked as protected will maintain this status as a read-only file even when the image file is transferred to the computer, or other data storage device.

Detailed Shooting Operations

Powering the D40x

The D40x uses the Nikon EN-EL9, a rechargeable lithiumion battery that is the only internal power source for this camera; it cannot accept any other battery. The EN-EL9 can only be inserted the correct way into the camera and is charged with the dedicated MH-23 Ouick Charger (supplied with the camera). This battery is rated at AC 100-240V (50/60Hz) so it can be used worldwide. A fully discharged EN-EL9 can be completely recharged in approximately 90 minutes using the MH-23. Unlike some other types of rechargeable batteries, the EN-EL9 does not require conditioning prior to its first use. However, the battery supplied with the camera is only partially charged. It is advisable to allow the initial charge cycle for a new battery to continue until the battery cools down while still in the charger before removing it. Do not be tempted to remove it as soon as the charging/charged indicator lamp on the MH-23 stops flashing, as the battery is unlikely to have reached full charge.

Note: Do not leave the EN-EL9 battery charging in the MH-23 for protracted periods as this may cause damage to the battery.

It is always worthwhile carrying a spare EN-EL9 battery, particularly when traveling; the MH-23 charger can be used worldwide with the appropriate electric plug. The profile of the EN-EL9 battery ensures that it can only be inserted into the camera in the correct orientation.

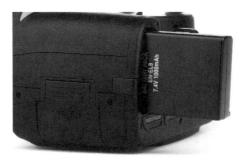

Using the EN-EL9 Battery

To insert an EN-EL9 into the D40x:

- 1. Push the small button on the battery chamber cover (on bottom of camera) toward the tripod socket. The cover should swing open.
- 2. Open the cover fully and slide the battery into the camera observing the diagram on the inside of the chamber cover.
- 3. Press the cover down (you will feel a slight resistance) until it locks (you will hear a slight click as the latch closes).

To remove an EN-EL9 from the D40x:

- 1. Repeat Step 1 (above).
- 2. Hold the cover open, turn the camera upright, and allow the battery to slide out taking care that it does not drop.
- 3. Close the battery chamber cover.

Whenever you insert or remove an EN-EL9, it is essential that you power the camera off. If you are in the process of making changes to the camera settings and the battery is removed while the power switch is still set to the ON position, the camera will not retain the new settings. Likewise, if the camera is still in the process of transferring data from the buffer memory to the storage medium when the battery is removed, image files are likely to be corrupted, or data lost.

The MH-23 is the dedicated AC charger for the EN-EL9 battery.

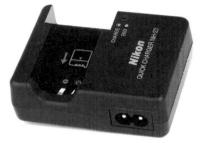

To charge an EN-EL9:

- 1. Connect the MH-23 to an AC power supply.
- 2. Align the white arrowhead on the EN-EL9 with that in the MH-23 slot, and then slide the battery toward the contact plates of the charger until it locks in place. The charge lamp should begin to flash immediately.

Hint: To ensure the battery has recharged fully, leave it in place until it has cooled to the ambient room temperature. Partially discharged lithium batteries, like the EN-EL9, can take a "top-off" charge without adverse consequences to battery life or performance.

I recommend owning a spare EN-EL9. Whenever the battery is not in the camera or charger, always place the semiopaque plastic terminal cover in place on the battery. Without it there is a risk that the terminals may short and cause damage to the battery.

The EN-EL9 battery has an electronic chip in its circuitry that enables it to report detailed information regarding its status to the D40x. To check the status of the battery, press the button to open the Shooting Information Display on the monitor screen.

D40x Battery Status

Monitor	Viewfinder	Battery Status		
		Fully charged		
		Partially discharged		
		Low – charge battery		
(blinks)	Discharged – charge battery		

EH-5 AC Adapter/EP-5 Adapter Connector

The Nikon EH-5 AC adapter, which is available separately, can also power the D40x via the EP-5 adapter connector. These accessories are particularly useful for extended periods of shooting, or camera use such as image playback through a TV set, to prevent the camera from powering off while the reflex mirror is raised (using the mirror lock-up facility in the setup menu) for inspection or cleaning of the low pass filter array, and when shooting with the D40x tethered to a computer and operated by Nikon Camera Control Pro, or for direct transfer of pictures to the computer hard drive. The EH-5 cannot be connected directly to the D40x; it requires the EP-5 adapter connector to be inserted in the camera's main battery chamber, substituting for the EN-EL9 battery (ensure the + and - terminals of the FP-5 are in the correct orientation). The cord from the EP-5 should be laid in the small notch in the edge of the battery chamber before closing the chamber cover. Connect the EH-5 DC plug to the DC terminal of the EP-5. Finally, connect the EH-5 AC plug of the AC cord to the EH-5 AC terminal, and connect the other end to the AC supply. When powered from an AC supply, the battery indicator of the D40x will show - in the Shooting Information Display.

Note: Always ensure that the power switch on the D40x is set to OFF before connecting/disconnecting the EH-5/EP-5. There is a risk that the camera's circuitry could be damaged if you plug/unplug the EH-5/EP-5 while the power switch is set to ON.

Internal Clock/Calendar Battery

The D40x has an internal clock/calendar that is powered by a rechargeable battery that, when fully charged, will power the clock/calendar for approximately one month. It requires charging for approximately 72 hours by the camera's main power supply, either the EN-EL9 battery or the EH-5/EP-5 AC adapter. Should the clock battery become exhausted, the message "Clock not set" will be displayed on the LCD, and the clock is reset to a date and time of 2007.01.01 00:00:00. If this occurs, the clock/calendar will need to be reset via the World Time option in the setup menu.

Note: Since the clock/calendar battery is not changeable by the user, should it not hold a charge the camera must be returned to a service center for a replacement battery to be fitted.

Battery Performance

Obviously the more functions the camera has to perform the greater the demand for power. Reducing the number of functions and the duration for which they are active is fundamental to reducing power consumption. Here are a few suggestions that will help preserve battery power.

- The EN-EL9 will exhibit a loss of charge if left dormant for a month or more, so ensure you recharge it fully before use.
- Using the camera's LCD monitor increases power consumption significantly. Unless you need it, turn the monitor off by pressing the shutter release button down halfway. Consider setting the *Image review* option in CS-07 to *Off* (the default setting is *On*). You can use CS-15 (*Auto off timers*) to limit the time the monitor remains on for Shooting Information Display, Image review, and the delay before Auto meter off.

Hint: If *Image review* is set to *On*, press the shutter release lightly as soon as you have checked the picture. This returns the camera to its shooting mode, and prepares it to take another picture, switching the LCD monitor off immediately.

- The Vibration Reduction (VR) feature available with some Nikkor lenses remains active as long as the shutter release button is depressed, thereby reducing battery life by approximately 10%.
- Maintaining a connection to either a computer or Pict-Bridge compatible printer will have a significant affect on battery charge since both functions draw a considerable level of power. Always disconnect the D40x from the other device as soon as you have finished using it.
- Low temperatures cause a change to the internal resistance of a battery that impairs performance. Though Lithium batteries are fairly resilient to cold conditions, to ensure continued shooting in such conditions keep a spare battery in a warm place (such as an inside pocket). As the performance of the battery in the camera dwindles, exchange it with the warm one. Allow the used battery time to warm-up again, and keep rotating between the two batteries to maximize their shooting capacity.
- Finally, if you expect to store the camera for more than four weeks, always remove the battery. Never store a battery that is discharged; if left in this condition for any period of time there is a risk it may be damaged permanently.

Secure Digital (SD) Memory Cards

These small solid-state cards measure $1.3 \times 0.9 \times 0.08$ inches (34 x 22 x 2 mm) and have a capacity of up to 2GB. While you should treat any memory card with the same care you would give your camera equipment, SD cards have no moving parts and are reasonably robust. They have a small, sliding write-protection switch on one edge that can be set to prevent data from being written to the card by the camera, or prevent deletion of data from the card by either a camera or computer (if you insert a locked SD card in to the D40x the camera will display a warning message). Finally, they are not affected by radiation from X-ray security equipment.

High capacity memory cards enable you to shoot many exposures in succession, which is a big advantage when unique opportunities arise.

Secure Digital High Capacity (SDHC) Memory Cards

To support the larger file sizes now generated by digital cameras and other devices, there is a growing need for SD cards with a capacity in excess of 2GB. To meet this demand, a new design of SD card has been introduced that retains the same physical dimensions and write-protect fea-

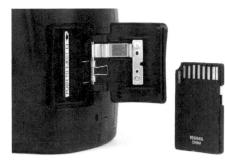

The D40x is compatible with both SD and SDHC memory cards. These cards have the advantage of using flat plate contacts, which are more durable than the pin-socket connection used by CompactFlash cards. ture of standard SD cards. The new card type complies with the SD specification version 2.0, which supports card capacities of 4GB and over, and is called Secure Digital High Capacity (SDHC). These higher-capacity cards are now being marketed by manufacturers within the industry.

The D40x is fully compatible with SDHC memory card format that uses the SD specification version 2.0 design; at the time of writing the first 8GB cards have been launched but this is nowhere near the theoretical maximum capacity, and card capacities up to 32GB are likely.

Note: The D40x accepts standard SD cards and SDHC cards; it is important to remember that many devices that are only SD compliant do not support SDHC cards. This may affect your ability to use SDHC cards with some card readers and other non-SDHC compliant devices.

The SD card should be inserted in the card slot with its beveled corner positioned to the upper left and its label facing the back of the camera.

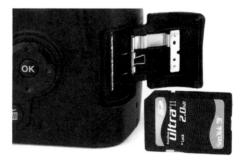

Formatting

As data is written to and erased from SD and SDHC cards, small areas of its memory can become corrupted as "bad sectors," and files can become fragmented, particularly if you delete individual image files from the card. By formatting the card in the camera, the worst effects of fragmentation are generally cleaned up.

It is a misconception that formatting a memory card permanently deletes the data on the card. Actually, the process of formatting causes the existing file directory information to be over-written, so that it no longer "points" to the image data held on the card. It is therefore difficult, although far from impossible, to recover previously written data from the card. If you should format a card inadvertently, it can be possible to retrieve the image files using software designed to recover data. To maximize your chances of recovering the data successfully, ensure no new data is written to the card before carrying out the recovery process. Since prevention is better than cure, always save your images to a computer or other storage device (and make a back up copy) before formatting a card.

Note: The D40x supports FAT32, which allows it to use a SDHC memory cards with a capacity in excess of 2GB. FAT16 is used when formatting any memory card already formatted in FAT16.

File Formats

The D40x saves images to the memory card in two file formats, Joint Photographic Experts Group (JPEG) and Nikon Electronic File (NEF), Nikon's proprietary RAW files. Strictly speaking, JPEG is not a file format but a standard of compression established by the Joint Photographic Experts Group (JPEG), but these days the term "JPEG format" is ubiquitous.

The D40x uses high-precision 12-bit digital image processing algorithms, a technology first introduced in the Nikon D2X and subsequently incorporated in the D200, D2Xs, and D80 models. The camera processes image data destined for saving as a JPEG file at a 12-bit depth, by taking the 12-bit raw data from the sensor and only reduces the data to an 8-bit depth at the point when the JPEG compression encoding is performed. In previous Nikon D-SLR cameras, the application of image attributes such as sharpening, tone (contrast), and color adjustments is done at an 8-bit level, which can result in posterization, causing the loss of certain tonal values. In shadow tones, this can result in an uneven appearance; and in highlight tones it can result in highlights that lack detail. By maintaining the image data at a 12-bit depth when performing in-camera modifications, the D40x produces far better looking JPEG files compared with previous Nikon D-SLR models, particularly in the shadow areas. Once the 12-bit image data is reduced to an 8-bit depth, the JPEG compression regime is applied. To prevent a build up of contrast and loss of acuity, I recommend you use the lowest level of compression by selecting an image quality of *Fine*.

Using the NEF format, the camera deals with sensor data in a different way. The D40x records compressed NEF files, so some of the 12-bit data from the sensor is discarded in a process that Nikon describes as being "visually lossless" (see below for the explanation of what actually occurs). The camera settings in use at the time an image is taken are recorded and saved to the relevant fields in the EXIF file. The camera also creates and stores a thumbnail image, akin to a JPEG file, alongside the NEF file.

Note: There is no option to record uncompressed NEF files with the D40x.

Using the JPEG format the camera produces a "finished" image from the sensor data and the settings in use at the time of the exposure. I put finished in quotation marks because these files can still be enhanced, if you want, after they have been imported to a computer. Using the NEF format requires that the work involved in producing a "finished" image be done by the photographer using appropriate software and a computer.

If you are beginning to form the impression that to eek out every last ounce of quality the D40x has to offer you should shoot in the NEF format, you are not too far off. However, while many photographers refer to RAW format as being "better" than JPEG, I prefer to consider the issue in terms of the strengths or benefits each offers, and recommend that you use the one that is best suited to your specific requirements. It is worth taking a look at the attributes of each format so you can make an informed decision.

Shooting in the NEF format provides image files with the greatest level of flexibility when processing pictures later in the computer.

JPEG Format

JPEG files have three attributes that can influence image quality in an adverse manner:

In-camera processing reduces 12-bit data from the sensor to 8-bit values when it creates a JPEG file. The D40x does have an advantage over many other D-SLRs in that all in-camera adjustments are made at a 12-bit level before the data is reduced to an 8-bit level, so the reduction to 8-bits is of little consequence if you have no intention of applying image processing with computer software. However, if you make significant changes to an image using software in post-processing, the 8-bit data of a JPEG file can impose limits on the degree of manipulation that can be applied.

- When the camera saves an image using JPEG, it encodes most of the camera settings for attributes such as white balance, sharpening, contrast, saturation, and hue into the image data. If you make an error and select a wrong setting, you will need to correct your mistake in post-processing using a computer. Inevitably this is time consuming time and there is no guarantee it will be successful.
- The technology of digital imaging is fast paced and the electronics used in any particular camera are only as good as the day the manufacturer decided on their specification and finalized the design of the camera. Granted, updated firmware may help to offset some obsolescence, but updates eventually stop being produced. By processing images in software on a computer, you can often take advantage of the latest advances in image processing, which are unavailable to the camera.

NEF (RAW)

Using NEF has only one real disadvantage to my mind, and that is the extra time it takes to process each image using computer imaging software to produce a finished picture. The larger file size of the NEF format can also be an issue in terms of the amount of available storage needed on your memory card and external storage facilities for archiving pictures. Equally, there can be limitations with some third party software applications when it comes to their ability to read and interpret Nikon's proprietary NEF files. The benefits of NEF include:

- More consistent and smoother tonal graduations.
- Color that is more subtle and accurate to the original subject or scene.
- A slight increase in the level of detail that is resolved.
- The ability (within fairly limited parameters) to adjust exposure in post-processing to correct for slight exposure errors.

• The ability, in post processing, to correct and/or change image color by resetting attributes such as the white balance value, contrast, saturation, and hue.

Note: Most modern software is capable of reading NEF files generated by a D40x. There is a wide variety of third party RAW file converters that enable a NEF file to be opened in most popular digital imaging software applications. For compatibility between NEF files from the D40x and Nikon software, you will require: PictureProject 1.7.5, or Nikon Capture NX 1.1.0.

Nikon describes the compression applied to NEF files as being "visually lossless," by which they mean it is impossible to see the difference between compressed and uncompressed NEF files. This compression process used by Nikon is selective, working on certain image data while leaving other data unaffected. It works in two phases: the first phase groups and rounds certain tonal values while the second is where conventional lossless compression is applied.

To begin, the analog signal from each pixel site on the sensor is converted to one of 4,096 possible values (i.e. a 12-bit depth). A value of 0 represents pure black (no data), and a value of 4,095 represents pure white (total saturation). During the first phase, the values that represent the very dark tones are separated from the rest of the data. Then the data with values that represent the remaining tones is divided into groups, but this process is not linear. As the tones become lighter the size of the group increases, so the group with the lightest tones is larger than a group containing mid-tone values. A lossless compression is then applied to each individual dark tone value and the rounded value of each group in the mid and light tones.

When an imaging application such as Nikon PictureProject or Nikon Capture NX opens a NEF file, it reverses the lossless compression process. The individual dark tone values are unaffected (remember the compression is lossless) but – and here is the twist – each of the grouped values for the mid and light tones must be expanded to its appropriate range on a 12bit scale. Since the rounding error in each group becomes progressively larger as the tonal values become lighter, the gaps in the data caused by the rounding process also become progressively larger at lighter tonal values.

However, the human eye does not respond in a linear way to increased levels of brightness, so it is incapable of resolving the very minor changes that take place, even in the lightest tones where the rounding error is greatest and therefore the data "gap" is largest (remember Nikon's phrase – "visually lossless"). Furthermore, our eyes are generally only capable of detecting tonal variations equivalent to those produced by 8-bit data, and even a compressed NEF file has more than that. Consequently the data gaps caused by Nikon's compression process are of no consequence.

Note: There is a small risk that the data loss caused by compression of NEF files might manifest in the highlight areas of an image that is highly altered during image processing (e.g., considerable color shift, significant modification of tone, or excessive sharpening).

Which Format?

In considering the attributes of JPEG and NEF, many photographers make an analogy with film photography; they compare the NEF file to an original film negative and the JPEG file to a machine-processed print. I do not disagree, but not every photographer has the desire, ability, or time to process NEF files with imaging software, so JPEGs are fine for them. The good news is that we have a choice. If you have sufficient storage capacity, you could select the NEF + JPEG preference from the options for image quality. That way the D40x can save a copy of an image in both formats, but this setting uses the highest level of compression for the JPEG file.

Image Quality and Size

The D40x allows you to save JPEG files at three different levels of quality:

- FINE Uses a low compression of approximately 1:4
- NORMAL The default uses a moderate compression ratio of approximately 1:8
- *BASIC* Uses a high compression ratio of approximately 1:16

Each JPEG file can also be saved by the D40x at one of three different sizes:

- *L* Large (3872 x 2592 pixels)
- *M* Medium (2896 x 1944 pixels)
- *S* Small (1936 x 1296 pixels)

You should select the lowest level of compression to maintain the highest image quality possible; a file saved at the FINE setting will be visually superior to a file saved at the BASIC setting. It is also true that JPEG compression can generate visual artifacts, and the higher the compression ratio the more apparent these become. If you are shooting for web publication, this is unlikely to be an issue. But if you intend to make prints from your JPEG images, you will probably want to use the Large/FINE settings.

There is no size option with NEF files since the D40x always uses the full 3,872 x 2,592 resolution of the sensor. NEF files can only be saved in a compressed form, quoted at a size of approximately 9.0MB in the Nikon manual. However, the degree of compression in a NEF as well as a JPEG will vary slightly depending on the nature of the scene photographed, meaning the file size will also vary. Hence it is possible the camera will record more pictures than the quantity initially displayed as the number of exposures remaining when the card is formatted in the camera (see page 253 for details of file sizes).

Note: The make of memory card can also influence the total number of pictures that an individual card can store, so do not be surprised if you see slight differences in card capacity between cards from different manufacturers.

Setting Image Quality and Size

To set image quality (JPEG or RAW) on the D40x, open the Shooting menu and use the multi selector to highlight *Image quality*; press the multi selector to the right to open a list of options and scroll up or down to highlight the desired one. Finally, press the source button to confirm your selection.

Alternatively, and in my opinion far more convenient and quicker, is to use the button method, which obviates the need to open the menu system. Press the button to open the Shooting Information Display, then press the button and use the multi selector to highlight *Image quality*. Press the button to open the list of quality settings, and use the multi selector to highlight the required option; there are five options available:

- RAW (NEF)
- FINE (JPEG)
- NORM (JPEG)
- BASIC (JPEG)
- *RAW* + *B* (NEF + JPEG Basic)

Finally, press the or button to confirm your selection.

To set image size for JPEGs on the D40x, open the menu and use the multi selector to highlight *Image size*. Press the multi selector to the right to open the list of options and press it up or down to highlight the desired setting: *Large, Medium,* and *Small*. Finally, press the button to confirm your selection.

Also, like setting the quality, you can use the more convenient and quicker button method. Start by pressing the

 light *Image size*. Press the button to open the list of size settings, and use the multi selector to highlight the required option:

- *L* (Large 3872 x 2592 pixels) this is the default setting.
- *M* (Medium 2896 x 1944 pixels).
- S (Small 1936 x 1296 pixels).

Press the obstruction button to confirm your selection.

White Balance

We are all familiar with the way the color of daylight changes during the course of a day, from the orange/yellow colors immediately after sunrise, through the cooler look of light around midday, to the red/orange colors that appear as the sun sets. However, the color of light, not to be confused with the color of the objects from which it is reflected, changes in subtle ways at other times of the day and in different climatic conditions. Furthermore, different types of light sources, such a household bulb or camera flash unit, emit different colored light. The color of light is defined by a color temperature and measured in degrees on the Kelvin (K) scale. Our eyes and brain are remarkably good at adapting to light with different color temperatures, so subtle changes are not always apparent to us.

Digital sensors, however, have an objective, fixed response to light with a specific color temperature. However, the electronics of digital cameras such as the D40x permit flexibility with regard to recording the color temperature of light, processing the picture data to equate to a variety of specific color temperatures, either automatically, or by selecting the color temperature manually. This function is known as the white balance (WB) control.

White Balance Options

The D40x offers a number of white balance options that are only available when shooting in the P, A, S, and M exposure modes. (In Auto and the Digital Vari-Program modes,

the white balance value is always selected automatically). The approximate color temperature for each option (except **PRE**) is in parentheses in the following list of descriptions:

AUTO Auto (3500 – 8000K): Nikon suggests that the D40x will measure light with a color temperature between 3500K and 8000K automatically. In most instances the Automatic option is quite effective, but as with all automatic features on any camera, you need to think for yourself and take control when appropriate. For example, if you shoot indoors under normal electric lighting, the color temperature is likely to be lower than 3500K. Alternatively, color temperature is likely to exceed 8000K outdoors in bright overcast conditions or open shade.

Incandescent (3000K): Use this in place of the *Auto* option when shooting indoors under tungsten lights. If you find that the result still looks too warm (red), use the fine-tuning control (see page 99) to make further adjustments.

Fluorescent (4200K): The light emitted from fluorescent tubes is notorious for causing unwanted color casts in pictures. This is due to the variability in the color temperature of the light they produce. However, this option is accurate for tubes that are described by their manufacturer as "daylight" balanced.

*** Direct sunlight (5200K):** This option is intended for subjects or scenes photographed in direct sunlight from around two hours after sunrise to two hours before sunset. At other times, when the sun is lower in the sky, the light tends to be warmer, which produces pictures with a redder appearance.

Hint: I know that white balance is a subjective issue, but to my eye the color temperature for the D40x's * option is too low (after all, most daylight color film is balanced to 5500K). When shooting in these conditions I prefer to use either the *Flash* $\frac{1}{2}$ or *Cloudy* O options.

Flash (5400K): As its name implies, this option is intended whenever you use flash as the main light source (Nikon refers to its own flash units as Speedlights).

Hint: As with the * option, I consider the color temperature of the • option to be too low, since the color temperature of light emitted by Nikon Speedlights is generally in the range of 5500–6000K. Therefore I often select the • option when working with Nikon flash units as the main light source.

Cloudy (6000K): This option is for shooting under overcast skies, when daylight has a high color temperature. It ensures the camera renders colors properly without the typical cool (blue) appearance that often results when shooting in this kind of light, particularly in pale skin tones.

c. **Shade (8000K):** This option applies a greater degree of correction than the setting and is intended for those situations when your subject or scene is in open shade beneath a clear blue sky, when the color temperature is likely to be very high. Under these conditions the light will be biased strongly towards blue, as it is comprised principally of light reflected from the sky.

PRE White balance preset: This setting allows the user to measure the color temperature of the light illuminating the subject or scene by making a test exposure. Alternatively, the photographer can use an existing image stored on the memory card as a reference for the color temperature value.

Selecting a White Balance Option

The options for white balance settings can be selected in two ways: (1) from the Shooting menu or (2) from the Shooting Information Display. However, the second method does not allow you to set a fine-tuning option or measure a value for the **PRE** white balance.

For the first method, press the button on the rear of the camera and use the multi selector to open the

menu. Navigate to *White balance* using the multi selector and press it to the right to open the next page, displaying the available options. Scroll down the list to highlight your choice and press the multi selector to right. A menu page that follows will display an option for fine-tuning your selection (see next page for details).

Note: White balance fine-tuning factors cannot be applied if the PRE white balance option is selected, or the camera is set to one of the Digital Vari-Program exposure modes, including The camera must be set to P, S, A, or M exposure modes in order to fine-tune white balance (see table on opposite page).

To use the second (and in my opinion a much quicker) method for selecting a white balance setting, press the button to open the Shooting Information Display, then press the button. Next use the multi selector to highlight the *WB* item. Press the button to display the list of white balance options, and use the multi selector to highlight the desired option. Finally, press the button to confirm your selection: The new WB icon is displayed in the Shooting Information Display.

Hint: If you expect to alter the white balance option frequently while on a shoot, I recommend using Custom Setting CS-11 to set the Function (Fn) button to *White balance*. Then, press and hold the Fn button (located on left side of the camera below the **O** button) to show the Shooting Information Display to on the LCD monitor: The currently selected white balance, rotate the command dial (on back upper right of camera) until the desired WB option is displayed, then release the Fn button.

Note: If you select a WB option from the Shooting Information Display, it is not possible to set and apply a fine-tuning factor; this can only be done by selecting from the **PRE** option if selected from the Shooting Information Display, though you can use the value that was most recently measured and recorded using **PRE**.

Fine-Tuning the White Balance Value (P. S. A. or M modes only)

Regardless of whether the color temperature is selected by the camera **AUTO** or selected manually from one of the six fixed WB options, the D40x allows you to fine-tune the color temperature value of the setting by increasing or decreasing it (excluding the White balance preset option). However, rather than express this fine-tuning factor in degrees Kelvin, Nikon uses a system of whole numbers between -3 and +3. Negative numbers set a higher color temperature, making pictures appear warmer (redder), and positive numbers reduce the color temperature making pictures appear cooler (bluer).

Note: If a fine-tuning factor other than 0 is set, you will see a + or - symbol accordingly placed adjacent to the selected white balance icon, which is displayed in both the Shooting Information Display and Shooting menu.

White	Fine Tuning - Color Temperature Values							
Balance	None	-3	-2	-1	+1	+2	+3	
AUTO	3,500- 8,000K	Fine tuning value selected on camera and added to AUTO color temp						
*	3,000K	3,300K	3,200K	3,100K	2,900K	2,800K	2,700K	
	4,200K	7,200K	6,500K	5,000K	3,700K	3,000K	2,700K	
☀	5,200K	5,600K	5,400K	5,300K	5,000K	4,900K	4,800K	
4	5,400K	6,000K	5,800K	5,600K	5,200K	5,000K	4,800K	
2	6,000K	6,600K	6,400K	6,200K	5,800K	5,600K	5,400K	
a //.	8,000K	9,200K	8,800K	8,400K	7,500K	7,100K	6,700K	
PRE		Not Available						

White Balance/Color Temperature Values

The white balance function provides a wide variety of options to control the color of light that is recorded.

Hint: Do you want to get creative? It is easy with the white balance control. Try mismatching the White balance selection with the color temperature of the prevailing light. For example, rather than shoot a scene lit by daylight using one of the daylight white balance values, set the white balance to *Incandescent*. The resulting picture will have a strong blue color cast. Remember, if the color temperature of the prevailing light is lower than the color temperature of the white balance value set on the camera, the scene will be rendered with a warm (red/yellow) color cast. Conversely, the scene will be rendered with a cool (blue) color cast if the color temperature of the prevailing light is higher than the color temperature of the white balance value set on the camera.

White Balance Preset

The **PRE** option allows you to measure a color temperature value from the light falling on a subject or scene being photographed, providing the most accurate way of setting a white balance value. The D40x offers two methods of selecting a WB preset value, either by using the camera to measure light reflected from a white or neutral gray test target, or by using the white balance value from a previous exposure as a reference.

Hint: Nikon suggests using either a white or a neutral gray object as a reference target for the White balance preset option. I strongly recommend that you use only a neutral gray object, such as a piece of card, for two reasons: (1) many white objects (paper, cards, and plastics) often contain pigments or dyes to whiten them, which can cause the camera to render colors inaccurately; and (2) it is more difficult to expose correctly for a pure white object, and errors in exposure can affect the white balance reading you obtain from the test target.

Note: In place of a test target such as a neutral gray card, there are a number of products that can be attached directly to the lens that not only allow the camera to obtain a white balance measurement, but also take an incident reading for the ambient light (i.e., measure the light falling on the scene rather than the light reflected from the scene) using its TTL metering system. Probably the best device I have used for this purpose is the filter-like ExpoDisc (www.expodisc.com).

Using the Preset Option

The **PRE** option for setting WB is only available in P, A, S, and M exposure modes. Using this item involves several more steps than the fixed WB selections. There are two methods available to obtain a White balance preset value: (1) direct measurement and (2) copying the white balance from an existing picture that was taken on a D40x camera. The camera can store only one value for the preset white balance, consequently only the most recently measured white balance value will be stored, regardless of the method used.

Direct Measurement: Start by placing a test target (neutral gray is best) in the same light that illuminates the scene or subject. I recommend you select manual focus, and set the focus distance on the lens' distance scale to the infinity mark (or focus manually on a distant object if the lens lacks a distance scale). The exposure mode you use is not critical, but I suggest Aperture-priority (A).

Now press the button and use the multi selector to open the menu. Navigate to *White balance* using the multi selector and press it to the right to open the next page to display the available options. Scroll to highlight the **PRE** option and press the multi selector to the right to open the next menu page that displays two further options: *Measure* and *Use photo*. Highlight *Measure* and press the multi selector to the right. The next page displays a message: *"Overwrite existing preset data?"* Highlight *Yes* and press the multi selector to the right. The next page displays a dialog box for a short period before the Shooting Information Display is restored, with the message: *"Take photo of white or gray object filling the viewfinder under lighting for shooting."* At this point **PRE** will be shown blinking in both the viewfinder and Shooting Information Display.

Note: If you wish to cancel the direct measurement process, highlight *No*; the White balance preset is reset to the last measured value.

Point the camera at your test target (taking care not cast a shadow over it) and make sure it fills the viewfinder frame (there is no need to focus on the test target card). Press the shutter release button all the way down. If the camera is able to obtain a measurement, the message: "Data acquired" will be displayed on the LCD screen and the letters "Gd" will be shown in the viewfinder display. The white balance is now set to the measured color temperature value of the prevailing light, automatically replacing any previous value stored on the camera. This value will be retained until you make another measurement, either direct or from an existing photograph. **Note:** You will need to repeat the process if the message, "Unable to measure preset white balance. Please try again." is displayed on the monitor screen and the viewfinder shows "no Gd." The camera may have difficulty measuring color temperature in low-level light, so try setting the lens to a larger aperture (lower f/number).

Hint: If you expect to take several preset white balance direct measurements over the course of a shooting period, I recommend setting the Fn button (selected via CS-11) to *White balance*. Prepare the camera (i.e. set manual focus and select A exposure mode) and neutral gray test target as described above before pressing the Fn button for approximately two seconds. The Shooting Information Display will then appear on the LCD screen, and **PRE** will blink in both the viewfinder and Shooting Information Display. Now proceed with the measurement process as described above. Once you become adept at handling the D40x, this method is considerably quicker than using the menu to select and measure a White balance preset value.

Note: Nikon suggests that selecting the **PRE** white balance option in the Shooting Information Display and pressing the button is an alternative route to obtaining a preset white balance direct measurement value. This is not the case; using this combination only opens the list of white balance options, from which there is no way to initiate the direct measurement process.

Copying White Balance From Existing Photograph: It is also possible to set a preset white balance value by copying the white balance value from an existing photograph; however, the reference photograph must have been taken on a D40x camera.

Start by pressing the button and use the multi selector to open the menu. Navigate to *White balance* and press the right arrow on the multi selector, opening the next page to display the available options. Scroll to highlight the **PRE** option and press the multi selector to the right to open the next menu page, which displays two further options: *Measure* and *Use photo*. Highlight the *Use photo* and press the multi selector to the right.

The next page displays the title "Use photo" and the last recorded photograph, together with two options: This image and Select image. If you wish to use the displayed photograph as the white balance value reference, select This image and press the O button.

To use an alternative photograph, highlight *Select image* and press the to display a list of all available folders that contain images. Highlight the required folder and again press the button to display up to six thumbnail images at a time. Scroll through the displayed images using the multi selector; the currently selected photograph has a narrow yellow border around it. If you wish to view the selected image full frame, press the button. To set the preset WB value from the highlighted photograph, press the button. This will return you to the menu, and **PRE** will be displayed against the White balance option. The *White balance* preset value will be retained until you make another measurement, either direct or from an existing photograph.

Optimizing Images

In addition to white balance, the D40x has several additional controls that affect the appearance of your pictures. These options can be applied to images shot in P, A, S, and M exposure modes. To select any of them, open the Shooting menu and navigate to the *Optimize image* item. Press the multi selector to the right to open the next menu page, which lists the available options. Use the multi selector to scroll to the desired control and press so to select it. The different options are:

ØN Normal

The default setting, it tends to produce a slightly subdued looking image that benefits from slight enhancement of levels and contrast by processing with imaging software, so it is useful if you intend to deal with images individually using a computer.

ØSO Softer

As the title suggests, this selection produces images with slightly lower contrast and lower edge acuity. It is useful for portraits or for pictures shot with flash as the main light source.

ØVI Vivid

This option increases color saturation and edge acuity (sharpness), adding a little extra bite to images. Use it if you expect to print images directly from the camera without any image processing in the computer.

ØVI⁺ More Vivid

An enhanced version of *Vivid*, this produces results similar to a high saturation color transparency film. It is best used when color intensity is more important than color veracity.

ØPO Portrait

This option appears to produce results that are almost identical to the *Normal* option, particularly in terms of the contrast.

Black-and-White

Nikon considers the in-camera technology applied using this option to be commercially sensitive, so the company has not divulged the process used. However, the camera sets sharpening and tone (contrast) to *Normal*, and appears to average the red, green, and blue values to produce a neutral-toned monochrome image. The algorithm used in this process is not the same as that used in the *Monochrome* option of the Retouch menu (see page 183).

Note: Like the other image attributes available under the *Custom* option of the *Optimize image* menu, the effects of the *Black-and-white* option can be achieved with a greater degree of control using digital imaging software once the image file has been imported to a computer; however, this option works effectively for images that will be output directly from the camera.

The D40x always saves a black-and-white picture as an RGB file, using Color Mode Ia, with saturation and tone (contrast) set to *Normal* and *Hue adjustment* set to 0.

Selection	Color Mode	Tone	Hue	Saturation	Sharpness
Normal	IIIa	Auto	0	Auto	Auto
Softer	la	Low (Less contrast)	0	Auto	Low
Vivid	IIIa	Normal	0	Enhanced	Med. High
More Vivid	IIIa	High (More contrast)	0	Enhanced	High
Portrait	la	Auto	0	Auto	Med. Low
B&W	la	Normal	0	Normal	Normal

Optimize Image Options

Hint: To maximize image quality I strongly recommend that you use the *Custom* option because no single level of sharpening or tone control is universally applicable.

Custom

It is vitally important to understand that the Custom option is the only one that provides full control, allowing you to adjust the image attributes of color mode, tone, hue, saturation, and sharpness. If you select any of the other Optimize Image options, the camera will automatically apply the settings shown in the table above; these cannot be altered by the user. In other words, even if you shoot a series of pictures of a similar scene, the values assigned in the *Normal*, *Softer, Vivid, More Vivid, Portrait*, and *Black-and-white* options may vary depending on the exposure and position of the subject within the frame area.

To ensure consistent results, use the *Custom* option but avoid selecting *Auto* for *Sharpening*, *Tone Compensation*, and *Saturation*, as you relinquish control of these attributes by doing so.

A color space describes the range (gamut) of colors that can be recorded by the camera. The color mode defines how accurate the rendition of the recorded colors will be. The settings for color space and color mode have been linked in the D40x (as outlined in the table on the opposite page). The color space is always sRGB in Color modes Ia and IIIa, and it is always Adobe RGB in Color mode II (see pages 110 and 111). Consequently, if you want Adobe RGB as the working color space, you have to select Color mode II, which is only available in the Custom setting of the Optimize Image options. This is the color space with the widest gamut, so its use usually ensures the highest level of color accuracy. This is particularly useful if the images will be subject to extensive work using imaging software in the computer because color shifts can be applied with a greater degree of control on either a global or localized basis.

Note: If you expect to use pictures directly from the camera to post to a website, send as an attachment to an email, or produce a print, I recommend color mode Ia (optimized for portrait pictures) and IIIa (optimized for landscape and nature pictures).

Settings Available In Custom-Optimize Image

Select Custom $\bigcirc \bigcirc$ and press the right arrow on the multi selector to open a list of available options. Highlight the desired option using the multi selector and press right arrow; scroll to the setting you want and select it by pressing \bigcirc . Finally, navigate to *Done* and press the \bigcirc button to confirm and save the selected settings; if you fail to carry out this last step the settings will *not* be saved. The Custom options are:

Image sharpening: This is a process applied to digital data that increases the apparent acuity of a picture. It is used to correct the side effects of converting light into digital data, which often causes distinct edges between colors, tones, and objects to look ill-defined or fuzzy. The D40x uses a technique that identifies an edge by analyzing the differences between neighboring pixel values. Then the process lightens the pixels immediately adjacent to the brighter side of the

edge, and darkens the pixels adjacent to the dark side of the edge. This causes a local increase of contrast around the edge that makes it look sharper; the higher the level of sharpening applied the greater the contrast at the edge.

Note: Sharpening is not a method for rescuing an out-of-focus picture–remember; once out-of-focus, always out-of-focus!

The D40x offers seven levels of Image sharpening:

- *Auto* The camera applies a level of sharpening that varies according to how the camera analyzes the image data. This is tricky because the level of sharpening can vary from image to image and you have no indication as to how the D40x actually applies sharpening at this setting.
- Normal Apparently the camera applies a moderate amount of sharpening at a consistent level. I say "apparently" because, again, Nikon does not provide specific values for the level of sharpening the camera applies.
- Low A lesser amount of sharpening is applied than Normal.
- Medium low Sharpening level is slightly higher than Low.
- Medium High Sharpening level is slightly higher than Normal.
- *High* The D40x applies an aggressive level of sharpening, which may not be appropriate for some subject/scenes.
- None No sharpening is applied to the image data.

Hint: No single level of sharpening is suitable for all picturetaking situations. Likewise, the level of sharpening should also be based on your ultimate intentions for the image (i.e. display on a web page, publication in a book or magazine, or producing a print for framing). Therefore, it is often preferable to apply sharpening during image processing on a computer, particularly if you want to work on images for a range of different output purposes. I would make the following suggestions with regard to incamera sharpening when shooting with the D40x:

- 1. For general photography when using JPEG format files, set sharpening to *Low* or *Medium Low* if you intend to process these images later using software in the computer.
- 2. For general photography when using JPEG format files, set sharpening to *Normal* if you intend to print pictures directly from the camera without any further image processing.
- 3. On occasions when you need pictures for publishing on a web page or in newsprint, use the JPEG format and set the sharpening level to *Normal* or *Medium High*.
- 4. If you shoot in the NEF file format, set sharpening to None.

Note: Although the data in a NEF file is not sharpened by the in-camera processing, any sharpening level other than None that is set will be stored in the file's EXIF data. This means that sharpening may be applied when you convert the image in another application, because some applications automatically read and apply the sharpening level stored in the EXIF file.

Tone Compensation: This control allows you to adjust the contrast of an image ("contrast control" would be a better name). It works by applying a curve control similar to those used in image-processing applications that alter the distribution of tones from the sensor data to fit the selected contrast range, as defined by the contrast curve. Again, there are several levels of *Tone Compensation*:

• Auto – The D40x uses its Matrix metering system to assess the differences between the levels of brightness in the scene. If these are significant, the camera assumes the scene has high contrast and applies compensation to lower it. Conversely, if scene contrast is assessed to be low, the camera will increase image contrast.

- *Normal* The D40x applies a standard contrast curve that produces images with contrast somewhere between the extremes of *Less contrast* and *More contrast*.
- Less contrast This setting produces images with noticeably less overall contrast, which can be a benefit when shooting a subject or scene that contains light tones that are well illuminated. However, it can also affect the density of very dark tones with the result that they lack strength.
- More contrast Image contrast is boosted, which can be a benefit when shooting subjects or scenes that lack contrast. However, this option should be used with care since there is an increased risk that highlight details may appear to be "burned out," and reducing contrast once applied (or over-applied) with this setting can be difficult to achieve without introducing unwanted side effects that affect image quality.
- Custom This option allows you to write your own contrast curve and upload it to the camera, but is only applicable if you have access to Nikon Camera Control Pro software. If no custom contrast curve is created and uploaded to the camera, this option performs the same as Normal.

Note: If you expect to perform processing on your pictures using software in your computer after downloading from your memory card, consider setting *Less contrast* since it is easier to increase contrast than reduce it at any stage subsequent to the original exposure.

Color Mode: The D40x offers a choice of three color modes, which determine the accuracy of the colors recorded in an image. You option for *Color mode* should be chosen based on the use to which the image will be put.

 Ia (sRGB only) – Recommended for portraits that will be used or printed without further modification, this mode is biased in favor of a range of colors that reproduces skin tones with a pleasant appearance (i.e. colors are slightly warm due to increased levels of yellow/red).

- *II (Adobe RGB only)* This color mode produces the most accurate rendition of colors recorded by the camera. It is used in conjunction with the Adobe RGB color space, which renders a wider range of colors compared with the sRGB color space, thus providing more options when it comes to subsequent image processing using a computer.
- Illa (sRGB only) This is the default setting on the D40x and is designed to enhance the rendition of green and blue, although yellow, orange, and red tend to look strong as well. It is a good choice for nature or landscape shots that will be used or printed without further modification.

I recommend using the color mode II unless your pictures will only be displayed on a computer monitor or will be printed directly with no additional processing. Since it is adapted to the Adobe RGB color space, it offers a subtle rendition and well-graduated tonal transitions, increasing the flexibility of an image that will be subject to image processing in the computer.

Hint: It is essential that your digital imaging application be set to the same color space (i.e. you work with a color managed system), otherwise the application will more than likely assign its own default color space and you will lose control over the rendition of colors.

Saturation: Adjusting the saturation changes the overall vividness (chroma) of color without affecting the brightness (luminance) of an image. *Saturation* options are:

- Auto The D40x will adjust the level of saturation automatically according to the camera's assessment of the scene or subject.
- Normal This is the default setting and is probably the option to use for most situations, since the camera offers limited control compared with an image-processing application applied later in the computer.
- *Moderate* The vividness of colors is reduced, but Nikon provides no information as to the level of adjustment that is applied.

• *Enhanced* – The vividness of colors is increased, but again there is no information about the level of adjustment that is applied.

Hue adjustment: The color modes used by the D40x to produce images is based on combinations of red, green, and blue light. By mixing two of these, a variety of different colors can be produced. If the third color is introduced, the hue of the final color is altered. For example, if the level of red and green data is increased relative to the blue data, the hue shifts (positive adjustment) to a warmer (red/yellow) rendition. If you apply a negative adjustment, the hue shifts to a cooler (bluer) rendition, for example red will shift toward purple. The default setting for the *Hue adjustment* of +/- 9° in increments of 3°.

Hint: I believe it is better to leave control of both color saturation and hue to a later stage when you apply processing to downloaded image files in the computer. Saturation and hue can be controlled to a far greater degree using a digital imaging application. I recommend that these controls be set to *Normal* and 0°, respectively.

ISO Sensitivity

One of the great advantages of digital photography is that digital cameras generally allow you to adjust the sensitivity from picture to picture. The D40x is no exception. It offers sensitivity settings (in ISO equivalent values) from 100 to 1600, available in steps of 1EV (one-stop), plus the option to select the HI 1 setting for increased sensitivity (HI 1 does not equate exactly to an ISO value of 3200). There is a selection for *Noise reduction* set from the Shooting menu for use with the higher ISO settings, and in addition a Custom Setting selection for *ISO auto* that can automatically vary the sensitivity value according to the light conditions.

However, the word "sensitivity" should be used advisedly since the sensor in the D40x actually has a fixed sensitivity equivalent to ISO 100. Higher ISO values are achieved by amplifying the signal from the sensor.

Setting Sensitivity

You can set the sensitivity value on the D40x in two different ways. One method is to open the Shooting menu and scroll to *ISO sensitivity*. Press the right multi selector arrow to open a list of numbers, then scroll down to highlight the desired value and press the subtron to set it.

Alternatively, press the $\textcircled{\bullet}$ button to open the Shooting Information Display then press the $\textcircled{\bullet}$ button; use the multi selector to highlight *ISO sensitivity*. Press the $\textcircled{\bullet}$ button to display the list of options: *100, 200, 400, 800, 1600,* and *HI 1*. Use the multi selector to highlight the required option. Finally, press the $\textcircled{\bullet}$ button to confirm your selection; the new ISO sensitivity value is displayed in the Shooting Information Display.

Hint: If you expect to alter the ISO sensitivity frequently during the course of a shoot, the quickest and most convenient way to change it is to select the *ISO sensitivity* option at Custom Setting CS-11. This assigns the operation to the Fn button. To change the ISO value, press and hold the Fn button, which opens the Shooting Information Display. Then highlight *ISO sensitivity* and rotate the command dial to adjust the ISO value as required. Release the Fn button to lock the new value.

At high sensitivity settings, an image will show increasing amounts of digital noise that causes a general reduction in image quality, affecting color saturation, contrast, and tonality.

For optimum image quality, set the D40x to ISO 100. At ISO 200, image quality is very high, and nearly as good at the 400 and 800 settings, with little evidence of noise and good color saturation. The 1600 setting produces images that are remarkably good for such a high ISO, though the effects

of luminance and color noise are perceptible, as is the affect on scenes with high contrast due to the narrower dynamic range that reduces the ability of the camera to record the extremes of deep shadow and bright highlights. However, due to significant noise effects, the HI 1 setting should be considered only when no other option (wider aperture or slower shutter-speed) would get the picture.

Hint: If the light level begins to drop as you shoot, you can either raise the ISO setting or use a longer shutter speed. Confronted with this situation, and assuming the subject does not require a fast shutter speed to record it, I recommend putting the camera on a tripod and selecting a longer exposure.

ISO Auto

This option should be used carefully because it does not work in quite the way I expect most users imagine. That said, the performance of the D40x at any ISO sensitivity level between 100 and 1600 is likely to satisfy most users, thus leaving the ISO Auto option switched on should not result in overly noisy images. Plus, the D40x does allow you to select a maximum ISO level for this control by choosing *Max. sensitivity* in CS-10.

In P (Programmed auto) and A (Aperture-priority) exposure modes, the sensitivity will not change until the exposure reaches the limits of the shutter speed range. The upper limit is always 1/4000 second but the lower limit is set by the user and can be adjusted between 1 second and 1/125 second (1/30 default) using CS-10 by selecting *Min. shutter speed*.

In S (Shutter-priority) exposure mode, the sensitivity is shifted when the exposure reaches the limit of the aperture range available on the lens. Indeed, this is the one exposure mode with which ISO Auto might be an advantage, because it will raise the sensitivity setting and thus maintain the preselected shutter speed, which in this mode is probably critical to the success of the picture. In M (Manual) exposure mode, the sensitivity is shifted if the selected combination of shutter speed and aperture cannot attain a correct exposure.

Although a blinking warning, ISO-AUTO, appears in the Shooting Information Display and viewfinder to indicate the sensitivity has been altered from the value set by the user, there is no indication of what ISO value has been set in these displays! You must find your way to page two of Shooting Data in the Photo Information Display (single-image playback) to see the changed ISO value (displayed in red).

Note: ISO Auto does not operate at the HI 1 ISO setting.

TTL Metering

To select one of the D40x's three metering modes, press the button to open the Shooting Information Display then press the button; use the multi selector to highlight the *Metering* option. Press the button to display the list of options: Matrix **S**, Center-weighted **(a)**, or Spot **(.)**. Use the multi selector to highlight the desired option. Finally, press the **(a)** button to confirm your selection; the metering option is displayed in the Shooting Information Display.

The Matrix metering II system used in the D40x covers virtually the entire frame area, as depicted by the shaded area in the diagram.

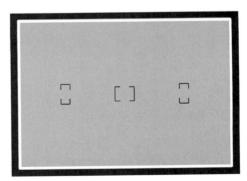

Matrix Metering

The metering pattern for this mode divides most of the image area into a series of segments (matrixes) and assesses the light seen through the lens for a number of attributes. The values for these attributes are then compared to a database of reference images, in the camera's memory, before the camera suggests a final exposure setting. The Matrix metering in the D40x uses a sophisticated 420-pixel RGB CCDtype sensor located in the viewfinder head that divides the frame area into 420 segments, using an alternating pattern of red, green, and blue sensors to measure light values. It is the same sensor used in the earlier D50 model but with enhanced data-processing algorithms.

To derive the most from the camera's Matrix metering capabilities, use a D-type or G-type Nikkor lens since these provide additional information from the autofocusing system. This assists the camera in estimating where in the frame the subject is likely to be (the camera assumes the subject is in the plane of sharp focus and located in the region of the active focus area). Hence, Nikon refers to the system as 3D Color Matrix metering II. The system defaults to Color Matrix metering II (i.e. the 3D element is not performed) if a Nikkor lens is used that does not communicate focus information (non D-type or G-type) to the camera. If a non-CPU lens is used the TTL metering system of the D40x does not function.

Note: The very extreme edges of the frame area are outside the area covered by the matrix-metering pattern.

By assessing color as well as brightness, this metering system helps reduce the influence of a monochromatic scene or subject, thereby improving its accuracy.

Matrix metering uses four principal factors when calculating an exposure value:

- The overall brightness level of in a scene
- The ratio of brightness (contrast) between the matrix pattern segments

The Matrix metering II system provides its greatest level of sophistication when the camera is used with either a D-type or G-type Nikkor lens.

- The active focus area, which suggests the position of the subject in the frame
- The focused distance, provided by the lens (D-type or G-type only)

Hint: The D40x has a tendency toward overexposing scenes that contain bright highlight values. Once this type of detail is "blown," data is lost that no amount of subsequent image enhancement will recover. Therefore, if the scene you photograph has a wide contrast range (large variation in brightness), you may wish to underexpose a bit since it is often possible to recover shadow detail in such images with processing software. Fortunately, the D40x has features that help you to evaluate an exposure to decide whether or not you should reshoot the scene: the histogram and highlights displays (see pages 151-155).

The Center-weighted metering system in the D40x assigns 75% of the metering sensitivity to an 8 mm circular area located in the middle of the viewfinder frame.

Ocenter-Weighted Metering

The center-weighted metering pattern dates to the very first TTL metering systems used by early Nikon SLR film cameras. In these models, the frame area was usually divided in a 60:40 ratio with the bias being placed in the central portion of the frame. The D40x uses a ratio of 75:25, with 75% of the exposure reading based on the frame's 8 mm central circle, and the remaining 25% based on the outer area. The camera's focusing screen does not show any markings to define this metering area.

Hint: In my opinion the center-weighted option is the least useful of the D40x's three metering patterns. Matrix metering will do an excellent job in most situations, and the spot meter is capable of taking readings from a specific area in particularly tricky lighting with greater accuracy than the center-weighted pattern.

Spot metering assigns the metering sensitivity to a circular area that represents approximately 2.5% of the total frame area. It can be centered on any of the three autofocus sensing areas.

• Spot Metering

Spot metering is extremely useful for measuring from a highly specific area of a scene. For example, faced with a subject against a virtually black background, the spot meter allows you to take a reading from the subject without it being influenced by the background. In similar circumstances, the Matrix metering system might very well overexpose the subject.

The sensing area for the spot metering function is a circle approximately 0.14-inches (3.5 mm) in diameter. The center of the metering area is aligned with the center of the selected (active) autofocus sensing area.

Note: If the AF-area mode is Closest subject, the camera will meter using the central autofocus sensing area.

Hint: Every TTL metering system measures reflected light and is calibrated to give a correct exposure for a mid-tone. When using the spot meter, you must make sure that the part of the scene you meter from represents a mid-tone, otherwise you will need to compensate the exposure value.

In Dynamic area AF, the D40x follows a moving subject by shifting focus control between any of the autofocus sensing areas. When this occurs, the spot metering also shifts, following the active sensing area. In Single area AF mode, the D40x will always position spot metering over the selected autofocus sensing area.

Exposure Modes

In addition to the mode and the Digital Vari-Program exposure options, the D40x offers four exposure modes that the user can partially or fully control: Programmed auto (P), Aperture-priority (A), Shutter-priority (S), and Manual (M). To select any of these exposure modes, rotate the mode dial on the top right of the camera until the desired mode symbol is aligned with the index mark on the side of the viewfinder head.

The camera will select the aperture and shutter speed in Programmed Auto (P) exposure mode.

Note: The exposure metering system of the D40x is disabled if you attach a non-CPU lens.

P – Programmed Auto

Program mode, as it is often referred to, automatically adjusts both the shutter speed and lens aperture to produce a correctly exposed image, as defined by the selected metering mode. As in the Arr and Digital Vari-Program modes, you relinquish control of exposure to the camera. If you want to make informed decisions about shutter speed and aperture for creative photography, it is better to use A, S, or M exposure modes.

However, the photographer does have a bit of influence in this mode. If you decide that a particular combination chosen by the camera is not suitable, you can override those settings by turning the command dial. An indicator (P *) appears in both the viewfinder and Shooting Information Display to show that you have overridden the settings: This is called the Flexible program mode. The values for aperture and shutter speed change in tandem, so the overall level of exposure remains the same (i.e. dialing a shorter shutterspeed decreases the f/number, and vice versa).

Hint: If you override the Program mode, its new shutter speed and aperture settings will remain locked, even if the meter automatically powers off and is then switched on again by halfway pressing the shutter release button. To cancel the override, you must either rotate the command dial until the P* indicator is no longer visible, change the exposure mode, turn the power switch to OFF, or perform a camera reset.

The spot metering option can be useful in challenging lighting conditions. Here a mid-tone area of the background was read and the exposure was set manually.

A – Aperture-Priority Auto

In this mode the photographer selects an aperture value and the D40x will choose a shutter-speed to produce an appropriate exposure. Rotate the mode dial until A is aligned with the index mark; the aperture is controlled by rotating the command dial and is changed in steps of 1/3 EV.

S – Shutter-Priority Auto

The photographer selects a shutter-speed and the D40x will choose an aperture value to produce an appropriate exposure. Rotate the mode dial until S is aligned with the index mark; the shutter-speed is controlled by the command dial and is changed in steps of 1/3 EV.

Note: The camera will display a warning H in the viewfinder if the subject or scene is too bright for the D40x to achieve a proper exposure in P, A, and S modes. Likewise, if the subject or scene is too dark for the D40x to achieve a proper exposure, it will display a warning in the viewfinder.

Shutter Speed Considerations

When handholding your camera, a rule of thumb about the minimum shutter speed can be helpful to prevent loss of sharpness due to camera shake. Take the reciprocal value of the lens focal length and use this as the slowest shutter speed with that lens. For example, with a focal length of 200mm, set a minimum shutter speed of 1/200 second. Do take care, because longer focal length lenses as well as the higher degree of subject magnification in close-up photography will amplify the effects of camera shake.

Since shutter speed controls the way that motion is depicted in a photograph, it can be used for creative effect. Generally, fast shutter speeds are used to freeze motion, for example in sports or action photography. Slower shutter speeds can introduce a degree of blur that will often evoke a greater sense of movement than a subject that is rendered pin-sharp. Alternatively, you can pan the camera with the subject at a slow shutter speed so that the subject appears relatively sharp against an increased level of blur in the background.

If you want shoot a picture of a static subject but "eliminate" any moving elements from your composition, try using a shutter speed of several minutes or more. While the subject is rendered properly, the moving element(s) do not record sufficient information in any part of the frame to be visible. In many cases, this technique will require a strong neutral density filter in daylight conditions to achieve a sufficiently long exposure time. So next time you want to take a picture of a famous building and excluded all the other visitors from cluttering up your composition, you know how!

M – Manual

This mode offers the photographer total control over exposure and is probably the most useful if you want to learn more about the effect of shutter speed and aperture on the final appearance of your pictures. You choose and control both the shutter speed (command dial) and lens aperture (command dial + button). An analog scale shown in

Autoexposure Lock

If you recompose after taking a meter reading in P, A, or S exposure mode, it is likely the metering sensing area will now fall on an alternative part of the scene that has a different level of reflectivity. The new composition will therefore produce a different exposure value. To respond to this, the D40x allows the Autoexposure lock (AE-L) function to lock and retain the initial exposure reading before you recompose and shoot.

While AE-L can be applied with all three metering modes, it is generally most effective with center-weighted and spot metering. These two modes are most useful in very difficult lighting conditions, when a more accurate exposure reading can be to taken from a specific area of the scene, which may otherwise fool the Matrix metering system.

Select a metering mode and position the part of the scene you want to meter within the sensing area, then press and hold the shutter release button down half way to acquire a reading. Next, press and hold the button (this assumes an appropriate option is selected at CS-12). You can now recompose and shoot the picture at the metered value ("EL" will appear in the viewfinder display while this function is active). Alternatively you can select *On* for CS-13, so that once the shutter release button is held half way, the exposure value set in P, A, or S, mode remains locked until the shutter button is released ("EL" is displayed as described).

Note: It is possible to change the settings for shutter speed and aperture while the AE-L function is in effect in P, A, and S exposure modes, although the metered exposure level remains unaltered. Once the exposure is locked, rotating the command dial will cause the shutter speed and aperture values to change, so you can set an alternative value for one and the other will be altered accordingly.

Exposure Compensation

The TTL metering system on the D40x assumes it is pointed at a scene with a reflectivity that averages to the equivalent of a midtone. Nikon appears to calibrate against a reference that has a reflectivity value of approximately 12% to 13%, so using a standard photographic 18% gray reference card to estimate exposure will give results that are approximately 1/3 to 1/2 stop underexposed.

Many scenes you encounter will not reflect 12% to 13% of the light falling on them. For example a landscape under a blanket of fresh snow will reflect far more light than a mountain covered with black volcanic rock. Unless you compensate your exposure, both of these extreme scenes will be rendered as midtones and look dull and flat.

accordingly). Finally, press the solution to confirm and set the *Exposure comp*. value, which is then displayed in the Shooting Information Display as both a numerical value and on an analog scale. (An analog scale is also displayed in the viewfinder where its central 0 blinks as a reminder that exposure compensation is set.) The number of bars shown in these analog scales reflects the amount of compensation set; each bar represents a shift of 1/3 EV. Once you have set a compensation factor, it will remain locked until you reset it to 0.0 using the *Exposure comp*. option in the Shooting Information Display.

In Manual exposure mode you adjust shutter speed and aperture using the TTL meter's recommended readings as a guide. An analog scale will appear in the viewfinder where a single bar below the central 0 indicates a proper exposure for an average midtone scene. When you apply a plus or minus value in M mode from the Exposure comp. option, additional bars appear on the analog scale, each representing a shift of 1/3 EV. A small "+/-" icon displays to the right of the scale in the viewfinder as a reminder that exposure compensation is applied. However, as you are shooting in Manual mode, the camera will not apply *Exposure comp* value automatically, as it does in P, S, and A exposure modes; therefore, it is necessary to adjust the shutter speed and/or aperture until the analog scale shows a single bar below the central 0 to put the *Exposure comp*, value into effect. Once set, the compensation factor will remain locked until it is reset to 0.0 via the Exposure comp. option in the Shooting Information Display.

An alternative (and quicker) way to apply exposure compensation (this method does not apply to M mode) is to hold down the 😰 button, located on the top right of the camera. Rotate the command dial until the desired plus or minus exposure compensation value is shown in the analog scale that appears in the viewfinder and Shooting Information Display, then release the 😰 button. Once you have set a compensation factor, it will remain locked until you hold down the 😰 button and reset the value to 0.0. **Note:** The analog scale that displays in the viewfinder has a range of +/- 2 EV. If you set a greater degree of compensation in P, S, and A modes, you can display the exact compensation value (it replaces the exposures remaining counter) by holding down the button. Also note, the D40x does not have an exposure bracketing feature.

Shutter Release

Press the shutter release button part way down to automatically focus the camera when an autofocus mode has been selected.

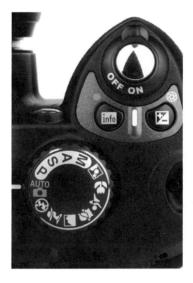

The shutter release button is located on the top right shoulder of the camera. If the D40x is powered on, light pressure (pressing no more than half way down) on the shutter release button will activate the metering system and initiate autofocus (assuming an autofocus mode has been selected). Once you let go of the button, the camera remains active for a fixed period, the duration of which depends on the selection of the options available at Custom Setting CS-15 (*Auto off timers*); the default setting is *Normal*, which causes the exposure meter to remain on for eight seconds.

Pressing the shutter release button all the way down operates the shutter mechanism to make an exposure. There is a short delay between the time the button is pressed all the way and when the shutter opens (referred to as shutter lag). Shutter lag on the D40x is approximately 80 to 100 milliseconds (1 millisecond = 1/1000 second); the mirror black out time (the time the viewfinder is obscured by the reflex mirror being in the raised position) is approximately 100 milliseconds.

However, release of the shutter can be delayed further, and in some cases prevented, if the certain features and functions are in operation at the time the release button is pressed:

- The capacity of the buffer memory is probably the most common cause of shutter delay. It does not matter whether you shoot in single frame or continuous shooting modes (see below for description), once the buffer memory is full, the camera *must* write data to the memory card before any more exposures can be made. As soon as sufficient space is available in the buffer memory for another image, the shutter can be released. For this reason, memory cards with fast data write speeds are recommended.
- Regardless of which autofocus mode is selected, the shutter is disabled until the D40x has acquired focus. In low light or low contrast scenes, the autofocus system can often hunt for a while before achieving focus (page 134 for a full explanation), which extends the delay period.
- In low light situations, the D40x will activate the AFassist lamp, provided it has been instructed to do so via CS-09, which introduces a short delay while the lamp illuminates and focus is acquired.

Note: The AF-assist lamp only operates in single-servo autofocus mode (if selected by user in AF-S or by camera in the AF-A focus modes).

- The Red-eye reduction function, which is one of the flash modes available on the camera, introduces an additional one-second shutter lag. This is the time it takes for the red-eye reduction lamp to emit light causing the subject's pupils to constrict.
- If you select HI 1 for ISO sensitivity, the D40x will automatically run a noise reduction feature that increases the processing time of each exposure, consequently reducing the frame rate. The same applies if you select an ISO value of 1600 and activate the *Noise reduction* in the Shooting menu.

Shooting Modes

Obviously the D40x does not have to transport film between each exposure (unlike a 35mm film camera), so it does not have that type of motor drive, but the shutter mechanism still has to be cycled. The camera offers a range of shooting modes, including Single frame, Continuous, several Selftimer options, and a remote shutter release feature.

To set the Shooting mode, press the button to open the Shooting Information Display then press the button; use the multi selector button to highlight the "Shooting mode" option. Press the button to display the list of options: S Single frame, Continuous shooting, Slos Self-timer, 22 Delayed remote, and Quick response remote. Use the multi selector button to highlight the desired option. Finally, press the button to confirm your selection; the new shooting mode option is displayed in the Shooting Information Display.

Using a remote release can help ensure sharp results by reducing the risk of camera movement when shooting at slow shutter speeds.

S Single Frame Shooting Mode

A single image is recorded each time the shutter release button is pressed. To make another exposure, the button must be pressed again; you can continue with single presses until the camera's buffer memory is full, in which case you must wait for data to be written to the memory card, or the memory card becomes full.

Hint: You do not have to remove your finger from the shutter release button completely between frames; by raising it slightly after each exposure and maintaining a slight downward pressure on the shutter release button, you keep the camera active, the focus distance locked, and are ready for the next shot. If you want to take a rapid sequence of pictures in Single frame mode, avoid stabbing the shutter button with your finger in quick succession. Instead, keep a light pressure on it and roll your finger over the top of the button in a smooth repeating action to reduce the risk of camera shake.

Continuous Shooting Mode

The D40x will continue to record images up to a maximum rate of 3-frames per second (fps) when you press and hold the shutter release button down.

Note: The frame rate is based on the camera set to AF-C mode, Manual (M) or Shutter-priority (S) exposure mode, and a minimum shutter speed of 1/250 second. It is important to remember that buffer capacity, use of other exposure modes, and the abilities of the autofocus system (particularly in low light) can reduce the frame rate.

Self-Timer

When set to the *Self-timer* option, the camera will not fire the shutter immediately when the shutter release button is pressed. Instead it waits for a predetermined period of time and then makes the exposure. The default delay for the selftimer is *10 seconds*, but it can be adjusted to *2*, *5*, or *20 seconds* using the relevant option at CS-16.

Traditionally, the *Self-timer* mode has been used to enable the photographer to be included in the picture, but there is

another useful function. By using the self-timer to release the shutter, the photographer does not have to touch the camera after activating the countdown, thus reducing the chance of camera shake. This is particularly useful when shooting with a shutter speed in the range of 1/2 to 1/30 second, and precise timing of the shutter release is less critical.

You should normally place your camera on a support such as a tripod when you want to use *Self-timer* mode. Compose the picture and make sure focus is confirmed before depressing the shutter release button (the shutter release will be disabled unless focus is acquired).

Hint: If you expect to use the *Self-timer* option frequently during a photo shoot, I recommend setting the Fn button option (set CS-11 to its default, *Self timer*). Press the Fn button to see the Shooting Information Display, on which the currently selected shooting mode will be changed, automatically, to the Self-timer option with a delay period, as set via CS-16. Press the shutter release button all the way down to activate the Self-timer function. Once the exposure has been made, the D40x is reset to the former shooting mode. If, after selecting the *Self-timer* option by pressing the Fn button, you decide you do not wish to use it, press the Fn button again to restore the former shooting mode.

Hint: When using autofocus, make sure nothing passes in front of the lens after setting *Self-timer*; this may well cause the point of focus to shift and prevent the camera from operating. I recommend setting the camera on Manual focus mode when using *Self-timer*.

Note: In all exposure modes except Manual, it is essential to cover the viewfinder with the supplied DK-5 eyepiece cap when the camera is operated remotely using the self-timer. This is because shutter speed and aperture settings are not altered by the camera in M mode, but in all other exposure modes the camera sets at least one of these values based on assessment of the light by the TTL metering system. Since the metering sensor is located in the viewfinder head, light enter-

ing the viewfinder eyepiece (as opposed to the lens) will influence the metering sensor, creating a false reading that results in underexposure. (When not using *Self-timer*, the photographer normally has their eye to the viewfinder blocking light from entering.

Hint: Fitting the DK-5 requires removal of the DK-16 rubber eyecup; this is a nuisance and increases the risk that the eyecup might be lost. I find it far quicker and more convenient to keep a small square of thick felt material in camera bag to drape over the viewfinder eyepiece when using the Self-timer mode.

After the shutter release button is pressed, the AF-assist lamp will begin to blink (it will also beep if the audible warning has been activated in CS-01) until approximately two seconds before the exposure is taken, at which point the light stops blinking and remains on continuously (the frequency of the beep will increase) until the shutter operates. To cancel Self-timer operation after the countdown has begun, turn the camera off.

The infrared receiver for the ML-L3 remote release is located immediately below the camera badge.

Using a Remote Release

The D40x uses the Nikon ML-L3 wireless infrared (IR) remote release that is common to several other Nikon D-SLRs. Pressing the transmit button on the ML-L3 sends an IR signal to the D40x's receiver, which is located behind a small widow on the front of the camera just below the camera's shutter release button. The system has a maximum effective range of approximately 16 feet (5 m).

Hint: Though it is most effective to have an unobstructed line of sight between the ML-L3 and the D40x's receiver, that is not a necessity. It is possible to bounce the IR signal from the ML-L3 off a reflective surface such as a wall or window, which increases the potential of this feature.

The ML-L3 can be used to release the shutter in two different ways:

D²*s Delayed remote* – The shutter is released with a delay of approximately two seconds after you press the transmit button on the ML-L3 remote control. The self-timer lamp will illuminate for approximately two-seconds, before the shutter is released.

Quick-response remote – The shutter is released as soon as you press the transmit button on the ML-L3 remote control. The self-timer lamp will flash immediately after the shutter is released.

Note: Regardless of whether you use Autofocus or Manual focus modes, it is essential that the D40x is able to acquire focus, otherwise the camera will return to its stand-by mode without the shutter operating, because the shutter is disabled until the camera obtains a point of focus.

Regardless of which Remote release modes you choose (*Delayed* or *Quick-response*), the D40x will cancel it automatically after a fixed period of camera inactivity. At the default setting (access through CS-17), this period is one minute, but you can also set it to 5, 10, or 15 minutes. **Note:** If you require a flash unit to be used with either of the remote release options in P, A, S, and M exposure modes, ensure that it is switched on and that the flash ready light is illuminated before you press the release button of the ML-L3.

Hint: If you want to make extremely long exposures, select Manual exposure mode and set the shutter speed to "bulb". Then select either *Delayed* remote or *Quick-response*; a pair of dashes replaces "bulb" in the Shooting Information Display. To start the exposure, press the transmit button on the ML-L3 once; then press a second time to end the exposure (the maximum duration of a single exposure is 30 minutes). A single flash of the AF-assist lamp confirms completion of the exposure. Before attempting any long time exposure, make sure the battery is fully charged and activate the noise reduction feature available in the Shooting menu.

The Autofocus System

The autofocusing system of the D40 marked a significant departure from the design of all previous Nikon AF D-SLR cameras because it was the first model that did not incorporate a built-in autofocusing motor to drive the focusing mechanism of Nikon lenses. The design of the D40x is the same, consequently, it only supports autofocus with either AF-S or AF-I type Nikon lenses that have a built-in focusing motor. If you have a Nikon AF or AF-D type lens, it will be necessary to perform manual focus when used with the D40x, although all other camera and lens functions will be supported.

Autofocusing Sensor

The D40x uses the Multi-Cam 530 autofocus module, first seen in the D40, which has 530-photosites. This sensor analyses contrast in the subject/scene it is pointed at, attaining focus when the contrast level is determined to be at a maximum. The 530 photosites are divided in to three defined sensing areas; each one approximately aligned to the three small square bracket pairs marked on the focusing screen that are arranged parallel to the long edge of the frame.

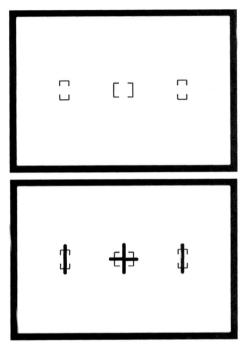

The three small squares marked on the focusing screen of the D40x define the center of each of the three autofocus sensing areas.

The actual area of coverage of the autofocus sensing areas extends beyond the area defined by the bracket pairs. This diagram shows the total approximate area of coverage of the D40x's autofocus system.

Only the central sensing area is a cross-type; this area is sensitive to detail in both a horizontal or vertical orientation. Therefore it is the most reliable sensing area. The other two sensing areas are line-types, sensitive only to detail in a direction that is perpendicular to their vertical orientation, detecting detail aligned with the long edge of the viewfinder frame.

Hint: Sometimes when using one of the line-type sensing areas, the autofocusing system of the D40x will hunt, or drive the focus of the lens back and forth, but it is unable to attain focus. This is indicative of the detail in the subject being aligned in the same orientation as the focus sensing area. If this occurs, try rotating the camera slightly $(10 - 15^\circ)$, as it is often sufficient to allow the camera to acquire focus, because the focus sensing area is no longer parallel to the detail. Once focus is confirmed, lock it (see page 192) and recompose the picture before releasing the shutter.

Focusing Modes

The D40x has two principal methods of focusing, AF (Autofocus) and M (Manual focus). The autofocus system offers three options known as the autofocusing modes: AF-A (Autoservo), AF-S (Single-servo), and AF-C (Continuous-servo).

To select the AF mode, press the button to open the Shooting Information Display then press the D button; use the multi selector to highlight the *Focus mode* option. Press the button to display the list of options: *AF-A*, *AF-S*, *AF-C*, and *MF*. Use the multi selector to highlight the desired option. Finally, press the button to confirm your selection; the new focus mode is displayed in the Shooting Information Display. Alternatively the focus mode can be selected from the Custom Setting menu using CS-02.

AF-A (Auto-servo) – In an attempt to remove the burden of choosing which of the two principal autofocus modes (AF-S and AF-C) you should use, Nikon developed this option, (inherited from the D50), which is the default AF mode. In AF-A mode, the D40x assesses the focus information and selects either AF-S or AF-C mode, depending on whether the camera determines that the subject is stationary or moving. More often than not, the AF-A option will select the appropriate AF mode, but if it makes the wrong choice the result can spell disaster for your photos!

Hint: In my opinion, the fully automated nature of the AF-A option simply does not provide sufficient reliability for correct Autofocus selection. I recommend you select the individual AF mode you require.

 AF-S (Single-servo) – The D40x focuses the lens as soon as the shutter release button is pressed (either half or all the way). The shutter can only be released once focus has been attained, displaying the in-focus indicator, a green dot, in the viewfinder. The camera will only initiate Predictive Focus Tracking in AF-S mode if it detects that the subject was moving when focus was acquired (see page 138).

- *AF-C* (Continuous-servo) The D40x focuses the lens while the shutter release button is pressed halfway, continuously shifting focus to follow the subject if the camera-to-subject distance changes, regardless of whether the subject moves constantly or stops and starts periodically. This occurs until either the shutter is released or you remove your finger from the shutter release button. However, the shutter can only be released once focus has been attained. Predictive Focus Tracking is active at all times (see page 138).
- *MF* (Manual focus) The user must rotate the focusing ring of the lens to achieve focus. There is no restriction on when the shutter can be operated. The in-focus indicator, a green dot, is displayed in the viewfinder as a confirmation that focus has been achieved, which is particularly useful in low light or low contrast conditions.

Note: Normally the focus mode is set via the Shooting Information Display; however, if you have selected one of the AF modes and wish to switch to Manual focus (provided the lens you are using has a switch that allows you to do so), you need only turn the focusing ring manually to disengage the AF system. As soon as you release the focusing ring and press down halfway on the shutter release, the camera will resume autofocus operation.

AF-S vs. AF-C

It is important to appreciate the fundamental difference between the AF-S and AF-C autofocus modes. In AF-S, the autofocus system acquires focus once and locks it at that distance for as long as the shutter release button is pressed halfway; the shutter cannot be released until focus has been acquired. AF-S mode is most useful when photographing static subjects. Even if the shutter release is pressed all the way down immediately, operation of the shutter is delayed until the camera has attained focus. In most shooting conditions, particularly in good light, this delay is so brief that it is not perceptible, and it is has no practical consequence. However, under certain conditions, such as low-light or photographing subjects with low contrast, there can be a discernable lag between pressing the shutter release button and the shutter opening, particularly if one of the two line-type focus sensing areas is used.

Conversely in AF-C, the autofocus system monitors focus continuously, even after focus has been acquired, provided the shutter release button is pressed halfway. Hence, AF-C mode is most useful when photographing moving subjects, because the focusing system will follow the subject, even if it moves after focus is first acquire. However, as with the AF-S mode, the shutter cannot be released in AF-C mode until focus has been acquired.

Hint: When using AF-C mode to photograph a subject that is moving, or likely to move, it is imperative that the camera is given as much time as possible to assimilate focusing data. Rather than use the shutter release button to initiate the AF system, use Custom Setting CS-12 to select the *AF-ON* option for the function for the **GP** button, and press and hold it down to keep the focusing system active; this removes the risk of the AF system switching off if you inadvertently remove you finger from the shutter release.

Predictive Focus Tracking

Provided focus has been acquired in either AF-S or AF-C mode, the shutter mechanism will operate when the shutter release is pressed down fully. However, there is a short delay between the time when the reflex mirror lifts out of the light path to the camera's sensor and when the shutter actually opens. If a subject is moving toward or away from the camera, the camera-tosubject distance will change during this delay. In these circumstances the D40x uses its Predictive Tracking System to shift the point of focus to compensate for the change in camera-to-subject distance, regardless of whether the subject is moving at a constant speed, accelerating, or decelerating. The camera achieves this by comparing multiple samples of contrast level as the camera monitors subject movement. The camera shifts the focus point accordingly based on this data. In AF-S mode, Predictive Focus Tracking is only initiated if the camera detects the subject to be moving at the time focus is attained. If the subject is stationary when focus is attained, the focus distance on the lens is locked at that specific camera-to-subject distance. If the subject moves subsequently, after focus is acquired and the focus distance is locked, the lens is not re-focused.

In AF-C mode, Predictive Focus Tracking is initiated as soon as the camera detects the subject is moving, regardless of whether this occurs when the camera is establishing focus, or if it detects the subject moves after focus is first acquired. The focusing system monitors focus constantly before the shutter is released in this mode.

Trap Focus

It is possible to use the AF system to perform the trap focus technique, which allows the camera to be pre-focused at a specific point and have the shutter released automatically as soon as a subject passes through it. This technique can be very effective provided you can predict the path of the subject.

To utilize this technique, select CS-12, AE-L/AF-L, and then choose the option for AF-ON. Focusing will now be performed only when the B button is pressed, not when the shutter release button is pressed. Select AF-S mode, Single area AF mode [1], and if the lens has a focus mode switch on it, set it to either A or M/A to ensure that autofocus operates. Pre-focus the lens to a point the same distance from the camera as the point through which the subject will pass by aligning the selected AF sensing area with it (you can use any of the three sensing areas). Then push the button to acquire focus, and then release it. Recompose the picture, making sure the selected AF sensing area covers the point through which the subject will pass. Keep the camera active by maintaining a light pressure on the shutter release button. When the subject arrives and fills the selected AF sensing area, the camera will detect focus and the shutter will be released.

AF-Area Modes

The D40x has three area modes for autofocus (not to be confused with the three autofocus modes described on pages 136-138) that determine how each of the autofocus sensing areas is used. To select the AF-area mode, press the button to open the Shooting Information Display, then press the button; use the multi selector to highlight *Focus mode*. Press the button to display the list of options: *Closest subject AF, Dynamic area AF,* and *Single area AF.* Use the multi selector to highlight the required option. Finally, press the button to confirm your selection; the new AF-area mode is displayed in the Shooting Information Display. Alternatively the AF-area mode can be selected from the Custom Setting menu using CS-03.

Closest subject AF – The focusing system selects the AF sensing area that detects a subject closest to the camera. Note I say a subject; not necessarily *the* subject: This is a fully automated process and the D40x provides no choice about which AF sensing area is used; hence, the camera can end up focusing on something other than the intended subject! After determining which AF sensing area to use, the relevant brackets are highlighted in the viewfinder. Always double check to see if the camera has selected an appropriate point of focus before you release the shutter.

Hint: Closest subject AF selects the correct AF sensing area a majority of the time, but it is far from foolproof. For predictable and precise control of the AF system, I strongly recommend either Single area AF or Dynamic area AF.

[:Dynamic area AF – The D40x focuses using the AF sensing area initially selected. However, if the camera detects the subject moving out of this area, the AF system will shift focusing to one of the other sensing areas if necessary. The AF area selected originally is highlighted in the viewfinder and remains highlighted even if the subject leaves it. This option is selected automatically in the

💐 mode.

[1] Single area AF – The focusing system uses only the single AF sensing area currently selected for focusing; the camera takes no part in choosing which sensor to use. The selected area is highlighted in the viewfinder. This option is selected automatically in the mode.

AF Mode and AF-Area Mode Overview

If you are new to Nikon's AF system, it will probably take a while to get used to the functionality of the D40x's Focus mode and Focus area mode. In conjunction with the descriptions above, refer to the following table that summarizes the various autofocus operations.

AF-Area Mode	Selection of Focus Area
Single	User
Dynamic	User ¹
Closest subject	Camera ²
Single	User
Dynamic	User ¹
Closest subject	Camera ²
	Single Dynamic Closest subject Single Dynamic

- In Dynamic area mode, the user selects the focus sensing area to be used initially, but if the camera determines subsequently that the subject has left this area, it will shift focusing to the focus sensing area it decides to be most appropriate (the focus sensing area used initially remains highlighted in the viewfinder).
- 2. If Closest subject AF is chosen, the camera selects the focus sensing area that it determines to be most appropriate; the user has no choice in selecting the AF area

Hint: I recommend avoiding use of **III** Closest subject AF, since you have no control over which AF sensing area is being used by the camera.

Focus Lock

Once the D40x has attained focus, it is possible to lock the autofocus system so the shot can be re-composed while focus is retained, even if an AF sensing area no longer covers the subject.

When using AF-S, press the shutter release button halfway to activate autofocus. As soon as focus is attained, the infocus indicator, a green dot, is displayed in the viewfinder and focus is locked. It will remain locked as long as the shutter release button remains depressed half way. Alternatively, press and hold the button to lock focus; once focus is locked using the button, it is not necessary to keep the shutter release button depressed (assuming one of the appropriate AF options has been selected at CS-12).

When AF-C has been selected, the autofocus system is constantly adjusting the focus point while the shutter release button is held halfway down, so the picture must be composed with an AF sensing area covering the subject. To lock focus and enable you to recompose the picture without keeping an AF area on the subject, press and hold the AE-L/AF-L button (again assuming one of the appropriate AF options has been selected at CS-12).

Hint: Use CS-12 to assign the function of the AE-L/AF-L button, which can be used for several purposes: To lock both exposure and focus, to lock exposure only, or to lock focus only. Once focus has been locked in either AF-S or AF-C focus modes, ensure the camera-to-subject distance does not change. If it does, re-activate AF and re-focus at the new distance before using the AF lock options.

AF-Assist Illuminator

The D40x has a built-in AF-assist lamp on the front of the camera that is designed to facilitate autofocusing in low light condition, though I consider this feature is largely superfluous. Here are a few reasons why I suggest using CS-09 (AF Assist) to cancel operation of this lamp.

- The lamp only works if you have a compatible autofocus lens (AF-I or AF-S type) attached to the camera, if the focus mode is set to AF-S, or if AF-S is selected in the AF-A mode. It is only usable with focal lengths between 24mm-200mm (ensure any lens hood is removed).
- The operating range is restricted to distances between 1 foot 8 inches and 9 feet 8 inches (0.5–3.0m).
- The lamp overheats quite quickly (6–8 exposures in rapid succession is usually sufficient) and will automatically shut down to cool. Plus, at this level of use, it also drains the battery faster.

Hint: Provided the conditions described above are met, it is possible to use the built-in AF-assist Illuminator lamp of either the SB-600 or SB-800 Speedlights. If you want to use either the SB-600 or SB-800 off camera, the SC-29 TTL flash lead has a built-in AF-assist lamp that attaches to the camera's accessory shoe.

Limitations of AF System

Although the autofocus system of the D40x is quite effective, there are some circumstances or conditions that limit its performance:

- Low light (use the central sensor for optimum AF performance).
- Low contrast (use the central sensor for optimum AF performance).
- Highly reflective surface.
- Subject too small within the AF sensing area.
- The AF sensing area covers a subject comprised of fine detail.
- The AF sensing area covers a regular geometric pattern.
- The AF sensing area covers a region of high contrast.
- The AF sensing area covers objects at different distances from the camera.

If any of these conditions prevent the camera from attaining focus, either switch to Manual focus mode, or focus on another object at the same distance from the camera as the subject and use the focus lock feature before re-composing the picture.

Using Non CPU-Type Lenses

With electronic communication between the lens and camera for the purposes of exposure metering and autofocus, a number of changes have been introduced to the Nikon F lens mount. Consequently, older non-CPU type lenses (i.e. those that lack electrical contacts around their mounting bayonet) offer a restricted level of compatibility with the D40x. If a non-CPU type lens is attached to the camera, only Manual exposure mode is available (the shutter release is automatically disabled if you select another exposure mode). The lens aperture must be set using the aperture ring on the lens, and the autofocus system, TTL metering system, electronic analog exposure display, and TTL flash control do not function. However, the electronic rangefinder does operate, provided the maximum effective aperture is f/5.6 or larger (for full details and lists of lens compatibility, see pages 53 and 237).

Depth of Field

When a lens brings light to focus on a camera's sensor, there is only a single plane-of-focus that is critically sharp. However, in the two-dimensional picture produced by the camera, there is a zone in front of and behind the plane of focus that is perceived to be sharp. This area of apparent sharpness is usually referred to as the depth of field, and its extent is influenced by the camera-to-subject distance, together with the focal length and aperture of the lens in use.

If the focal length and camera-to-subject distance is constant, depth of field will be shallower with large apertures (low f/numbers) and deeper with small apertures (high f/numbers). If the aperture and camera-to-subject distance are constant, depth of field will be shallower with long focal lengths (telephoto range) and deeper with shorter focal lengths (wide-angle range). If the focal length and aperture are constant, depth of field will be greater at longer camera-to-subject distances and shallower with closer camera-to-subject distances. Depth of field is an important consideration when deciding on a particular composition; it has a direct and fundamental effect on the final appearance of the picture.

It is important to understand that images shot on a D40x exhibit slightly less depth of field than those shot on a 35mm film camera. This is due to the smaller size of the sensor compared with a 35mm film frame. The digital picture must be magnified by a greater amount compared with 35mm film to achieve any given print size. Therefore, at normal viewing distances, detail that appears to be sharp in a print (i.e. within the depth of field) made from a film-based image may no longer look sharp in a print of the same dimensions made from a digital file.

You will maximize depth of field in landscape photos by setting a small aperture (high f/number). It is also worth observing that at mid to long focus distances, the zone of apparent sharpness will extend about one-third in front of the point of focus and two-thirds behind it. Therefore, by placing the point of focus about a third of the way into your scene, you will maximize the coverage of the depth of field of the shooting aperture.

In portrait photography, is often preferable to render the background out-of-focus so it does not distract from the subject(s). The simplest way to achieve this effect is to use a longer focal length lens (a focal length of 70 to 105mm is ideal) in combination with a large aperture (low f/number).

In close-up photography, depth of field is limited, so convention suggests you set the lens to its minimum aperture (highest f/number) value. However, I strongly recommend that you avoid doing this because the effects of diffraction at

or near the minimum aperture of a lens cause a significant loss of image sharpness. Generally, you will achieve superior results at an aperture about two-stops more (lower f/number) than the minimum value of the lens. Although it does vary slightly from lens to lens, I have found the effects of diffraction become apparent with the D40x around f/11 to f/13. Do consider using a tripod because the shutter speed is likely to be rather slow, even in good light, when shooting with a small lens aperture.

Unlike the distribution of the depth-of-field zone for mid to long focused distances, at very short distances the depth of field extends by an equal amount in front of and behind the plane of focus. By placing the plane of focus with care, you can use this fact to further maximize depth of field.

Controlling the depth of field is probably one of the most important considerations when preparing to shoot a picture. A small aperture (high f/number) was used to provide plenty of depth of field and to ensure that all of the fine detail was recorded sharply in this telephoto shot.

Two-Button Reset

To restore settings on the D40x to their default values, hold down the and solutions for approximately 2 seconds. The monitor will turn off briefly during the reset. (The green dots beside each button are a reminder that they function together in this way.)

Default
Single frame
AF-A (Auto-select)
Closest subject
Center
Matrix
Off
+/- 0
Fill flash ²
+/- 0
JPEG Normal
Large
Auto ³
100 4

Two-button Reset Default Values

1. In 4 mode = Dynamic area is set.

In = Single-area is set. 1 .Q.

2. In

modes = Auto is set. **.**

- mode = Auto slow-sync is set. In
- 3. Fine tuning set to 0.
- 4. ISO Auto is set in and Digital Vari-program modes.

Note: The two-button reset process does not affect options selected in the Custom Setting menu.

Image Playback Options

One of the most useful features of a digital camera is the ability to get nearly instant feedback on photographs as you shoot. Using the playback functions on the D40x will allow you to see not only the images you have taken, but also a range of helpful and interesting information. Keep in mind that the small image displayed on the screen is not represented with sufficient precision to make critical analyses of such attributes as color or exposure. I believe that the image displayed is helpful to confirm that an exposure has been recorded, the success (or otherwise) of its composition, its potential accuracy in terms of exposure based on the histogram display, and its degree of sharpness using the zoom function.

Image Review

Immediately after taking an exposure, the image can be reviewed on the LDC monitor as long as *On* is selected for *Image review* at Custom Setting CS-07 (the duration of the display is determined by the option selected at *Auto timers off* under CS-15). In Single frame and Self-timer shooting modes, the image is displayed almost immediately after the exposure is made. In the Continuous shooting mode, the camera must write the image data from the buffer memory to the memory card for all of the images recorded, so a short delay may occur; the camera displays each image chronologically as soon as it has been saved.

Note: Select Off for the Image review option at CS-07 if you do not want the camera to display the image automatically after shooting.

Basic Single Image Playback

Press the Dutton on back of the camera to the left of the LCD monitor to display the most recent image taken by the camera. If you wish to view other images saved on the memory card, simply press the multi selector to the left or right to scroll through them. Pressing the shutter release button halfway returns the camera to its Shooting mode. **Note:** If you want images shot in an upright (vertical) composition to be displayed in the correct orientation, select *On* for the *Auto image rotation* option in the setup menu, and select *On* for the *Rotate tall* option in the Playback menu.

Photo Information Pages: A useful feature of the playback function is the host of information that can be accessed while viewing the image on the monitor. This data can help confirm your composition as well as give detailed information about how, when, and where the exposure was made. Up to six different pages of information can be displayed for each image file displayed on the LCD monitor.

To access these, first display an image for playback by pressing the **b**utton, then press the multi selector up and down to scroll back and forth through the following pages:

- File Information This Photo Information Page displays an unobstructed view of the image while providing additional information about the photo, such as Protect status; Retouch indicator; Frame number/Total number of frames; Folder name; File name; Image quality; Date of recording; Time of recording; and Image size.
- Shooting Data Page 1 A block of information is superimposed over the center portion of the screen, obstructing the view of the image: Protect status; Retouch indicator; Camera name; Metering method; Shutter speed; Aperture; Exposure mode; Exposure compensation; Focal length; Flash sync mode; Frame number/Total number of images.

Note: This screen can be particularly useful if you are trying to achieve consistent results in similar shooting conditions, learning about your shooting style, and attempting to understand which settings produce particular results.

 Shooting Data Page 2 – A block of information is superimposed over the center portion of the screen, obstructing the view of the image: Protect status; Retouch indicator; Image optimization; ISO sensitivity; White balance/White balance adjustment; Image size/Image quality; Tone compensation; Sharpening; Color mode/Hue adjustment; Saturation; Image comment; Frame number/Total number of images. If the ISO Auto feature (CS-10) is active and adjusts the ISO value automatically, the new value is displayed in red.

Note: This screen can help you understand the effects of image settings and adjustments on the appearance of your picture.

Retouch History – A block of information is superimposed over the center portion of the screen, obstructing the view of the image. It displays: Protect status; Retouch indicator; Retouch history, which lists changes made to image using Retouch menu options, with most recent change shown first; Frame number/Total number of images.

Note: This screen will only be displayed if the Retouch menu has been used to create a modified version of a picture recorded by the D40x, and saved to the installed memory card.

• *Highlights* – Displays an unobstructed view of the image: Protect status; Retouch indicator; Image highlights; Frame number/Total number of images.

Note: This screen is very useful for checking if information may have been lost as a result of overexposure; any relevant areas that may be affected will flash alternately black and white.

 Histogram – Provides an individual histogram for each of the red, green, and blue channels, together with an RGB composite histogram and a thumbnail of the image file. It shows: Protect status; Retouch indicator; Frame number/Total number of images; and Histogram.

Use the histogram display to assess the exposure level when reviewing images on the LCD monitor. It clearly and precisely indicates the range of tones that have been recorded.

Assessing The Histogram Display

The histogram is a graphical display of the tonal values recorded by the camera. The shape and position of the histogram curve indicates the range of tones that have been captured in the picture. The horizontal axis represents brightness, with darker tones distributed to the left of the histogram graph and lighter tones to the right. The vertical axis represents the number of pixels that have that specific brightness value. In a picture of a scene containing an average distribution of tones that includes a few dark shadows, a sizable number of mid-tones, and a few bright highlights, the curve will start in the bottom left corner and slope upwards, then curve down to the bottom right corner. In this case a wide range of tones will have been recorded.

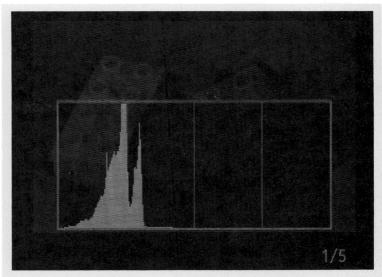

The curve is biased toward the left side of the graph with virtually no light tones recorded, showing this shot is 2-stops underexposed. Attempting to rescue this image is very likely to emphasize the effects of electronic noise, which will degrade the image quality.

Obviously not all scenes contain an even spread of tones; many have a natural predominance of light or dark areas. In these cases the histogram curve will be biased to the right (light scenes) or the left (dark scenes); this is not an indication of over or underexposure respectively, but an indication of the limited range of tones in the scene. Hence there is no single perfect or ideal histogram curve for all scenes and subjects; the shape of the histogram curve will vary widely depending on the nature of the scene recorded. However, provided the histogram curve stops on the bottom axis before it reaches either end of the graph, the image should contain a full range of the available highlight or shadow tones in the scene being photographed. If the curve begins at a point part way up the left or right vertical axes of the histogram display, so it does not end on the horizontal axis but looks as though it has been cut off abruptly, the camera will not have recorded tones in either the shadows (left side) or highlights (right side). This is often an indication of underexposure or overexposure.

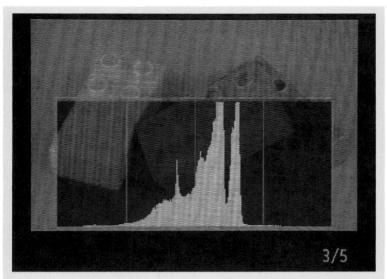

Properly exposed, the left and right-hand ends of the curve stop on the bottom axis before reaching either side of the graph, indicating that all tones have been recorded.

Generally, controlling exposure to retain highlight detail is more important than exposing for shadow areas. If the histogram curve is weighted heavily toward the right side of the graph and is cut off at a point along the right-hand vertical axis, highlight data will probably be compromised or lost. In this case, reduce the exposure until the righthand end of the curve stops on the horizontal axis before it reaches the vertical one. Conversely, if shadow detail is important, make sure the curve stops on the bottom axis before it reaches the left-hand vertical axis.

Scenes that are low in contrast will have a rather narrow curve that ends before reaching either the left or right-hand extremities of the bottom axis. You have two choices about how to deal with this situation: (1) In the Shooting menu, select *Tone compensation*, which is within the *Custom* option of the control for *Optimize image* (see page 109) to

This is 2-stops overexposed The curve is biased to the right side of the graph and the curve is cut-off at a point up the right axis. Highlight detail was likely lost due to total saturation. These areas will appear as featureless highlights in the picture.

have the contrast control performed by the camera; or (2) adjust the contrast level at a later stage using an image-processing software application.

Note: It is always preferable to err on the side of lower contrast because it is easier to boost contrast than it is to try and reduce it at any stage subsequent to the original exposure.

The three pictures shown here represent a range of exposures of a scene that contains a wide range of tones from deep shadow to bright highlight.

Thumbnail Playback

If you wish to view multiple images on the monitor, press the the button; press once to view four and press again to view nine images simultaneously. To view fewer images ,press the the button. A yellow border surrounds the highlighted image: To scroll through the images, press the multi selector left, right, up, or down. Once an image is highlighted, use the the button to show the image full frame, and press the to button to return to multiple image display. Protect an image by pressing the (O-n) button, located on back of camera to right of viewfinder. Delete an image by pressing the button, located on back lower right of camera. To return the camera to the Shooting mode, press the shutter release button.

Playback Zoom

The image displayed on the LCD monitor is usually too small to check with any certainty for sharpness; the playback zoom will allow you to enlarge the image by up to 25x. To do so, press the button. The image will appear slightly enlarged, and a thumbnail with a yellow border indicating the sectional view of the image is displayed briefly before turning off automatically. To increase the degree of magnification, press the button repeatedly until the required zoom is achieved. You can navigate around the enlarged image by pressing the multi selector in the direction you want to shift the view. It is possible to examine other images at the same location of the frame and the same degree of magnification by rotating the Command dial. To zoom out, press the button repeatedly.

Protecting Images

To protect an image against inadvertent deletion, display it on the LCD in either the full-frame single image playback or multiple image display (ensure the image is highlighted with a yellow border), and press the $(\mathbf{O}_{\mathbf{n}})$ button. A key icon will appear in the upper left corner, superimposed over the image. To remove the protection, open the image and press $(\mathbf{O}_{\mathbf{n}})$ again, checking that the key icon is no longer displayed. *Note:* Protected images will retain that status even when the image file is transferred to a computer or other storage device. However, all protected images on a memory card will be erased during card formatting.

Deleting Images

Images can be deleted using one of two methods. The quickest and easiest is to press button while the image is displayed on the LCD monitor. The first press opens a warning dialog box that asks for confirmation of the delete command. To complete the process, press the button again. To cancel the delete process, press the button to return to viewing the image. Images can also be deleted by selecting the *Delete* option in the Playback menu. There are two options: delete *Selected* images or delete *All* images stored on the memory card.

Camera Menus

The D40x makes extensive use of a sophisticated and comprehensive menu system that is displayed on the LCD monitor. It is divided into five main sections:

Setup Menu – Used to establish the basic configuration of the camera.

Shooting Menu – Used to select more scphisticated camera controls that have a direct influence on the quality and appearance of the pictures recorded by the camera.

Retouch menu – Offers useful features for performing a range of enhancements and modifications to images recorded and stored on the installed memory card.

Custom Setting Menu – Options allow the user to select and set a wide range of controls to fine-tune camera operation to meet specific requirements.

Playback Menu – Used for reviewing, editing, and managing the pictures stored on the memory card.

The D40x's menu system allows you to configure the camera to your specific requirements for a wide variety of shooting situations.

Note: While Nikon should be commended for including the options available in the Retouch menu, I believe it is important to put them in perspective. The items available in this menu cannot be considered as sophisticated as their equivalents in the many good digital imaging software applications available today. They are intended to provide a convenient and largely automated method of producing a modified version of the original image, without the need to use a computer. As such they offer a relatively effective level of control, using in-camera processing, to produce a finished picture direct from the camera.

Access to Menus

To gain access to any menu, push the 🛛 💷 button and press multi selector to the left to highlight one of the five tabs used to identify each menu (top to bottom): Y Setup menu, Retouch menu, Ø Custom Setting Shooting menu, menu, and **P**layback menu. Highlight the desired menu tab by scrolling up or down with the multi selector and the first level of menu options will open. Press the multi selector to the right to highlight an option in the selected menu (again navigating to a specific menu item by pressing the multi selector up or down). To display the second level of options (sub-options) available for each menu item, press the multi selector to the right, and once more press the multi selector up or down to highlight the desired sub-option. To select any highlighted item in any menu, press the or button (although pressing the multi selector to the right has the same effect, plus it is quicker and more convenient). To return to the previous menu level, press the multi selector to the left once. To exit the menu svstem and return to the Shooting mode, either press the shutter release button lightly or press the button twice.

Note: The menus have multiple options that sometimes cannot all appear on a single page. Keep scrolling up or down to access those options not originally displayed on the screen. If a menu item is gray, it is not available at the current camera settings.

Many of the options within the menu system can be set using buttons and the command dial in conjunction with the Shooting Information Display. Where such an alternative route is available it will generally improve the efficiency of camera handling. If you need a reminder about what a particular menu option or camera setting does, press and hold the the button to display a description of the function or feature. You may need to press the multi selector up or down to scroll through the display.

Setup Menu (Simple Option)

The Setup menu is used to establish the basic configuration of the camera. Once set, the items in this menu are generally not changed very frequently. This menu can be displayed in either an abbreviated format (*Simple*) that shows a partial list of commonly used selections, or in an unabridged format (*Full*) that shows the complete listing of items. Furthermore, the Setup menu is home to the *My menu* item, which enables the user to select only those options from all five menus that they wish to display. This effectively allows the entire menu system to be customized to the user's specific requirements.

The following ten items will be displayed in the Setup menu if the *Simple* option (default) is active, which is one of three choices under the *CSM/Setup* selection (see below).

CSM/Setup Menu

This option is used to determine whether the camera displays an abbreviated list of all the options available in both the Setup menu and the Custom Setting menu (it does not affect the display of options in the other three camera menus, which are always shown in full unless you have set up the menu display differently using the *My Menu* option). To select which options are displayed in the menu system:

- 1. Select CSM/Setup from the Setup menu.
- 2. Highlight *Simple* to display only the abbreviated form of the Setup and Custom Setting menu, *Full* to display all the options in all menus, or *My Menu* to display only those menu items you choose to select from all five of the camera's menus.
- 3. Press the solution to confirm your selection of either *Simple* or *Full*.
- 4. For My menu it is necessary to select which menu items you want to display. Highlight My menu and press the multi selector to the right to display a list of the five camera menus. Select one by highlighting it and press the multi selector to the right. A list of all items in the menu will be shown with a check-box next to each one. Use the multi selector to scroll through the menu items and press it to the right to select or deselect each item (a check mark is shown in the box for each item that is selected). Once you have finished making your selections for the menu, highlight Done and press the Button to confirm and return to the list of main menus. Repeat this process for each main menu. Finally, highlight Done in the list of main menus and press the Button to confirm the settings and return to the Setup menu. It is essential that Done be confirmed in both instances, otherwise your changes will not be saved.

Format Memory Card

A new memory card should always be formatted when it is first placed into the D40x. It is also good practice to format any memory card whenever you insert it in to the camera. This is particularly important if you use your memory cards between different camera bodies.

To format a memory card:

- 1. Select Format memory card from the Setup menu.
- 2. Select Yes or No.
- 3. Press the os button to confirm your selection.

The D40x provides ample opportunities for creative control.

To help prevent accidental deletion of image files, the *No* option is highlighted when the sub-menu of options is displayed. If you select *Yes*, the camera will display the following message on the monitor screen: "All pictures on memory card will be deleted. OK?" During the formatting process, "Formatting memory card," followed by, "Formatting complete" will be displayed on the LCD monitor.

Make certain that power to the camera is not interrupted during formatting. A loss of power could damage the card, so ensure the battery is adequately charged or use the optional EH-5 AC adapter and EP-5 connector adapter.

Note: The D40x supports the SDHC version 2.00 standard, which allows it to use a memory card with a capacity in excess of 2GB.

The formatting process does not permanently delete image files and data from the memory card, but actually overwrites the file directory so that it is no longer possible to access any image files stored on the card. If you should format a card inadvertently, it may be possible to recover the image files using appropriate data recovery software.

Info Display Format

The D40x offers three different styles for the Shooting Information Display: *Classic, Graphic,* and *Wallpaper.* It is possible to have one style displayed when using the and Digital Vari-Program modes, and another style when shooting in the P, S, A, and M exposure modes.

To select a style for the Shooting Information Display:

- 1. Select Info display format from the Setup menu.
- 2. Highlight, *Digital Vari-Program* or *P, S, A, M* and press the multi selector to the right.

If you wish to use a photograph as the Wallpaper display:

- 1. Select Info display format from the Setup menu.
- 2. Highlight *Select wallpaper* and press the multi selector to the right.
- Up to six thumbnail pictures will be shown on the monitor. Use the multi selector to highlight the picture you want for display (pressing the solution displays the picture full screen), and press the button to confirm your selection.

Hint: I recommend using the <u>Classic</u> display because it offers the greatest clarity; however the <u>Graphic</u> display may be more helpful to less experienced photographers because it provides a visual representation of the lens aperture and shutter speed. Personally, I consider the <u>Wallpaper</u> option little more than a gimmick. Unless you use a picture with large areas of continuous tone, the Shooting Information Display becomes difficult to distinguish.

Auto Shooting Info

This option enables the camera to automatically display Shooting Information when the shutter release button is either pressed half way then released (without making an exposure), or after it is depressed fully and an exposure is made.

Note: If CS-07 (Image review) is set to On while this function is enabled, the picture recorded by the camera will be displayed on the monitor screen immediately after the shutter has been released, in place of the Shooting Information Display.

Note: If CS-07 is set to *Off* while this function is enabled, the normal Shooting Information Display appears automatically on the monitor after the shutter has been released.

To set Auto Shooting Info:

- 1. Select *Auto shooting info* from the Setup menu, and press the multi selector to the right.
- 2. Highlight *Digital Vari-Program* or *P, S, A, M* and press the multi selector to the right.
- 3. Highlight *On* or *Off* as desired, and press the button to confirm your selection.
- 4. If you select *On*, shoot a picture and press the multi selector up or down to display the required Photo Information Page. Thereafter, each subsequent exposure will cause the same page to be displayed.

World Time

World time enables you to set and change the date and time recorded by the camera's internal clock, and also how this information is displayed. Once you have selected World time from the Setup menu, four options are displayed: Time zone, Date, Date format, and Day!ight savings time. Each one requires the user to input information.

To set Time Zone:

- 1. Select *Time zone* from the options list.
- 2. Scroll right or left through the world map using the multi selector until the relevant time zone is highlighted.
- 3. Press the os button to select it.

To set Date:

- 1. Select Date from the options list.
- 2. Scroll through the settings by pressing the multi selector left or right, and press it up or down to set each value for the date and time.
- 3. Press the os button to confirm the date/time.

To set Date Format:

- 1. Select *Date format* from the options list and press the multi selector to the right.
- 2. Highlight the desired configuration for the date display.
- 3. Press the os button to confirm the selection.

To set Daylight Savings Time:

- 1. Select *Daylight savings time* from the options list and press the multi selector to the right.
- 2. Highlight either *On* or *Off* depending on the time of year or location in which the camera is to be used.
- 3. Press the 🛛 button to confirm the selection.

LCD Brightness

The brightness of the LCD monitor can be adjusted to help improve the visibility of any displayed image or page of information. This feature can be particularly helpful when trying to review images in bright outdoor light.

To adjust LCD Brightness:

- 1. Select *LCD brightness* from the Setup menu, and press the multi selector to the right.
- 2. Adjust the brightness value by pressing the multi selector up or down.
- 3. Press the observation button to set the brightness value you have chosen.

Note: A negative adjustment will darken the screen while a positive adjustment will brighten it. The screen displays a gray scale to help you judge the brightness effect on the full tonal range present in your images.

The D40x's large LCD monitor can be adjusted so you can see it better in bright, outdoor conditions, making it easier to check composition and exposure during image review.

Video Mode

This option allows you to select the type of signal used by video equipment to which you may connect your camera, such as a DVR/VCR or television. This should be set before connecting your camera to the device with the supplied EG-D2 video cord.

To set Video Mode:

- 1. Select *Video mode* from the Setup menu and press the multi selector to the right.
- 2. Use the multi selector to highlight either *NTSC* (used in USA, Canada, and Japan) or *PAL* (most other countries).
- 3. Press the 🚳 button to confirm your selection.

Language

The *Language* option on the D40x allows you to select one of 15 languages for the camera to use when displaying menus and messages.

To set the Language:

- 1. Select *Language* from the Setup menu and press the multi selector to the right.
- 2. Highlight the desired language from the list displayed by pressing the multi selector up or down.
- 3. Press the obstance button to confirm the selection.

Image Comment

You can attach a short note (up to 36 characters) to an image file. It may contain letters and/or numbers. Since the process requires each character to be input individually, this is not a feature you will use for each separate picture. However, it is useful to assign a general comment (e.g., the name of a location or event) or a note about authorship or a copyright.

Note: The "keyboard" used for inputting a comment is the same one used for file and folder naming.

To attach an Image Comment:

- 1. Select *Image comment* from the Setup menu and press the multi selector to the right.
- 2. Select Input comment from the options list.
- 3. To enter your comment, highlight the character you wish to input by using the multi selector and press the button to select it. If you accidentally enter the wrong character press the button to erase it.
- 4. Press the substant button to save the comment and return to the *Image comment* options list.
- 5. To attach the comment to your photographs, scroll to the *Attach comment* option and select *Set*. A small check mark will appear in the box to the left of the option. If you fail to select *Set* and place a check mark in the box, the image comment will not be attached to the image file.
- 6. Finally, once you have completed this process highlight *Done* and press the **w** button to confirm the selection.

If you wish to exit this process at any time without attaching a comment or changing an existing one prior to step 5, simply press the button.

When the check mark is present in *Attach comment*, the saved comment will be attached to all subsequent images shot on the camera. To prevent the comment from being attached to an image, simply return to the *Image comment* menu and uncheck the *Attach comment* box. The comment or note will remain stored in the camera's memory and can be attached to future images by rechecking the *Attach comment* box.

The first thirteen characters of the comment will be displayed on Shooting Data Page 2 (Photo Information Pages) available via the *Image review* option. The full comment can be viewed when using the supplied Picture Project software, or optional Nikon Capture NX.

USB

This allows you to select the correct USB interface for the type of operating system used by any computer to which the camera is connected for the purposes of transferring images using Nikon software, printing direct from the camera via a PictBridge compatible printer, or controlling the camera using Nikon Camera Control Pro software.

Note: The selection for the USB option *must* be made before connecting your camera to your computer/PictBridge printer using the supplied USB cable.

To select USB:

- 1. Select *USB* from the Setup menu and press the multi selector to the right.
- 2. Highlight either Mass Storage or MTP/PTP.
- 3. Press the os button to confirm the selection.
- MSC (Mass storage)-The D40x acts like a card reader in this default setting, and the computer sees the memory card in the camera as an external storage device; it only

allows the computer to read the data on the memory card. This option must be used if your computer is running Windows 2000 Professional. The Mass Storage option can also be used when running Windows Vista (32-bit Home Basic, Home Premium, Business, Enterprise, or Professional), Windows XP (Home or Professional), or Macintosh OS X (10.3.9, or 10.4.x). Also make sure the camera is un-mounted from the computer system in accordance with the correct procedure for the operating system in use before it is switched off and disconnected from the USB cord.

MTP/PTP – The D40x acts like another device on a computer network and the computer can communicate and control camera operations. Use this option if the computer is running Windows Vista (32-bit Home Basic, Home Premium, Business, Enterprise, or Professional), Windows XP (Home or Professional), or Macintosh OS X (10.3.9, or 10.4.x).

Note: You must select the MTP/PTP option to control the camera using the optional Nikon Camera Control Pro software. When Camera Control Pro software is running, the camera will display "PC" in place of the number of exposures remaining.

Setup Menu (Full Option)

The following additional six items will be displayed in the Setup menu only if *Full* is selected under the *CSM/Setup menu* item, or they are included in the user defined *My menu* list (see page 162).

Folders

The D40x uses a folder system to organize images stored on the installed memory card. The *Folders* option in the Shooting menu allows you to select which folder your images will be saved in, and it also enables you to create new folders.

If you do not use any of the options pertaining to folders, the camera creates a folder named "ND40X" automatically in which the first 999 pictures recorded by the camera will be stored on the memory card. The folder will automatically be assigned a three-digit prefix, so the title of the default folder will be "100ND40X." If you exceed 999 pictures, the camera creates a new folder named "101ND40X", and so on for each set of 999 pictures. You can create your own folder(s). The folder title will always be preceded by a three-digit number between 100 and 999, which can be assigned by the user. The suffix, "ND40X", remains the same.

If you use multiple folders, you must select one as the active folder to which all images will be stored until an alternative folder is chosen, or the maximum capacity of 999 pictures in the active folder is exceeded. In the latter case, the D40x will create a new ND40X folder and assign a three-digit prefix with an incremental increase of one (e.g. if folder "100ND40X" becomes full, the D40x creates folder "101ND40X" into which subsequent pictures will be stored).

Note: If the folder that has reached full capacity is folder number "999ND40X," the camera will disable the shutter release button, preventing you from making an exposure. You will have to create a new folder with a lower number, or choose another folder on the card that still has space to hold new images.

To create a new folder:

- 1. Select *Folders* from the Shooting menu and press the multi selector to the right.
- 2. Select New from the list of options.
- 3. Designate the new folder by highlighting the required letter or number from the displayed keyboard and pressing
 to select it. Repeat this process up to four times to create the new folder name.
- 4. To delete a character, press the 🗴 button.
- 5. Press the Sutton to confirm the new folder title and return to the Setup menu.

To select an existing folder:

- 1. Select *Folders* from the Shooting menu and press the multi selector to the right.
- 2. Select *Select folder* from the options list and press the multi selector to the right.
- 3. Highlight the folder you wish to use by pressing the multi selector up or down.
- 4. Press the source button to confirm the folder in which pictures will be stored, and return to the Shooting menu.

Folders may be useful if you expect to take pictures of a variety of subjects. For example, on a touring vacation you can create a folder for each location visited, and file your images on the memory card(s) location-by-location. However, I find that using multiple folders is time consuming and potentially confusing. If you have more than one different Nikon digital camera model and move cards between them, the individual cameras will not be able to handle images in folders created by another camera. Even multiple folders created by the D40x can present problems, as images will be saved to the currently selected folder with the highest prefix number. I would rather use a browser application such as PictureProject or Nikon Capture NX to browse and organize my images after they have been imported to a computer.

File Number Sequence

D40x file names contain three letters (DSC), a four-digit number, and the three-letter file extension (.JPG or .NEF).

There will be an underscore next to DSC, either as a prefix to denote Adobe RGB, or as a suffix to denote the sRGB color space (e.g. _DSC0001.JPG denotes a JPEG file, number 0001, saved in the Adobe RGB color space; DSC_0001.JPG is saved in the sRGB color space). The *File no. sequence* option in the Shooting menu allows you to select whether file numbering is reset to 0001 whenever a new folder is created, the memory card is formatted in camera, or a new memory card is inserted.

To use File No'Sequence:

- 1. Select *File no sequence* from the Setup menu and press the multi selector to the right.
- 2. Highlight *Off* (default) to reset the file number to 0001 whenever a new folder is created, the memory card is formatted in camera, or a new memory card is inserted. Select *On* to continue numbering from the last number used after a new folder is created, the memory card is formatted in camera, or a new memory card is inserted. Select, *Reset* to number the next image file 0001 and continue numbering as if the *On* had been selected.
- 3. Press the obstance button to confirm the selection and return to the Shooting menu.

Mirror Lock-Up

This feature is exclusively for cleaning or inspecting the low-pass filter (it cannot be used to lock the reflex mirror in its raised position to reduce camera vibration while shooting). It is essential not to interrupt the camera's power supply when *Mirror lock-up* is active, particularly if you have cleaning utensils in the camera at the time, as the reflex mirror will drop to its normal position with potentially dire consequences. Make sure the camera battery is fully charged or use the optional EH-5 AC adapter with EP-5 adapter connector.

Note: This option will not function if the battery charge indicator displayed in the Shooting Information Display shows , or blinking.

To use Mirror Lock-up:

- 1. Select *Mirror lock-up* from the Shooting menu and press the multi selector to the right.
- 2. Highlight *On* and press the button. A message with instructions on how to proceed will be displayed on the monitor screen and a series of dashes will appear in the control panel.
- 3. Press the shutter release button fully; the mirror will lift and the shutter will open. Proceed with any necessary inspection/cleaning.
- 4. To return the reflex mirror to its normal position, turn the camera off.
- 5. If you wish to cancel the function select *Off* at step 2, and press the **w** button.

Note: Exceptional care should be taken whenever the Mirror lock-up function is in use because the low-pass filter is exposed. There is an increased risk that unwanted dust or moisture might enter the camera. Always keep the camera facing down: Gravity is your best friend in this situation.

Firmware Version

Select *Firmware version* to see the current version (A & B) of the firmware installed on the camera. It is worthwhile to check periodically on the various Nikon technical support web sites (details of these are listed on page 275) to see if any firmware updates have been released for the D40x. The first firmware version issued for the D40x was A=1.00/B=1.00.

Dust Off Ref Photo

The *Dust off ref photo* option on the D40x is specifically designed for use with the Image Dust Off function in Nikon Capture NX. The image file created by this function creates a mask that is "overlaid" electronically on a NEF file to enable the software to reduce or remove the effects of shadows that are cast by dust particles on the surface of the low-pass filter.

Note: This function can only be used with NEF files. To obtain a reference image for this function, you must use a CPU-type lens, and Nikon recommends use of a lens with a focal length of 50mm, or more.

To use Dust Off Ref Photo:

- 1. Select *Dust off ref photo* from the Setup menu and press the multi selector to the right.
- Highlight On and press the button. A message will instruct you to "Take photo of bright featureless white object 10 cm from the lens. Focus will be set to infinity."
- 3. Point your camera at an evenly lit, white featureless surface, such as a card, positioned approximately 4 inches (10 cm) from the front of the lens, ensuring the white surface fills the viewfinder frame.
- 4. Press the shutter release button halfway and focus will be set to infinity automatically. Alternatively, in Manual focus mode, set the lens to infinity focus.
- 5. Fully depress the shutter release button to acquire the reference frame for the Image Dust Off function in Nikon Capture NX.

If the lighting conditions for your subject are too bright or too dark, the camera will display the error message: "Exposure settings are not appropriate. Change exposure settings and try again." In these conditions it is not possible to complete the process, so either increase or decrease the level of illumination of the test target accordingly, or chose an alternative test target.

Once you have recorded the Image Dust Off reference photo, it can be displayed in the camera. Its file extension is .NDF, and it appears as a grid pattern with Image Dust Off Data shown within the image area. These files cannot be viewed using a computer.

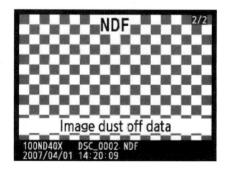

Note: The Dust off reference photo only records the position of extraneous material on the low-pass filter at the time of its exposure. If any of the material moves position while shooting, this function will not be effective at masking the effects. Therefore it is worthwhile to record several Dust off reference photos if you are engaged in a protracted period of shooting.

Auto Image Rotation

The D40x automatically recognizes the orientation of the camera as it records an image, whether formatted horizontally or vertically depending on how you hold the camera. At its default setting, the D40x stores this information so the image can be rotated automatically during image playback, or when viewing images on the computer with compatible software, such as Nikon Picture Project, or Nikon Capture NX.

How to set Auto Image Rotation:

- 1. Select *Auto image rotation* from the Setup menu and press the multi selector to the right.
- 2. Highlight On (default) or Off.
- 3. Press the or button to confirm the selection.

If you do not wish the camera to record its orientation, or if you shoot with the camera pointed up or down, which will usually render this feature unreliable, select *Off*.

Note: I have encountered some digital imaging software that is incapable of recognizing the image orientation information written to the image file, which can prevent the software from opening the file. I recommend testing pictures shot on the D40x with whatever software you use and turning this feature off if you have problems opening image files.

Shooting Menu

The options in this menu help determine the attributes of the recorded image file. The Shooting menu also contains specialty features, such as noise reduction for high ISO/long time exposures. You can use the *My menu* option, selected under the *CSM/Setup menu* item in the Setup menu, to select which Shooting menu items are displayed. The full menu contains the following options:

Optimize Image

The *Optimize image* option allows you to make changes to sharpening, contrast, color mode, saturation, and hue based on the current shooting situation and/or the user's preferences. It also allows you to select a variety of options for shooting pictures in the Black-and-white recording mode. See pages 104-112 for full details.

Image Quality

The *Image quality* option allows you to select the file format(s) to be used for images recorded by the camera. See pages 93-94 for full details.

Image Size

The selection for *Image size* determines the file size, or resolution, of an image in terms of pixel quantity. See pages 93-94 for full details.

Note: Image size adjustments will only apply to images saved using the JPEG format. NEF files are always saved at the camera's highest resolution of 3,872 x 2,592 pixels.

White Balance

The *White balance* option allows you to select the color temperature applied to the images you are shooting. There are eight options available when shooting in the P, A, S, and M exposure modes. See pages 95-104 for full details.

ISO Sensitivity

This item for *ISO sensitivity* is the digital equivalent to film speed. It emulates the light sensitivity of film bearing the same ISO number. The ISO sensitivity in the D40x is a measure of the degree of amplification applied to the signal from the sensor, since the sensitivity of the sensor is fixed at its base level, which is equivalent approximately to ISO 100. See pages 112-115 for full details.

Noise Reduction

Images taken at high ISO settings and/or using a long exposure will often exhibit the effects of electronic noise, which is the result of amplification processes that are applied to the data captured by the sensor. Noise generated by using a high ISO setting can result in a slight loss of color saturation (colors can look flat) and reduction in contrast. Noise produced during a long exposure is manifest as irregularly placed bright, colored pixels that disrupt the appearance of an image, particularly in areas of even tonality. The *Noise reduction* feature of the D40x will help reduce the appearance of both these types of noise.

If On is selected for Noise reduction, it will be applied to pictures shot at an ISO above 400 and/or at a shutter speed of approximately 8 seconds, or longer. If this option is applied to counter the effect of noise produced during a long exposure, the processing time for each recorded image will increase by 50-100%. The blinking letters "Job nr" will appear in place of the shutter speed and aperture value displays in the viewfinder until the process is complete, and the green access lamp will glow. No other picture can be taken while these are displayed.

If Off is selected for Noise Reduction, it will not operate at an ISO of 800 or less; however, a low-level of noise reduction is always performed at ISO sensitivities above 800.

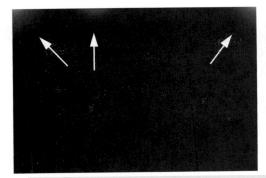

The three arrows indicate the areas in which noise as a result of signal amplification shows, clearly in long time exposures. This example was created with a 5 minute exposure using the JPEG (Large/Fine) option, at ISO 1600, with the Noise Reduction feature set to Off (camera serial number 7402xxx).

Nikon D40x - Noise issue

During testing of my own D40x camera I noticed that when I used it to shoot long exposures of a minute, or more there was a significant level of noise produced by sensor signal amplification at high ISO settings (1600, or H1). The noise was particularly prevalent (i.e. it is clearly visible when the image is reviewed on the camera's monitor screen) in the top corners of the frame and in an area about a third the way along the top edge of the frame (see the dark frame exposure example). Remember, in the camera these areas are at the bottom of the sensor, as the image formed by the lens on the sensor is upside down, which suggests that a localized increase in temperature due to heat generated by a component(s) close to sensor are at the root of this issue.

I have tested several other D40x cameras with similar results; therefore, if you use your D40x at high ISO settings (i.e. 1600, or H1) with an exposure duration of 30 seconds, or longer, with the Noise Reduction feature in the Shooting menu set to Off you will more than likely see noticeable levels of noise in the top corners of the frame, especially, if you perform any subsequent adjustment in computer post-processing, which raises the level of these photosites (pixels), significantly, in these areas.

Thankfully the Noise Reduction feature of the camera is very effective at reducing the level of noise present in the image, so if you want to shoot long exposures my advice is to always set Noise Reduction to On, and keep the ISO setting as low as possible, preferably ISO 400, or lower. *Note:* The process used by the D40x to perform noise reduction for long exposures involves making a second exposure known as a "dark frame exposure," during which the shutter remains closed but the camera maps the sensor and records the values of each photosite (pixel). It's possible for a photosite to retain a value that is erroneous. This can occur if the sensor becomes too warm due to prolonged use, although other influences such as internal camera temperature or ambient atmospheric temperature also contribute to noise. After mapping the sensor for hot (overly bright) photosites, the camera subtracts the "dark frame" photosite values from the photosite values of the main exposure in an effort to reduce the effect of noise in the final image.

Retouch Menu

This menu contains a range of items that create copies of image files stored on the camera's memory card. These options enable you to create retouched (modified), trimmed (cropped), or resized versions of the original image file, which are saved to the installed memory card. The original image is always preserved.

You can use the *My menu* option, selected under the *CSM/Setup menu* item in the Setup menu, to select which of the Retouch menu items are displayed. *The D-lighting, Red-eye correction, Monochrome,* and *Filter effects* items are not available if the original image was recorded with the *Black-and-white* option under *Optimize image* in the Shooting menu.

Note: With the exception of the Small picture options (see page 185), all other effects in the Retouch menu can also be applied to a copy image on the memory card (previously created with the Retouch menu). However, each option can only be applied once and this may result in a loss of image quality, depending on the option.

While the items in this menu can be useful, they are not as sophisticated as their equivalents in many of the more powerful digital imaging software applications that are available to install on your computer. The selections in the Retouch menu are intended to provide a quick, convenient, and largely automated method to modify a version of the original image without the need to use a computer.

Selecting Images

Images can be selected for processing from either single image playback in Image review mode (image fills the full frame), or from the Retouch menu itself.

To select and produce a copy of an image from the playback function, display the image and open the Retouch menu by pressing the button. Scroll with the multi selector to highlight the desired menu item, and then press right to display options within the selected item. Again, press the multi selector up or down to highlight the required option, and press it to the right to apply the option. You can return to single image playback at anytime without creating a copy image by pressing the button.

Note: It is not possible to use the *Image overlay* item during full-frame single image playback.

To select and produce a copy of an image directly from the Retouch menu, open the menu and highlight the desired item using the multi selector. Press the button to display up to six thumbnail images on the monitor screen (pressing the button in the *Monochrome, Filter effects,* and *Small picture* items opens a subsequent options page, so select the required option and press the button again). A yellow border frames the selected picture; then either scroll with the multi selector or rotate the command dial to move through the pictures. To view an enlarged version of the selected picture, press and hold the button. Once you have selected the picture to be modified and copied, press the button. You can return to single image playback at anytime without creating a copy image by pressing the button.

Image Quality

The image quality and size of the copied image created by the Retouch menu will depend on the quality and size of the original image file(s), and the option within the Retouch menu that is used:

- Select *Small picture* to create a copy that is saved as a JPEG file at the Fine (1:4 compression ratio) quality level.
- Select *Image overlay*, an option that combines two existing NEF images, to create a separate single photo (the two original images must be stored on the same memory card and taken with the D40x).
- All other options in the Retouch menu copy NEF files and save them as JPEGs at the Fine (1:4) compression ratio. Unless noted otherwise, these copies are sized to 3,872 x 2,592 pixels.

D-Lighting

The D-lighting feature brightens shadow areas to reveal more detail. It is not a simple global brightness control, but its application is selective and only affects the shadow areas of the recorded image.

Highlight *D-lighting* in the Retouch menu and press the button to display two thumbnail images; one unmodified and the other modified (the latter allows you to preview the effect). You can select three levels of this feature that increase brightness respectively from *Low* to *Normal* to *High*. Press the button to apply the desired level and create the copy.

Red-Eye Reduction

This option is only available with pictures taken using either the built-in or an external Speedlight (if an image was not shot using a Nikon Speedlight flash unit, a yellow box appears in the center of the thumbnail indicating the effect cannot be applied). First, examine the picture in single image playback and use the subtron to zoom in and the button to zoom out of the image. You can navigate around the image using the multi selector (a navigation window is displayed while these buttons are pressed).

If you see red-eye in the image, return to single image playback by pressing the button. Then press the button to display the Retouch menu and highlight *Red-eye correction*. Press the button again; the D40x will then analyze the original image data and assess it for red-eye. If none is detected, a message is displayed accordingly and the full image playback/Retouch menu display is restored. If the camera determines that red-eye is present, it creates a copy image with reduced red-eye. However, since this is a completely automated process, it is possible for the camera to apply the red-eye correction to areas of an image that are not affected by red-eye, which is why it is prudent to check the preview image before selecting this item.

Trim

This item enables you to crop the original image to exclude unwanted areas. The selected image is displayed along with a navigation window to show the location of the border that marks the crop area (you can navigate around the image using the multi selector). As you use the and a buttons to zoom in and out of the single full-framed image, the crop size is displayed in the top left corner of the image and shows the pixel dimensions (width x height) of the crop area. Once you have decided on the size and location of the crop area, press the button to create a cropped copy of the original picture and return to the single image playback or Retouch menu display.

Monochrome

This item allows you to save the copied image in one of three monochrome effects: *Black-and-white* (grayscale), *Sepia* (brown tones), and *Cyanotype* (blue tones). In all three cases the image data is converted to black and white using an algorithm dedicated to this feature (different than the algorithm used for the black-and-white options in the *Optimize image*

menu). Once converted to black and white, the image data is still saved as an RGB file (i.e. it retains its color information). If you select either *Sepia* or *Cyanotype*, the appropriate color shift is applied after the copy is converted to black and white: You can press the multi selector to increase or decrease the degree of color shift. Once you are satisfied with the preview image, which is displayed next to a thumbnail of the original for the purposes of comparison, press the solution to save the processed copy.

Filter Effects

There are three options in this menu. One emulates a skylight filter and a second emulates the type of color correction (warm) filter used for color photography. The third is a color balance that allows you to adjust the amount or red, green, blue, and magenta in the image.

Open the Retouch menu and highlight *Filter effects*. Press the multi selector to display the three available options, then highlight the one you want and press the multi selector to the right. If you select either *Skylight* or *Warm filter*, a preview image is displayed. To apply the effect and save a copy of the image, press the source.

- *Skylight* the effect subtly increases the amount of red in the image by a modest amount so it looks less blue.
- *Warm filter* This effect increases the amount of red in the image to a greater degree and produces a result similar to the use of a Wratten 81-series color correction filter. Again, the effect is subtle and proper control of the white balance should obviate the need to use it.
- Color balance This causes a thumbnail image to appear alongside histograms for the red, green, and blue channels. Below the thumbnail is a color-space map with a cross hair aligned on its center. Press the multi selector up to increase the level of green, and down to increase the level of magenta. Pressing to the left increases the level of blue, and right increases the level of red. The

center point of the cross hair will shift accordingly, and the thumbnail image can be used to preview the effect. Once you are satisfied with the adjustment, press the

button to apply the color shift and save a copy of the image.

Small Picture

The *Small picture* item offers options to reduce the resolution of the original image to create a copy that has a far smaller file size:

- 1. 640 x 480 pixels-suitable for playback on a television set.
- 2. 320 x 240 pixels-suitable for display on Web pages.
- 3. *160 x 120 pixels*-suitable for sending as an attachment to an e-mail.

The selection of a picture for processing in this menu (from single image playback) is described on page 181. However, the method of selecting a photo after choosing *Small picture* differs from the method described previously. It is necessary to select the image size as the first step, and then select the picture(s) to which the process will be applied.

- 1. Open the Retouch menu and highlight Small picture.
- 2. Use the multi selector to display two options: *Select pic-ture* and *Choose size*. Make sure the latter is highlighted.
- 3. Press the multi selector right to display the three size options (listed above), and highlight the required size.
- 4. Press the solution to confirm your choice and return to the previous page. Highlight *Select picture* and press the multi selector right to display up to six thumbnail images. The currently selected image is shown framed by a yellow border.
- 5. Use the multi selector to highlight a desired image (the yellow border will shift accordingly), then press the multi selector up or down to select it (a small icon appears in the top right corner of the thumbnail to indicate it has been selected).

- 6. Repeat as desired; once you have selected all the images you want to reduce in size, press the solution. A confirmation page will be displayed indicating how many images will be processed.
- Select Yes to proceed with the process, or No to return to the previous page. If you select Yes, press the button to apply the effect and save the copy picture(s).

Note: To identify images saved using the *Small picture* item they are displayed with a gray border during single image playback; it is not possible to use the zoom function with these images, as it is disabled.

Image Overlay

Image overlay enables the user to combine a pair of NEF files to form a single, new image (the original image files are not affected by this process). The images do not have to be taken in consecutive order but must have been recorded by a D40x camera and be stored on the same memory card.

To use Image Overlay:

- 1. Select *Image overlay* from the Retouch menu, and press the multi selector to the right.
- 2. The Image overlay page will open with *Image 1* high-lighted.
- 3. To select the first picture, press and a thumbnail view of all NEF files stored on the memory card will be displayed. Scroll through the images by pressing the multi selector left or right to highlight the image you wish to select. Pressing displays the highlighted image full frame.
- 4. Press and the selected image will appear in the Image 1 box and the Preview box.
- 5. Highlight the *Image 2* box and press second picture to be combined with the first. Use the same process as step 3.
- 6. Press to select the second image, which will appear in the Image 2 box and in the Preview box, overlaying the first image.

- 7. Adjust the gain value of either Image 1 or Image 2 by scrolling up and down using the multi selector while the image you wish to adjust is highlighted. To highlight either image, press the multi selector to the left or right. The effect of the gain control can be observed in the Preview box (the default value is 1.0).
- 8. Once you have adjusted the gain of both images to achieve the desired effect, highlight the *Preview box* by pressing the multi selector to the left or right.
- To view a larger version of the preview image, press the
 Button. Press the
 button to return to the thumbnail view.
- To generate a preview of the new image, highlight Overlay using the multi selector, and press
 To save the new image press
 To return to the Image overlay editing screen press the
 button.
- To save the image without a preview, highlight *Save* and press the button.

Note: Image attributes such as white balance, sharpening, color mode, saturation, and hue will be copied from the image selected as Image 1. Similarly, the shooting data is copied from the same image.

Note: Although limited to combining only two separate images the Image Overlay feature can be used to emulate the effect of a double-exposure. For example, try shooting to exposure of the same subject, one in focus and the other slight out of focus, and then combining them to create a soft focus effect.

Custom Setting Menu

Many of the default settings for the various functions and features of the D40x can be altered to suit your shooting style. This is achieved using the Custom Setting (CS) menu that has seventeen items, many with multiple sub-options.

The My menu option offers the ability to display specific, selected menu items. This refines the D40x's handling to provide quicker access to the controls you desire.

At the camera's default setting for menu displays, it is necessary to scroll through the list of available options in the Custom Setting menu each time you want to make an adjustment to a particular one. In an effort to simplify and speedup this process, the D40x offers two different levels of Custom Setting menu, *Simple* (default) and *Full*. The *Simple* option will display only the first six of the 17 total items available in the Custom Setting menu. The *Full* option enables access to all items in the CS menu.

The option for *My* menu is also available to display for selection only those options you want from the Custom Setting menu (or any of the five main menus on the camera). Each of these three Custom Setting levels is set from the *CSM/Setup* option in the \Im Setup menu (see page 161 for a description of how to set different options in *CSM/Setup*).

To view the Custom Setting menu, press the o button and use the multi selector highlight to the o Custom Settings tab. Press the multi selector to the right, and then press it up or down to scroll through the menu.

Hint: To save time, the menu will wrap-around in a continuous loop in both directions as you scroll–just keep pressing the multi selector either up or down.

Once your chosen menu item is highlighted, press the multi selector to the right to display its options. Highlight the desired option by pressing the multi selector button up or down, and select it by pressing the button.

Help Button

Rather than try to remember what each option does or refer to printed instructions, a built-in help function provides a brief description on the LCD of each Custom Setting item. Highlight the item and press and hold the subtron to display a descriptive text on the screen (if necessary press the multi selector button down to scroll through the text).

(R) Custom Setting Reset

All 17 items in the Custom Setting menu have a default value (indicated in the follow descriptions). If you wish to cancel all your user-set options and restore the camera to its default Custom Settings, select Reset (CS-R) and highlight *Yes*, then press the the button. This action only resets the Custom Setting menu; it does not restore default settings in any other camera menus.

CS-01 Beep

An audible signal can sound when the camera has performed certain functions, such as the countdown during Self-timer operation and Delayed remote release mode, confirmation that focus has been acquired in AF-S, and that shutter operation has been activated with the ML-L3 remote control in Quick-response release mode.

- On (default) The camera will beep. A musical note icon is shown in the Shooting Information Display. However, the sound can be a distraction in many shooting situations.
- Off (camera is silent) The camera is silent. A musical note icon with a strike through is shown in the Shooting Information Display.

CS-02 Focus Mode

These options determine how the camera's autofocusing system operates.

- *AF-A* (Auto-servo AF) The default, in this mode the AF system will decide to select either AF-S or AF-C based on whether it determines the subject is static or moving.
- *AF-S* (Single-servo AF) The AF system will acquire focus when the shutter release is pressed halfway or is activated by using the *AF-ON* option of CS-12, and will lock the focus distance. It is ideal for stationary subjects.
- AF-C (Continuous-servo AF) The AF system will acquire focus when it is activated by pressing the shutter release halfway or using the AF-ON option of CS-12. It will continue to monitor the focus distance, adjusting focus if subject-to-camera distance changes. It is ideal for moving subjects.
- *MF* (Manual Focus) The user must rotate the focus ring of the lens to alter the point of focus.

CS-03 AF-Area Mode

The D40x has three different autofocus area modes that determine which focus sensing areas are used. (Also see pages 140-142 for a full description of the autofocus area modes.)

Closest subject – This is the default for all exposure modes except Sport and Close-up Digital Vari-Programs. The camera selects the autofocus area; the user has no choice.

[12] Dynamic area – A single user-selected focus area is used to acquire focus unless the AF system detects the subject moving out of this area, in which case it shifts to another AF area to follow the subject. (Default for Sport Digital Vari-Program.)

[1] Single area – Only the single user-selected focus area is used to acquire focus. (Default for Close-up Digital Vari-Programs.)

CS-04 Shooting Mode

The D40x offers five shooting modes that determine how and when the shutter is released. (Also see pages 128-134 for a full description of the shooting modes.)

Single frame (default) – One exposure is made each time the shutter release button is pressed all the way down.

Continuous – Exposures are recorded at a maximum rate of 3 per second while the shutter release button is pressed fully down.

 \mathfrak{O}^{10s} Self-timer – The exposure can be delayed for a fixed duration.

 $\mathbf{\bar{D}}^{2s}$ Delayed remote – Use the ML-L3 remote to release the shutter after a short delay.

Quick-response remote – Use the ML-L3 remote to release the shutter immediately.

CS-05 Metering

The D40x has three methods of measuring light using its TTL (through the lens) metering system. This applies to P, S, A, and M exposure modes only. (Also see pages 115-119 for a full description of the metering modes.)

Matrix (default) – The camera uses its 420-pixel RGB sensor to evaluate brightness, contrast, and color. Distance and position of the subject are provided by the AF system.

 \bigcirc Center-weighted – 75% of the metering is biased from a circle at the center of the frame area that is 8 mm in diameter.

• Spot – The TTL metering system reads from an area approximately 3.5 mm in diameter, centered on the active AF sensing area.

CS-06 No Memory Card?

To prevent you from thinking the camera is recording pictures when in fact there is no memory card installed, the shutter release of the camera is disabled (although this can be overridden to allow the camera to save pictures directly to a computer using appropriate Nikon software).

- *Release locked* (default) The shutter will not operate if a memory card is not installed.
- *Enable release* The shutter release will operate normally even with no memory card installed in the camera. The photograph is displayed on the LCD monitor but the image data is NOT saved.

Hint: Leave this option set to *Release lock* (default). Otherwise it will appear to be operating normally but no pictures will be recorded and saved!

CS-07 Image Review

The D40x can display a picture on its LCD monitor almost as soon as an exposure is made.

- On (default) Pictures are shown almost immediately on the LCD monitor after an exposure is made.
- Off Pictures are not displayed on the LCD monitor after an exposure is made.

Hint: I suggest you set this option to *On* unless you need to conserve battery power. Displaying the picture acts as confirmation that an exposure has been made. You can also show the histogram at the same time by selecting the appropriate Photo Information page. As soon as you have finished looking at the picture/histogram, you can switch the monitor off by lightly pressing the shutter release button.

CS-08 Flash Compensation (P, S, A, and M modes only)

The amount of light output by the built-in Speedlight (flash) or a compatible external Speedlight can be adjusted (compensated) in a range from -3EV to +1EV in steps of 1/3EV.

Hint: If you set a flash output compensation level, it will remain locked until you restore the value to 0.0 (default), even if the camera is powered off and then on again.

CS-09 AF-Assist

The AF-assist lamp will light automatically when the camera determines that light levels are low and there is a risk that the AF system will not be able to acquire focus. However, there are limitations depending on the type of lens in use; AF-assist is only effective with focal lengths between 24 and 200mm, and any lens hood should be removed. Plus it has a maximum effective range of only 9 feet 10 inches (3 m).

- On (default) AF-assist lamp will light automatically in AF-S, or when AF-S is selected in AF-A.
- Off The lamp will not operate regardless of the ambient light conditions.

Hint: I prefer to keep this set to *Off*. Not only does using the lamp drain the battery, it is often a distraction to the subject. In addition, its limited range means it is of no value with many of the subjects I shoot!

Note: AF-assist is not available in a or exposure modes

CS-10 ISO Auto

This function is available in P, S, A, and M modes only. The camera will automatically shift the ISO sensitivity if an optimal exposure cannot be made at the selected value. Although the camera displays "ISO-AUTO" in the control panel and the viewfinder when this option is selected, and this icon flashes as a warning when the camera has changed the ISO value, there is no indication as to what ISO setting is in use without opening Shooting Data Page 2 of Photo Information (Playback mode). The ISO value is displayed in red if it has been altered by the camera. The operation of this function is also dependent on the exposure mode you select.

- Off (default) The camera retains the ISO (sensitivity) setting selected by the user and will not change it.
- On Assuming certain exposure conditions prevail, the camera will alter the ISO setting to compensate if an optimal exposure cannot be made (the flash output is adjusted appropriately). The maximum ISO setting can be set by selecting *Max. sensitivity*. In P and A exposure modes, the sensitivity is only adjusted if underexposure would occur at the lowest shutter speed selected by the user at the *Min. shutter speed* option.

Hint: I suggest turning this function *Off* if you want to be sure of the exact sensitivity level used in order to control ISO noise.

CS-11 Fn Button

The Fn button can be set to offer a quick and convenient way to activate several different camera functions.

- *Self-timer* (default) Press the Fn button to set Self-timer operation (the delay is determined by the setting selected at CS-16) in the Shooting Information Display, and press the shutter release to start the function.
- Shooting mode Press the Fn button to highlight the Shooting mode setting in the Shooting Information Display, and rotate the command dial to adjust it.
- Image Quality/Size Press the Fn button to highlight the image quality and image size settings in the Shooting Information Display, and rotate the command dial to adjust them.
- *ISO sensitivity* Press the Fn button to highlight the ISO setting in the Shooting Information Display, and rotate the command dial to adjust it.
- White balance Press the Fn button to highlight the white balance setting in the Shooting Information Display, and rotate the command dial to adjust it (P, A, S, and M exposure modes only).

Hint: Selection of the Fn button operation will depend on the shooting situation and specific user requirements. For what it is worth, I generally select either ISO sensitivity or White balance when shooting in available light.

CS-12 AE-L/AF-L

This item assigns a variety of functions to the B AE-L/AF-L button.

 AE/AF lock (default) – The exposure value and autofocus are locked when the button is pressed and held down.

- AE lock only The exposure value is locked but autofocus continues to operate when the button is pressed and held down. This may be the most useful option because you can take a reading from a specific area, lock it, and then re-compose before releasing the shutter.
- *AF lock only* Autofocus is locked but exposure value can continue to be altered when the button is pressed and held down. This can be useful when you know where the subject is going to be but want autoexposure to operate right up to the moment you make the exposure.
- *AE Lock hold* Exposure value is locked when the button is pressed and remains locked until it is pressed again.
- AF-ON Camera will only autofocus when the button is pressed; pressing the shutter release button will not activate autofocus. AF-ON has two distinct ways of being used. First, it can be considered an extension of the AF lock feature, where pressing the button in AF-S mode operates the autofocus system using the active focus sensing area without having to press the shutter release button. You can recompose the shot as many times as you wish before releasing the shutter if you continue to hold down the AE-L/AF-L button. Alternatively, this option can be used to perform the trap focus technique (see page 139 for details).

CS-13 AE Lock

This option determines if the D40x locks an autoexposure value when the shutter button is pressed halfway down.

- Off (default) The exposure is not locked when you press the shutter release button half way.
- On The exposure value is locked when the shutter release button is pressed halfway (P, S, A, and Digital Vari-Program modes)

You can lock focus and then recompose if you wish to place the subject outside the coverage of the three focus area sensors.

Hint: I set this option to *On* since I find it far simpler and quicker to lock exposure using the shutter release button.

CS-14 Built-in Flash

This option sets the flash mode for the built-in Speedlight when using P, S, A, and M exposure modes. It does not affect external Speedlight units (other than the SB-400).

- *TTL* (default) The built-in flash operates in the i-TTL mode for fully automatic control of flash output and always emits monitor pre-flashes.
- *Manual* The flash output is fixed at a predetermined level selected from options in this item. The flashes in the Shooting Information Display and viewfinder when this option is selected.

Hint: You will probably want to select TTL when using either the built-in Speedlight or optional external Speedlights (currently only the SB-800, SB600, SB-400, and SB-R200 units are compatible; the SB-R200 requires either an SB-800 or SU-800 as a commander unit). This option offers the most sophisticated level of TTL flash exposure control.

CS-15 Auto Off Timers

This option sets the duration of display on the LCD monitor and of the TTL metering display in the viewfinder, assuming no other function/action is activated that would otherwise turn it off.

- Short The monitor and exposure meters remain on for 4 seconds. If *Image review* (CS-07) is *On*, the picture is displayed for 4 seconds after the exposure is made.
- Normal (default) The monitor and exposure meters remain on for 8 seconds. If *Image review* (CS-07) is *On*, the picture is displayed for 4 seconds after the exposure is made.
- Long The monitor remains on for 20 seconds; the exposure meters remain on for 1 minute. If *Image review* (CS-07) is *On*, the picture is displayed for 20 seconds after the exposure is made.
- *Custom* The display duration for monitor and image review can be chosen from *4s, 8s, 20s, 1 minute,* and *10 minutes.* The exposure meter display duration can be set to *4s, 8s, 20s, 1 minute,* and *30 minutes.*

Hint: I recommend selecting shorter durations because the monitor consumes a relatively high level of power. Remember, you can always switch off the monitor display by pressing the shutter release button halfway down.

Note: If you connect the D40x to the Nikon EH-5 AC adapter via the EP-5 adapter connector, the displays do not turn off automatically. This cannot be altered.

CS-16 Self-Timer (Delay of Self-Timer Operation)

When using Self-timer, this setting lets you select several different durations for the delay between the time you press the shutter release and when the exposure is made. The options are:

• 2s (two seconds), 5s (five seconds), 10s (ten seconds, default), and 20s (twenty seconds).

Hint: A delay of 2 seconds is ideal for releasing the shutter when you want to minimize camera vibration caused by touching it. The ML-L3 remote release is probably a more practical option since you do not need to press the camera's shutter release button to initiate the shutter action and the timing of its release can be controlled with precision. This also allows you to release the shutter some distance from the camera.

CS-17 Remote on Duration

This option allows you to determine the duration in which the D40x can receive the infrared (IR) control signal from the ML-L3 remote control before it automatically cancels the remote release function. The setting options are:

• 1 min (default), 5 min, 10 min, and 15 min.

Hint: The camera draws more power than usual when it remains active awaiting the IR signal. Therefore I recommend you set the shortest duration possible, based on the shooting conditions.

Press the AE-L/AF-L button when reviewing single images or thumbnails to protect photos from being inadvertently deleted during playback.

Playback Menu

The following items are displayed in the Playback menu. If the installed memory card contains no pictures, all items except *Playback folder* and *Rotate tall* will be gray. You can use the *My menu* option, selected under the *CSM/Setup menu* item of the Setup menu, to select the Playback menu items you want to display.

Delete

You can choose to erase individual images, a group of images, or all of the images on the card by using this function. To delete images one by one, it is quicker and easier to use the button on the rear of the camera. However, to erase a group of images, the *Delete* function in the Playback menu will probably save you a lot of time (and button pushing!).

To delete a group of images:

- 1. Select *Delete* from the Playback menu and press the multi selector to the right.
- 2. Highlight *Selected* and press the multi selector to the right.
- 3. Thumbnails of all of the images stored in the active folder will be displayed on the LCD monitor. Scroll through the images by pressing the multi selector to the left or right; a yellow border is shown around the selected image. To see an enlarged view of the selected image, press the S button.
- 4. To select the highlighted image for deletion, press the multi selector up or down. A small icon of a trashcan will appear in the upper right corner of the thumbnail image.
- 6. The total number of images to be deleted will be displayed, along with two options: *No* or *Yes*. Select the require option and press the button to either complete (Yes), or cancel (No) the delete process.

Note: If *All* is selected from the *Playback folder* item (see below), you can view all images stored in all folders on the memory card, not just those in the active folder.

To delete all images:

- 1. Select *Delete* from the Playback menu and press the multi selector to the right.
- 2. Select *All* and press the multi selector to the right: A warning appears, "All images will be deleted. OK?"
- 3. Highlight either Yes or No.
- 4. Once you have selected the desired option, press the button to either complete (Yes), or cancel (No) the delete process.

Note: This process cannot delete pictures that have been protected. Images that have been hidden will not be displayed, and therefore cannot be selected for deletion.

Hint: It can take a long time (up to 30 minutes) to delete a high volume of pictures. To save draining the camera battery and placing additional wear and tear on your D40x, when erasing a large quantity of files it is probably better to connect your memory card to a computer (using a card reader) and use the computer to carry out the deletion process.

Playback Folder

This option allows you to determine which images on the installed memory card will be displayed during playback. There are two options available:

- *Current* (default) Only the images in the folder currently set for image storage, via the *Folders* option in the Setup menu, will be displayed during playback.
- *All* All of the images stored on the card are displayed, regardless of which folder they are stored in.

To apply the Playback folder:

- 1. Select *Playback folder* from the Playback menu and press the multi selector to the right.
- 2. Highlight the desired option: Current or All
- 3. Press 💿 button to confirm your selection.

Rotate Tall

Use this option to automatically turn pictures taken in the vertical (portrait) format and display them on the LCD in their proper orientation. The *Auto image rotation* option in the Setup menu must be turned on for the *Rotate tall* function to operate, otherwise all images will be displayed in a horizontal (landscape) orientation regardless of the camera orientation at the time of exposure.

To set Rotate tall:

- 1. Select *Rotate tall* from the Playback menu and press the multi selector to the right.
- 2. Highlight On or Off.
- 3. Press 🚳 button to confirm your selection.

Hint: You will probably prefer to leave this feature switched *Off*, since rotating an image to a vertical orientation for display on the monitor screen will decrease the overall size of the image by about 1/3.

Slide Show

The *Slide show* option lets you view all of the images stored on the camera's memory card in sequential order. This can be a useful and enjoyable feature, especially if the camera is connected to a television for viewing.

To use Slide show:

- 1. Select *Slide show* from the Playback menu and press the multi selector to the right.
- 2. *Start* will be highlighted; to begin the slide show immediately, press the button (images will be displayed for approximately two seconds).
- 3. To pause the slideshow, press the button again. This displays a sub-menu of *Restart, Frame interval* (you can choose a duration of either 2, 3, 5, or 10 seconds), and *Exit* to stop the slide show.

Print Set (DPOF)

The *Print Set* option enables the user to create and save a set of images to be printed automatically by a compatible printing device. This "print order" will communicate which images should be printed, how many prints of each image, and the information that is to be included on each print. This information is saved on the installed memory card, in the Digital Print Order Format (DPOF), to be read subsequently by DPOF compatible printing device. See pages 263-264 for more details.

Nikon Flash Photography

Before we take a look at the flash capabilities for the D40x it is important to understand a few basic principles of flash photography. Light from a flash unit decreases in intensity as it travels away from its source, as described by the Inverse Square Law. Put simply, if you double the distance from a light source the intensity of light drops by a factor of four. This is because light spreads out as it travels away from its source; so if the distance is doubled, the area covered is four times larger. Since a flash unit emits a precise amount of light, it will only light a subject correctly at a specific distance depending on the flash unit's intensity. Consequently, if the flash exposes the subject correctly at a given distance, then anything closer to the flash will be overexposed, and anything further away will be increasingly underexposed. Also, to produce a balanced exposure between the subject and its surroundings you will want to balance the light from the flash with the ambient light.

When the D40x's built-in Speedlight (or an external Speedlight SB-400, SB-600, or SB-800) is used with a D-type or G-type Nikkor lens, and the camera is set to Matrix metering, 3D Multi-sensor Balanced Fill-flash is active. In this mode, the camera attempts to balance ambient light with the flash output. The system used in the D40x is Nikon's third generation of TTL flash exposure control, which is known as i-TTL (intelligent TTL). This is Nikon's most sophisticated flash exposure control system to date. It is part of a wider set of flash features and functions that Nikon refers as the Creative Lighting System (CLS).

An SB-600 flash unit was used off-camera with an SC-28 TTL flash cord. The flash was held below the camera—to the right—in order to provide a directional light that cast precisely positioned, well defined shadows. **Note:** Currently the internal Speedlight of the D200, D80, D70-series, D50, D40x, D40, and the SB-800, SB-600, SB-400, and SB-R200 external Speedlights are the only Nikon flash units to support CLS. If any other external Nikon Speedlight is attached to the D40x, TTL flash exposure control will not be supported.

The Creative Lighting System

During 2003 Nikon raised the bar a considerable distance for photography with portable, camera mounted, flash units by introducing the SB-800 Speedlight and D2H digital SLR camera, the first two components of their Creative Lighting System (CLS). The CLS encompasses a range of features and functions that are as much a part of the cameras that support it, as the Speedlight units themselves. These features include: i-TTL, Advanced Wireless Lighting for wireless TTL control of multiple compatible Speedlights, Flash Value (FV) Lock, Flash Color Information Communication, Auto FP High-Speed Sync, and Wide-Area AF-Assist Illuminator. However, the D40x does not support the Auto FP High-Speed Sync, or FV Lock feature; its built-in Speedlight does not support the Advanced Wireless Lighting control.

i-TTL (Intelligent TTL) Flash Exposure Control

Nikon's most recent TTL flash exposure control system, i-TTL uses only one or two pre-flash pulses that have a shorter duration and slightly higher intensity than those used for the TTL and D-TTL system used in previous Nikon cameras and Speedlights. Currently, the D40x supports i-TTL with compatible Speedlights (its built-in Speedlight, SB-800, SB-600, SB-400) at sensitivity settings between ISO 100 and ISO 1600. The SB-400 is not compatible with wireless TTL control; it is a basic unit capable of TTL or manual flash exposure control when used with the D40x.

Note: Due to its design, the SB-R200 cannot be mounted on the accessory shoe of the D40x; it can be used only as a remote flash, controlled wirelessly by either the SU-800 Commander unit or an SB-800 Speedlight. The built-in Speedlight of the D40x does not support wireless control of remote CLS Speedlights.

There are several key differences between the i-TTL system and the earlier TTL and D-TTL systems. When shooting with the flash units listed above and the D40x these include:

- i-TTL uses fewer monitor pre-flashes but they have a slightly higher intensity. The greater intensity of the pre-flash pulses improves the efficiency of obtaining a measurement from the TTL flash sensor, and by using fewer pulses the amount of time taken to perform the assessment is reduced.
- The D40x uses its 420-pixel RGB sensor to measure and control the output of flash, regardless of whether you use a single Speedlight attached to the camera (directly, or via a dedicated TTL flash cord such as the SC-28), or the appropriate multiple Speedlights in a wireless TTL configuration.
- Monitor pre-flashes are always emitted before the reflex mirror is raised regardless of whether the camera is used with one or more compatible Speedlights; if you look carefully you can often observe the pre-flash emission a fraction of a second before the viewfinder blacks because the reflex mirror is raised.

The following is a summary of the sequence of events used to calculate flash exposure in the D40x, when used with a single or multiple compatible Speedlights (the built-in unit, SB-800, SB-600, SB-400, or SB-R200) and a D-type or G-type Nikkor lens:

1. Once the shutter release is pressed the camera reads the focus distance from the D-type or G-type lens.

- 2. The camera sends a signal to the Speedlight to initiate pre-flash; the system emits one or two pulses of light from the Speedlight(s).
- 3. The light from these pre flashes is bounced back from the scene, through the lens on to the 420-pixel RGB sensor housed in the camera's viewfinder head, via the reflex mirror.
- 4. The information attained from the pre-flash analysis is combined with ambient light and focus readings from the 420-pixel sensor. The camera's microprocessors determine the amount of light needed from the Speedlight(s) and set the duration of the flash discharge accordingly.
- 5. The reflex mirror lifts up out of the light path and the shutter opens.
- 6. The camera sends a signal to the Speedlight(s) to initiate the main flash discharge, which is quenched the instant the amount of light pre-determined in Step 4 has been emitted.
- 7. The shutter closes at the end of the predetermined time duration, and the reflex mirror is lowered to its normal position.

Note: The emission of pre-flashes occurs before the reflex mirror is raised. In some shooting situations, because of the slight delay between the mirror being raised and the shutter opening, photographers may fail to see a subject's blink reflex caused by the firing of preflashes.

Note: The SB-400 does not support the Advanced Wireless Lighting system that provides wireless control of control multiple Speedlights using i-TTL flash exposure control.

Flash Output Assessment

The crucial phase in the sequence is step 4 (above), when the output from the flash is calculated. I understand from Nikon technicians and engineers that, in Matrix metering mode, three distinct elements are considered during this process:

- Brightness In Matrix metering mode the camera will assess the overall level of brightness, using its 420-pixel RGB sensor.
- Contrast The camera compares the relative brightness of each pixel in its 420-pixel RGB sensor. The camera is preprogrammed to recognize specific lighting patterns across the metering segment array. For example, outer segments that detect a high level of brightness and a central segment with a lower level of brightness indicate a strongly backlit subject in the center of the frame.

The camera then compares the detected pattern with patterns pre-stored in its database of example exposures. If the first comparison generates conflicting assessments the segment pattern maybe re-configured and further analysis is performed. Finally, if any segment detects an abnormally high level of brightness in comparison to the others (as might occur if a highly reflective surface such as glass or a mirror caused a specular reflection in part of the scene), the camera will usually ignore this information in its flash exposure calculations.

• Focus Information – This is provided in two forms: camera-to-subject distance, and the level of focus/defocus at each focus sensor. The D40x uses this focus information to assess how far away the subject is likely to be and its approximate location within the frame area.

Generally, the focus-distance information will influence which segment(s) of the Matrix metering sensor contribute to overall exposure calculations. For example, assuming the

A single on-camera SB-600 Speedlight was used to light this shot; the flash was bounced from a white ceiling, while a small reflector below the subject reflected some light to fill the shadow areas.

subject is positioned in the center of the frame and the lens is focused at a short range, the camera will place more emphasis on the outer metering segments and less on the central ones. An exception to this occurs if the camera detects a very high level of contrast between the central and outer sensors it may, and often does, reverse the emphasis, weighting the exposure according to the information received from the central sensors. Conversely, if the subject is positioned in the center of the frame and the lens is focused at a mid to long range, the camera will place more emphasis on the central metering segments and less on the outer ones. Essentially what the camera is trying to do in both cases is prevent over exposure of the subject, which it assumes is in the center of the frame.

Note: To provide focus-distance information, a D-type or G-type Nikkor lens must be mounted on the camera.

Individual focus sensor information is integrated with focus-distance information, as each AF sensor is checked for its degree of focus. This provides the camera with information about the probable location of the subject within the frame area. Using the examples given in the previous paragraph the camera notes that the central AF sensor has acquired focus while the two outer AF sensors report defocus. Therefore exposure is calculated on the assumption that the subject is in the center of the frame and the camera biases its computations according to the focus-distance information it receives from the lens.

However it is important to understand that other twists occur in the interaction between exposure calculation and focus information. For example, if you acquire and lock focus on a subject using the center AF sensor and then recompose the shot so that the subject is located elsewhere in the frame (so the central AF sensor no longer detects focus), the camera will, generally, use the exposure value it calculated when it first acquired focus. However, if it detects that the level of brightness measured by the central metering segment has consequently changed significantly from the point when focus was acquired with the subject in the center of the frame the camera can, and often does adjust its exposure calculations but not necessarily for the better!

The Built-In Speedlight

The D40x's build-in Speedlight (Nikon's proprietary name for its flash units) has a Guide Number 39 in feet (12 in meters) at ISO100 (manual flash - Guide Number 42/13). It can synchronize with the shutter at speeds up to 1/200 second. It has a minimum range of 2 ft (.6 m), the flash/camera will not necessarily calculate a correct flash exposure if the subject is closer than this minimum.

If the D40x determines that the ambient light level is low, or the subject is backlit strongly, the built-in Speedlight is raised automatically in the $\overset{\text{WO}}{\longrightarrow}$, $\overset{\text{Z}}{\swarrow}$, $\overset{\text{Q}}{\clubsuit}$, $\overset{\text{W}}{\longrightarrow}$, and

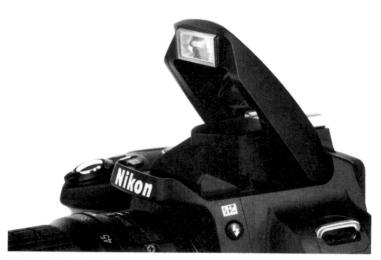

The built-in Speedlight of the D40 has a Guide Number of 39 feet (12m) at ISO 100 for automatic flash.

Digital Vari-program modes; however, it is not available in (2), or (4) DVP modes. In P, S, A, and M exposure modes it must be activated manually by pressing the (5) button, which causes the flash head to pop up.

The built-in Speedlight draws its power from the camera's main battery, so extended use of the flash will shorten battery life. As soon as the flash unit pops up it begins to charge. The flash ready symbol appears in the viewfinder to indicate charging is complete and the flash is ready to fire. If the flash fires at its maximum output, the same flash ready symbol will blink for approximately three seconds after the exposure has been made, as a warning of potential underexposure. This flash ready symbol operates in the same way when an external Speedlight is attached and switched on.

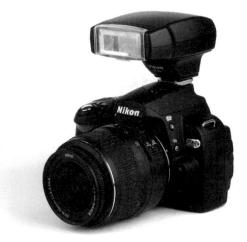

The D40x with SB-400 Speedlight

External Speedlights

In addition to the built-in Speedlight, the D40x offers full i-TTL flash exposure control with three external Speedlights that are compatible with the CLS:

- SB-400 Guide number 69/21 (ISO100, ft/m, 18mm)
- *SB-600* Guide number 98/30 (ISO100, ft/m, 35mm)
- SB-800 Guide number 125/38 (ISO100, ft/m, 35mm)

All three models can be mounted to the camera's flash shoe, or connected via a dedicated TTL remote flash cord, such as the SC-28 or SC-29.

Note: The D40x does not support TTL flash exposure control with any other Nikon shoe-mounted Speedlight. The SB-R200 can only be controlled as part of a wireless flash system using either the SB-800 or SU-800 as a Commander Unit.

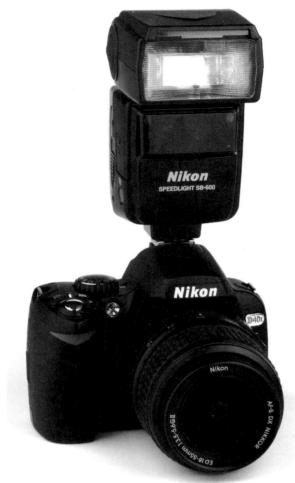

The D40x with SB-600 Speedlight.

SB-400

Weighing 4.5 oz. (127 g), this lightweight Speedlight is fully compatible with the D40x's i-TTL flash exposure control system. It offers a fixed angle of coverage equivalent to that of a focal length of 18mm (when used on the D40x with its DX-

format sensor), and the flash head can be tilted in four positions: horizontal, 60, 75, and 90 degrees for bounce flash. However, the flash head does not swivel.

Used with the D40x the SB-400 supports the following flash sync modes: Slow Sync, Red-eye reduction, Red-eye reduction with Slow sync, Rear-curtain sync; plus manual flash exposure control, which is set from the camera, via CS-14.

SB-600 and SB-800

Aside from being more powerful, the SB-600 and SB-800 Speedlights are considerably more versatile than the built-in flash on the D40x, or the SB-400, since their flash heads can be tilted and swiveled for bounce flash. They also have an adjustable auto zoom-head (SB-800, 24-105mm) (SB-600, 24-85mm) that controls the angle-of-coverage of the flash discharge, and a wide-angle diffuser for a focal length of 14mm.

Note: Unlike earlier Nikon Speedlights, which cancelled monitor pre-flashes if the flash head was tilted or swiveled for bounce flash photography, the SB-800 and SB-600 emit pre-flashes regardless of the flash head position.

Hint: The focal lengths used by the SB-600 and SB-800 Speedlights in their zoom heads assume the units are used with film cameras, and not digital SLRs, such as the D40x with its reduced angle-of-view due to the smaller size of the DX sensor. Therefore, the flash will illuminate a greater area than is necessary when used on the D40x, which means you will be restricting your shooting range and squandering flash power. Use the following table to maximize the performance of an external Speedlight on the D40x:

Zoom head position (mm)
20
24
28
35
50
50
70
85
105 1

1. Available on SB-800 only.

TTL Flash Modes (Built-In and External Speedlights)

The D40x supports the following methods of i-TTL flash exposure control with either its built-in Speedlight or a compatible external Speedlight.

i-TTL 3D Automatic Balanced Fill-flash – the most sophisticated of Nikon's i-TTL flash exposure control, it is only available when a D-type or G-type lens is mounted on the D40x. The camera considers the following factors when calculating the required flash output: focus-distance information from the lens (hence the "3D" designation), information from the camera's TTL light metering system, and information from the monitor pre-flashes that were emitted immediately prior to the exposure. This system is particularly effective at detecting instances when the background is abnormally light (e.g. sky) or dark (e.g. dimly lit interior), or there are highly reflective surfaces in the scene (e.g. glass or a mirror), and generally does not consider these in flash exposure computations, as normally such factors would have an adverse effect on exposure accuracy.

- *i-TTL Automatic Balanced Fill-flash* essentially the same as 3D Multi-sensor Balance Fill-flash except focus-distance information is not taken in to consideration during flash exposure calculations. However, the icons displayed on Nikon Speedlights to indicate you are in either 3D Automatic Balance Fill-flash or Automatic Balanced Fill-flash are identical! The only way to determine which mode the camera/flash is using to calculate flash exposure is to be aware of which mode is supported by the camera with which lenses. For example, if you mount a non D-type or non G-type lens to the D40x, flash exposure control will default to Automatic Balanced Fill-flash.
- Standard i-TTL Flash this differs from the automatic balanced flash control methods described above because the 420-pixel sensor determines the output of the flash independently from any measurement of the ambient light performed by the camera's TTL metering system; the camera treats the two values as mutually exclusive to ensure the flash exposure for the subject is correct, regardless of background brightness.

Note: Standard i-TTL Flash has very important implications when mixing ambient light with light from a Speedlight for the fill-flash technique, as any compensation factor selected for either the ambient exposure, the flash exposure, or both will be applied at the level pre-determined by the photographer. In either of the Automatic Balanced Fill-flash options the camera can, and often does, override any flash output compensation applied, which makes achieving consistent, repeatable results impossible (see page 226).

Note: Selecting spot metering on the D40x will cause the flash exposure system to default to Standard i-TTL flash. Standard i-TTL flash control can also be selected on compatible external Speedlights.

Nikon Flash Terminology

Many photographers fail to understand how their choice of exposure mode can affect the appearance of a photograph made with a mix of ambient light and flash. All too often they assume that because the camera is performing Automatic Balanced Fill-flash that both the subject and background will be rendered properly. Their frustration deepens when they realize that any exposure compensation factor that they apply on the camera, Speedlight, or both, is often either overridden, or ignored completely!

So what is going on? The first clue to this conundrum is quite obvious – read the title again – Automatic Balanced Fill-flash.

The photographer is not in control here – it is the camera that is responsible for all exposure decisions in the Automatic Balanced Fill-flash options when the camera is set to any of the automatic exposure modes (P, A, and S), and all flash exposure decisions in the Balanced Fill-flash options when the camera is set to Manual exposure mode.

Furthermore, if you select P, A, or one of the DVP modes that supports use of flash, the available range of shutter speeds is restricted (see the table, below). If the level of ambient light requires a shutter speed outside of this range, as is usually the case when shooting in low-light conditions such as a dimly lit interior, the areas of the scene lit predominantly by ambient light will be underexposed.

Exposure Mode	Flash Sync Shutter Speed range				
P, A, 🏜 💈 🔮	1/200 – 1/60 second				
*	1/200 – 1/125 second				
2 *	1/200 – 1s				
S, M	1/200 – 30s				

An SB-400 was used off camera with an SC-28 TTL flash cord to maintain full TTL control from the camera for fill flash.

Hint: If you use any exposure modes, other than S and M, with flash consider setting Slow sync flash mode (do not confuse this with Rear-curtain sync mode) as it overrides this restriction on shutter speed range, and allows the full range of speeds available on the camera, between the maximum flash sync speed and the slowest shutter speed to be used, so areas lit by ambient light appear more balanced with those lit by flash.

The second clue is the word Balanced, which means that the camera uses its TTL metering system to measure both ambient light, and measure flash output to combine these to create a "balanced" exposure from both light sources. For example, a background lit by ambient light and a subject in the foreground lit by the flash is each exposed at a similar level. The camera achieves this more often than not by compensating the exposure for either the ambient light, the flash, or sometimes both. As mentioned above any exposure compensation factor applied by the photographer is frequently overridden or even ignored, because in all the Automatic Balanced Fill-flash options the camera and flash operate automatically, which makes consistent repeatable results difficult to accomplish.

The third part of this generic term Automatic Balanced Fill-flash just serves to confuse users even further! Fill-flash is a recognized lighting technique in which the flash is used to supplement the main ambient light source, and as such its output is always set at a level below that of the ambient light. Generally, the purpose of this fill light from the flash is to provide additional illumination in the shadows, and other less well-lit areas of a scene to help reduce the overall contrast range, although many photographers also use the technique to put a small catch light in their subject's eyes.

Nikon's use of the term fill-flash is misleading in the context of the title Automatic Balanced Fill-flash: first, depending on the prevailing light conditions, generally when the level of ambient light is very low, using one of the Automatic Balanced Fill-flash options will often cause the Speedlight to become the principal light source for illuminating the scene, and second, as discussed above balanced implies that the exposure for the ambient light and flash comprise equal proportions.

Note: Whenever you see the term Automatic Balanced Fillflash remember that existing ambient light and flash will be mixed to produce the final exposure; how the two light sources are mixed and in what proportion will depend on the combination of camera, lens, exposure mode, and selected flash exposure control option. In my opinion a more accurate term for this system would be Automatic Balanced Flash.

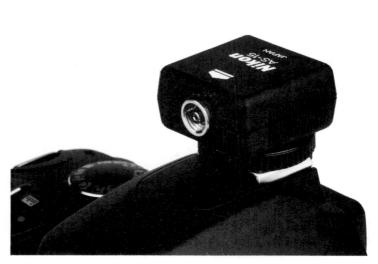

The D40x lacks a standard PC flash sync terminal; the AS-15 adapter that attaches to the hot shoe provides one.

Non-TTL Flash Modes (SB-800 Speedlight Only)

When using the SB-800 external Speedlight with the D40x there are two additional non-TTL flash modes available.

• (AA) Auto Aperture – With the flash in AA mode and the D40x set to A or M camera exposure modes, the SB-800 reads the sensitivity (ISO) setting and lens aperture from the D40x automatically. The system uses a sensor on the front panel of the Speedlight to control the flash exposure, and as soon as this sensor detects that the flash output is sufficient, the flash pulse is quenched. If you decide to alter the focal length of the lens, or change the lens aperture the Speedlight will adjust its output accordingly to maintain a correct flash exposure. The problem with this option is that the sensor does not necessarily "see" the same scene as the lens, nor does it use any interpretation of scenic data, which can lead to inaccuracies in flash exposure.

• (A) Automatic (non-TTL) – this is the only automatic (non-TTL) flash mode available with earlier DX-type, and non-DX type Speedlights. This mode is also offered on the SB-800. It can be used in A and M exposure modes. This is similar to the AA mode in which a sensor of the front of the SB-800 monitors flash levels and shuts of the flash when the Speedlight calculates that sufficient light has been emitted. However, the lens aperture and sensitivity (ISO) values must be set manually on the Speedlight to ensure the subject is within the flash shooting range. As with the AA mode, the sensor does not necessarily "see" the same scene as the lens, which can lead to inaccuracies in flash exposure.

Manual Flash Mode

In Manual flash mode the user sets the output of the Speedlight (built-in or external) to a fixed level. It is necessary to calculate the correct lens aperture based on the flash to subject distance and the Guide Number (GN) of the Speedlight.

At its base sensitivity of ISO 100 (equivalent) the built-in Speedlight of the D40x has a Guide Number (GN) of 42 ft (13 m). The output level of the built-in Speedlight and SB-400 is set in CS-14, where a value between 1/1 and 1/32 can be selected (available in P, S, A, and M exposure modes only).

Since there is only one specific exposure value for any given level of sensitivity at a particular flash-to-subject distance, it is necessary to calculate the lens aperture required to record a proper exposure. Use the following equation:

Aperture = GN/Distance

So for example using the built-in Speedlight of the D40x set to its full output (1/1), and at a shooting distance of exactly 7.5 ft, the lens aperture for a correct exposure of the subject will be f/5.6. (5.6 = 42/7.5).

Note: Similar calculations will have to be performed when using an external Speedlight in manual flash mode. Check the Guide Number for the Speedlight model and ensure that you conduct the calculations using the same measuring system (feet or meters) throughout.

Flash Sync Modes

Not to be confused with Flash Modes available with the D40x, described above, the Flash Sync (synchronization) Modes determine when the flash is fired and how it combines with the shutter speed. These apply to the built-in Speedlight, and the compatible external Speedlights.

To set a flash sync mode on the D40x press the button to open the shooting information display then press the button; use the multi selector button to highlight the Flash mode option. Press the button to display the list of options indicated by the relevant icons and thumbnail "assist images." Use the multi selector button to highlight the required option. Finally, press the button to confirm your selection; the new Flash mode is displayed in the shooting information display.

Alternatively, press and hold the O button, to show the Shooting Information Display and highlight the flash mode currently set; rotate the command dial to scroll through the various options until the icon for the desired flash sync mode appears. Release the O button to confirm the selection.

Flash Sync in P, S, A, and M Modes

Front-curtain sync – the flash fires as soon as the shutter has fully opened. In P and A exposure modes the flash will sync with a shutter speed between 1/60 and 1/200 second. In S and M exposure modes the Speedlight synchronizes at shutter speeds between 1/200 second and 30 seconds. **4 (***Front-curtain sync with red-eye reduction*) – the D40x uses the AF-assist lamp on the front right side of the camera body to light for approximately one second before the main exposure in an effort to reduce the size of a subject's pupils. Shutter speed synchronization is the same as for front –curtain sync.

Hint: This mode does cause an inordinate delay in the shutter's operation by which time the critical moment has generally passed and you have missed the shot! Personally, I never bother with this feature.

+ SLOW (*Slow sync*) – only available in P and A exposure modes—the flash fires as soon as the shutter has fully opened and at all shutter speeds between 30 seconds and 1/200 second. It is useful for recording low-level ambient light as well as those areas of the scene or subject illuminated by flash.

4 (D) + SLOW (*Slow sync with red eye reduction*) – same as Slow sync (above) except the Red-eye reduction lamp is switched on for approximately one second before the shutter opens for the reason stated above under Red-eye reduction.

Hint: The same advice applies - avoid this mode!

+ REAR (*Rear-curtain sync*) – In S and M exposure modes, the flash fires just before the shutter closes at all shutter speeds between 30 seconds and 1/200 second. Any image of a moving subject recorded by the ambient light exposure will appear to be behind (or to follow naturally) the parts of the subject illuminated by the flash output.

+ SLOW + REAR (*Slow Rear-curtain sync*) – in P and A camera exposure modes, the flash fires just before the shutter closes at all shutter speeds between 30 seconds and 1/200 second. Any image of a moving subject recorded by ambient the ambient light exposure will appear to be behind the parts of the subject illuminated by the flash output.

Flash Sync with Digital Vari-Program Modes

Using the built-in flash with the 32, 2, 32, 32, 33, and 12 Digital Vari-program modes provides the following flash sync modes:

4 + AUTO (*Auto Flash*) – In 2, 2, 2, 3modes only, the flash fires as soon as the shutter has fully opened; the camera selects a shutter speed between 1/60 and 1/200 second (1/125 – 1/200 second in 3 mode), automatically.

4 () + AUTO (Auto Flash with red-eye reduction) – In $\overset{\text{AUTO}}{\sim}$, \overset

+ AUTO + SLOW (*Auto Flash with Slow sync*) – In mode only, the flash fires as soon as the shutter has fully opened; the camera selects a shutter speed between 1 second and 1/200 second, automatically.

4 \bigcirc + AUTO + SLOW (*Auto Flash with Slow sync and red-eye reduction*) – In \boxdot only, the D40x uses the AF-assist lamp on the front right side of the camera body to light for approximately one second before the main exposure in an effort to reduce the size of a subject's pupils. Shutter speed synchronization is the same as for Auto flash with Slow sync.

(*Flash off*)– The flash will not operate even if the camera detects a low ambient light level, or the subject is backlit.

Note: If you attach an external Speedlight to the D40x when the camera is set to any of the Digital Vari-program mode options that support use of flash, except the mode, the only flash sync modes available are front-curtain sync, or front-curtain sync with red-eye reduction. If mode is selected the only flash sync modes available are Slow sync, or Slow sync with red-eye reduction.

Additional Flash Features and Functions

Flash Exposure Compensation

In P, S, A, and M exposure modes flash output compensation can be set on the D40x in increments of 1/3EV over a range of +1 to -3-stops via CS-08.

Tip: If you use the default i-TTL Balanced Fill-flash mode it will automatically set flash compensation based on scene brightness, contrast, focus distance, and a variety of other factors. The level of automatic adjustment applied by the D40x will often cancel out any compensation factor entered manually by the user. Since there is no way of telling what the camera is doing you will never have control of the flash exposure. To regain control set the flash mode to Standard i-TTL by selecting spot metering when using the built-in or an external Speedlight, or selecting Standard i-TTL mode directly on the external Speedlight (SB-800 and SB-600 only).

Flash Color Information Communication

The built-in Speedlight and external Speedlights (SB-800, SB-600, and SB-400) automatically transmit information about the color temperature of the light they emit to the camera. If the camera is set to automatic white balance control, this information is used to determine the white balance setting in an attempt to match the color temperature of the flash output to the color temperature of any ambient light.

Limitations of Using the Built-In Speedlight

While the built-in Speedlight of the D40x is not as powerful as an external Speedlight, it can still provide a useful level of illumination at short ranges, especially for the purpose of fill-flash, since it supports flash output level compensation. However, if you want to use this built-in Speedlight as the main light source you should be aware of the following:

• The built-in Speedlight of the D40x has an ISO 100 Guide Number (GN) of 39 ft (12 m). Thus, at an aperture of f/5.6

To provide a low level of fill-flash for this photo, the flash output compensation of an SB-600 was set to -2 EV.

this unit provides its full output at a range of little less than just 7.0 ft (2.1 m), as the maximum flash shooting distance is equal to the GN divided by the lens aperture.

- The flash head of the built-in Speedlight is much closer to the central lens axis than with an external flash; hence the likelihood of red-eye occurring is increased, significantly.
- Again, the proximity of the built-in Speedlight to the central lens axis often means that the lens obscures the output of the flash, especially if it has a lens hood fitted. If the camera is held in a horizontal orientation the obstruction of the light from the flash will cause a shadow to appear on the bottom edge of the picture.
- The angle of coverage achieved by the built-in Speedlight is limited, and only extends to cover the field of view of an 18mm lens. Using of a shorter focal length the flash

will not be able to illuminate the corners of the frame and these areas will appear underexposed. Even at the widest limit of coverage it is not uncommon to see a slight fall off of illumination in the extreme corners of the full frame.

Aperture, Sensitivity (ISO), and Flash Range

The flash shooting range of the built-in Speedlight will vary depending on the values set for the lens aperture and sensitivity (ISO).

A 100	perture a 200	at ISO E 400	quivalent 800	1600	feet	Range meters
f/1.4	f/2	f/2.8	f/4	f/5.6	3.25 - 24.50	1.0 - 7.5
f/2	f/2.8	f/4	f/5.6	f/8	2.33 - 7.75	0.7 - 5.4
f/2.8	f/4	f/5.6	f/8	f/11	2.00 - 12.50	0.6 - 3.8
f/4	f/5.6	f/8	f/11	f/16	2.00 - 8.85	0.6 - 2.7
f/5.6	f/8	f/11	f/16	f/22	2.00 - 6.25	0.6 - 1.9
f/8	f/11	f/16	f/22	f/32	2.00 - 4.50	0.6 - 1.4
f/11	f/16	f/22	f/32		2.00 - 2.92	0.6 - 0.9
f/16	f/22	f/32			2.00 - 2.33	0.6 -0.7

Note: Any flash unit places a high demand on the batteries used to power it; the built-in Speedlight draws its power from the camera's battery, so extended use will exhaust these batteries quite quickly.

Lens Compatibility with Built-In Speedlight

Due to the proximity of the built-in Speedlight to the central lens axis when the lenses mentioned in the table below are used at the focal lengths and shooting ranges given, there is a possibility that they will obscure some light from the flash, and cause uneven exposure.

Lens	Zoom Position	Min. Range				
		feet	meters			
12–24mm f/4G	20mm	9 ft 10 in	3.0			
ED-IF AF-S DX	24mm	3 ft 3 in	1.0			
17–35mm f/2.8D	24mm	6 ft 7 in	2.0			
ED-IF AF-S	28mm	3 ft 3 in	1.0			
	35mm	2 ft 3 in	0.6			
17–55mm f/2.8G	28mm	4 ft 11 in	1.5			
ED-IF AF-S DX	35mm	3 ft 3 in	1.0			
	45–55mm	2 ft 3 in	0.6			
18–35mm f/3.5-4.5D	24mm	3 ft 3 in	1.0			
ED-IF AF	28–35mm	2 ft 3 in	0.6			
18–70mm f/3.5-4.5G	18mm	3 ft 3 in	1.0			
ED-IF AF-S DX	24–70mm	2 ft 3 in	0.6			
20–35mm f/2.8D AF	24mm	8 ft 2 in	2.5			
	28mm	3 ft 3 in	1.0			
	35mm	2 ft 3 in	0.6			
24–120mm f/3.5-5.6G	24mm	3 ft 3 in	1.0			
ED-IF AF-S VR DX	28–120mm	2 ft 3 in	0.6			
28–70mm f/2.8D	35mm	4 ft 11 in	1.5			
ED-IF AF-S	50–70mm	2 ft 3 in	0.6			
200–400mm f/4G	250mm	8 ft 2 in	2.5			
ED-IF AF-S VR	300–400mm	6 ft 7 in	2.0			

Using a Single Speedlight Off-Camera with TTL Cord

When you work with a single external Speedlight it is often desirable to take the flash off the camera. Nikon produce a number of dedicated cords for this purpose: the SC-17 (now discontinued), SC-28, and SC-29. All three cords are 4.9 feet (1.5m) long: up to three, SC-17, or SC-28 cords can be connected together to extend the operating range away from the camera.

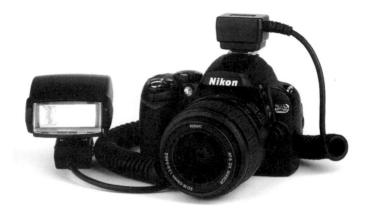

The SC-28 TTL flash cord allows you to take an external Speedlight off-camera but retain full control.

The benefits of taking a Speedlight off camera include:

- Increasing the angle between the central axis of the lens and the line between the flash head and a subject's eyes will reduce, significantly, the risk of the red-eye effect with humans, or eye-shine with other animals.
- In situations when it is not practical to use bounce flash, moving the flash off camera will usually improve the quality of the lighting. This is especially true for the degree of modeling the flash provides, compared with the rather typical flat, frontal lighting produced by a flash close to the central lens axis of the lens.
- By taking the flash off camera and directing the light from the Speedlight accordingly, it is often possible to control the position of shadows so that they become less distracting.
- When using fill-flash it is often desirable to direct light to a specific part of the scene to help reduce the level of contrast in that area.

Hint: Whenever you take a Speedlight off camera and use any flash mode that incorporates focus-distance information in the flash output computation, take care where you position the flash. If the Speedlight is located at a different distance from the subject than the camera, the accuracy of the flash exposure may be compromised. The TTL flash control system works on the assumption that the flash is located at the same distance from the subject as the camera.

Note: Compatible with either the SB-800, SB-600, or SB-400 Speedlights, the SC-29 has an AF-assist lamp in the terminal block that attaches to the camera accessory shoe; positioning an AF-assist lamp immediately above the central axis of the lens can help improve the accuracy of autofocus when using these Speedlights off the camera.

Note: An SB-800 Speedlight or SU-800 Commander unit connected to the D40x via one of Nikon's dedicated TTL cords can be used to control multiple, remote Speedlights, using the Advanced Wireless Lighting system.

For full details of Nikon's contemporary flash system, see my book, *Magic Lantern Guides: Nikon AF Speedlight Flash System*, published by Lark Books.

Nikon Lenses and Accessories

Nikon's F mount for its Nikkor lenses is legendary. It has been used on all its 35mm film and digital SLR cameras, virtually unchanged, since the introduction of the original Nikon F SLR in 1959. As such, a great many of the lenses produced by Nikon in over four decades can be mounted on the D40x. However, in a departure from previous designs, the D40x is the first Nikon AF camera that does not have a built-in motor for driving the focusing mechanism of autofocus lenses. Excluding this motor reduces the weight of the D40x by about one ounce (30 g), and enables the lens mount to be located closer to the base of the camera, helping to reduce the height of the camera body. Consequently, the D40x only supports autofocus with AF-S and AF-I Nikkor lenses (see page 53). Furthermore, the level of compatibility between the camera and lens is restricted severely if a non-CPU type lens (see page 238) is attached to the D40x.

DX-Format Sensor

All Nikon digital SLR cameras to date have the same size sensor, which Nikon calls the DX-format (often referred to as an APS-C sized sensor). At 15.6 x 23.7 mm (.61 x .93 inches), it is smaller than a 35mm film frame, which reduces the field-of-view seen by the D40x by about 1.5x compared with that seen by 35mm film camera.

Nikon produces a variety of lenses designed specifically for close-up and macro photography. However, not all offer support for AF when used with the D40x. This is rarely a problem though, as manual focus is more applicable for close-up and macro photography. The circle represents the total area covered by the image circle projected by a 35mm format lens. The pale grav rectangle is the image area for a 35mm film frame (24 x 36 mm), and the dark gray rectanale represents the area covered by the DX-format (15.6 x 23.7 mm) sensor used in the D40. (Diagram not shown to scale)

Some people state, erroneously, that the smaller size of the DX-format sensor creates a 1.5x magnification of the lens focal length compared with the same lens used on a 35mm film camera. But in fact, a lens with a focal length of 200mm used on a Nikon 35mm film camera still has the same focal length on the D40x-no ifs or buts! It is the fieldof-view that changes, decreased by about 1.5x (the actual factor is closer to 1.52x). In other words, the view seen through the camera with a DX-format sensor, such as the D40x, becomes narrower. If you where to shoot two pictures, one on a D40x and the other on a Nikon 35mm film body, mounted side-by-side pointing at exactly the same scene with the same focal length lens, and then cropped the film image to the same area as the sensor in the D40x, you would end up with identical pictures. The following table gives the approximate equivalent effective focal length in millimeters if the same focal length lens used on a 35mm format camera is mounted on a D40x.

Focal length with 35mm format	12	20	35	50	105	180	200	300	400	500
Equivalent focal length DX-format	18	30	53	75	158	270	300	450	600	750

There is a benefit to this reduced angle-of-view: Since the sensor of the D40x is only using the central portion of the total image projected by those lenses designed for 35mm format film cameras (see the diagram on preceding page), the effects of optical aberrations are kept to a minimum, as these are generally more prevalent toward the edge of the image circle. Using Nikkor lenses designed for 35mm film cameras on a digital camera can significantly reduce, if not eliminate, some or all of the following:

- Light fall-off toward the edge and corners of the image area (vignetting)
- · Vignetting with filters
- Chromatic aberration
- Linear distortion both barrel and pin-cushion
- Focus field at corners of frame being out of focus

Choosing a Lens

Nikon makes a wide range of lenses known by their propietary name, Nikkor. Wide-angle lenses offer a large field-ofview. Typically they are associated with landscape photography where they can capture a sweeping vista, but wideangles are great for many subjects. Their close-focusing ability, extended depth-of-field, and broad angle-of-view can be combined to create dynamic compositions, particularly if the subject is placed close to the lens so it dominates the foreground and is set against an expansive backdrop, accentuating the perspective between the two elements. Telephoto lenses provide a narrower angle-of-view and magnify a subject. These characteristics make them ideal for sport, action, and wildlife photography where it is usually difficult to be close to the subject. The optical effects of a telephoto can be used in many other areas of photography, such a portrait or landscape, because these lenses help isolate a subject from its background due to their limited depth-of-field and have a tendency to flatten perspective.

Zoom lenses allow you to adjust the focal length, the range of which can be exclusively wide-angle, telephoto, or span both. Speaking strictly, most modern lenses described as a zooms are in fact vari-focal lenses: a true zoom lens maintains focus as the focal length is changed. A varifocal will not have this ability and focus must be fine-tuned after zooming. However, whether a true zoom or not, this type of lens is extremely versatile, as you have several focal lengths available in one, which reduces the number of lenses you need to carry, and the need to spend time changing lenses. However, convenience comes at a price; many zoom lenses have smaller maximum apertures, often two-stops less than fixed focal-length types. This can be an issue when shooting in low light. Zoom lenses with large maximum apertures, such as f/2.8, tend to be expensive due to the complexity of their optical engineering. For general photography with the D40x, a couple of zoom lenses that cover focal lengths between 18mm and 200mm will handle most shooting situations; for the greatest level of compatibility and functionality you should use AF-S Nikkor lenses, either D-type or G-type (see descriptions pages 239-241).

Lens Compatibility

The D40x is the first Nikon autofocus SLR camera that does not have a built-in focusing motor; therefore, autofocus is supported only when either an AF-S or AF-I lens (identified as such on the lens barrel, and each of which has a built-in autofocus motor) is attached to the camera. Other AF Nikkor lenses that do not have a built-in focus motor can be used with the D40x, but focusing must be done manually. Nikon classifies all AF-S, AF-I, and AF Nikkor lenses, plus manual focus Ai-P Nikkor lenses, as CPU-type lenses. The lens and camera communicate exposure and focus data. These lenses can be identified by the electrical contact pins set around the edge of the lens mount bayonet flange.

The following table sets out the compatibility of the D40x with CPU-type Nikkor lenses:

Camera Setting		Focus		Mode	Metering	
Lens/Accessory	AF	MF (with electronic range finder)	MF	Digital Vari Program,	м	• 1
AF-S, AF-I Nikkor		•	•	•	•	•
PC-Micro Nikkor 85mm f/2.8D ²		• 3	•		•	•
AF-S/AF-I teleconverter ⁴		• 5	•	•	•	•
Other AF Nikkor (except lenses for F3AF		• 6	•	•	•	•
AI-P Nikkor		•7	•	•	•	•

- 1. Spot metering reads selected focus area.
- Camera exposure metering and flash control may not function when lens is shifted and/or tilted or aperture is not set at maximum.
- 3. Electronic rangefinder cannot be used when shifting or tilting lens.
- 4. Compatible with the following lenses:

 AF-S VR Micro ED: 105mm f/2.8G IF (autofocus not supported)

 AF-S VR ED: 70–200mm f/2.8G IF, 200mm f/2G IF, 300mm f/2.8G IF, 200–400mm f/4G IF

• AF-S ED: 80–200mm f/2.8D IF, 300mm f/2.8D II IF, 300mm f/2.8D IF, 300mm f/4D IF*, 400mm f/2.8D II IF, 400mm f/2.8D IF, 500mm f/4D II IF*, 500mm f/4/D IF*, 600mm f/4D II IF*, 600mm f/4D IF* •AF-I ED: 300mm f/2.8D IF, 400mm f/2.8D IF, 500mm f/4D IF*, 600mm f/4D IF*

- 5. With maximum effective aperture of f/5.6 or faster.
- If AF 80–200mm f/2.8 D, 35–70mm f/2.8D, new-model 28–85mm f/3.5-4.5D, or 28–85mm f/3.5-4.5D is zoomed while focusing at minimum range, image on matte screen in viewfinder may not be in focus despite in-focus indicator display. Focus manualiy.
- With maximum aperture of f/5.6 or faster.
 *Autofocus not available with TC-17E II or TE-20E II AF-S teleconverter.

Using Non-CPU Lenses

Although the Nikon F mount has remained largely unchanged for almost fifty years, the design of modern cameras has moved on considerably! The initiation of electronic communication between the lens and camera for the purposes of exposure metering and autofocus has introduced a number of changes. such that older non-CPU type lenses (i.e. those lenses that do not have any electrical contact pins around the lens mount bayonet flange) offer a very restricted level of compatibility with the D40x. In this case, the camera can only be used in Manual (M) exposure mode (if you select another exposure mode, the camera disables the shutter release automatically). The lens aperture must be set using the aperture ring on the lens, while the autofocus system, TTL metering system, electronic analogue exposure display, and TTL flash control do not function. However, the electronic rangefinder does operate, provided the maximum effective aperture is f/5.6 or larger (faster), unless stated otherwise, with the following non-CPU type lenses:

- Ai-modified, Ai, Ai-S, and E-series Nikkor lenses
- Medical Nikkor 120mm f/4 (only shutter speeds slower than 1/180 second can be used)
- Reflex Nikkor lenses (electronic rangefinder does not operate)
- PC Nikkor lenses (electronic rangefinder does not operate if lens is shifted)
- Ai-type teleconverters (electronic rangefinder requires an effective aperture of f/5.6, or larger to operate).
- PB-6 Bellows focusing attachment
- Extension rings PK-11A, PK-12, PK-13, and PN-11

Incompatible Lenses and Accessories

The following accessories and lenses are incompatible with the D40x. You may damage your equipment if you attempt to use them.

- K2 extension rings
- TC-16A AF Teleconveter
- All pre Ai-type Nikkor lenses (Ai-types introduced from 1977 onwards)

- Lenses that require the AU-1 focusing unit (400mm f4.5, 600mm f/5.6, 800mm f/8, 1200mm f/11)
- Fisheye-Nikkor (6mm f/5.6, 8mm f/8, OP 10mm f/5.6)
- 21mm f/4 (first type with protruding rear element)
- 180-600mm f/8ED (serial numbers 174041-1744180)
- 360-1200mm f/11 (serial numbers 174031-174127)
- 200-600mm f/9.5 (serial numbers 280001-300490)
- AF 80mm f/2.8, AF200mm f/3.5, TC-16 teleconverter (for F3AF camera)
- PC 28mm f/4 (serial numbers 180900 or earlier)
- PC 35mm f/2.8 (serial numbers 851001-906200)
- PC 35mm f/3.5 (early type)
- Reflex 1000mm f/6.3
- Reflex 1000mm f/11 (serial numbers 142361-143000)
- Reflex 2000mm f/11 (serial numbers 200111–200310)

Features of Nikon Lenses

The designation of Nikkor lenses, particularly modern autofocus types, is peppered with initials and acronyms; here is a list of the most common with an explanation of what they indicate:

- **D-type** these lenses have a conventional aperture ring and an electronic chip that communicates information about lens aperture and focus distance between the lens and the camera body. The 'D' designation appears on the lens barrel.
- **G-type** these lenses have no aperture ring and are only compatible with Nikon cameras that allow the aperture value to be set from the camera body. They do contain an electronic chip that communicates information about lens aperture and focus distance between the lens and the camera body, similar to the D-type lenses. The 'G' designation appears on the lens barrel.
- **AF-type** these lenses are the predecessors to the later D, and G-type designs. They have a conventional aperture ring but do not communicate focus distance infor-

mation to the camera. When used with the D40x, the camera can only perform standard Color Matrix metering, not 3D Color Matrix metering. Autofocus is not possible since these lenses do not have a built-in motor to drive the focusing mechanism.

- **DX** lenses in the DX-Nikkor range have been designed for use on Nikon digital SLR cameras. They project a smaller image circle compared with lenses designed for the 35mm format cameras, but the light exiting their rear element is more collimated to improve the efficiency of the photo sites (pixels) on the camera's sensor.
- **CPU Lens** a CPU lens can be identified easily by the array of small electrical contact pins set around the lens mount bayonet. These electrical contacts enable communication between the camera and the lens for the purposes of exposure control and focus information
- Non-CPU Nikon uses the term non-CPU lens type to describe any Nikkor lens that lacks the electrical connections and electronic microchip that enable CPU-type lenses to communicate information about the lens to the camera (with the exception of the PC-Micro 85mm f/2.8D lens and Ai-P type Nikkor lenses, all manual focus Nikkor lenses are non-CPU types).
- AF-S not to be confused with single-servo autofocus, AF-S denotes the lens has a silent-wave motor (SWM) used for focusing; it uses alternating magnetic fields to drive the motor, which moves lenses' elements to shift focus. This system offers the fastest autofocusing of all AF Nikkor lenses. Most AF-S lenses have an additional feature that allows the photographer to switch between autofocus and manual focus, without adjusting camera controls, by just taking hold of the focus ring.
- **AF-I** predecessor to the AF-S type lenses, these also have an internal focusing motor and can be used for autofocus with the D40x.

Nikkor AF-S VR 70-300mm f/4.5-5.6G ED-IF

- ED Nikon developed a special type of glass to bring various wavelengths of light to a common point of focus in order to reduce the effect of chromatic aberration. The exact formulation of the ED glass varies from lens model to lens model depending on the specific requirements of the lens design.
- **IF** Nikon developed their internal focusing (IF) system to speed up focusing, particularly with long focal length lenses. This moves a group of elements within the lens, so that it does not alter length during focusing, and prevents the front filter mount from rotating, which facilitates use of filters such as a polarizer.
- VR Vibration Reduction is Nikon's name for a sophisticated technology that enables a lens to counter the effects of camera shake/vibration by using a set of builtin motion sensors that cause micro-motors to shift a dedicated set of lens elements to improve the sharpness of pictures.

Filters

In many shooting situations, the white balance control of the D40x obviates the need to carry a range of color correction or color compensating filters that you would normally need when shooting on film. However, there are a few filter effects that you simply cannot replicate using white balance settings or your computer. I would recommend that you consider the three types of filters mentioned below:

Polarizing Filter

The most useful and probably well-known filter is a polarizer. Often associated with its ability to deepen the color of a blue sky, a polarizer has many other uses. Its unique effect makes it essential for digital photography: It removes reflections from non-metallic surfaces, including water, making it a favorite with landscape photographers. Even on a dull, overcast day, a polarizer can help reduce the glare from foliage caused by the reflection of the sky, thereby intensifying color.

Hint: The automatic focusing and TTL metering systems of the D40x will not function properly if you use a linear-type polarizing filter; be sure to use a circular-type polarizer, such as the Nikon Circular Polarizer II.

Neutral Density Filters

At the D40x's base sensitivity of ISO 100, it is sometimes not possible to set a lens aperture or shutter speed to achieve the required results, particularly when shooting in very bright light. Continuous tone neutral density filters help to reduce the overall amount of light that reaches the camera's sensor, so you can use longer shutter speeds and/or wider apertures under these conditions. Nikon no longer produces continuous neutral density filters, but many independent companies do.

Graduated Neutral Density Filters

Coping with excessive contrast is one of the most difficult aspects of digital photography. For example, sky is often much brighter than land, which can make shooting landscapes tricky. If you set the exposure to record the darker portion of the scene, the lighter portion is often too bright to be recorded properly, with the result that it becomes overexposed. Graduated neutral density filters, which are clear at one end and become progressively denser toward the other, are the ideal solution. They come in a variety of strengths and rates of change. If you use a slot-in type of filter system, it is easy to align these graduated filters so their dense area darkens the sky and the clear portion is over the foreground, which is unaffected. Nikon does not produce graduated neutral density filters, but several independent companies do.

Hint: Avoid the round, screw-in type graduated neutral density filters since the transition portion of the filter is always in the center of the frame and you are not permitted to adjust its position in relation to the frame area.

No doubt someone will point out that another way to solve this exposure problem is to make two exposures of the same scene, one for the shadow areas and another for the highlight areas, and then combine the two shots using software and a computer. This can often work well, but sometimes an element in the scene will move between making the two exposures, and the technique is revealed! I would always advocate trying to get as much right in the camera. Apart from anything else, it means you spend less time in front of a computer; time you can spend using your camera.

Hint: Nikon states that the 3D Color Matrix and Matrix metering of the D40x is not recommended when using any filter with a filter factor over 1x. The filter factor is the amount of exposure compensation you need to apply to compensate for the reduction in light transmission caused by the filter. For example a filter factor of 2x is equivalent to one-stop, a factor of 8x is equivalent to three-stops; this can often apply when using polarizing and neutral density filters. Generally, I have not experienced any problems with Matrix metering in these situations; however, you may wish to consider switching to center-weighted or spot metering.

General Nikon Accessories

• **BF-1A** – body cap that will help prevent dust from entering the camera. Keep it in place at all times when a lens is not mounted on the camera.

Note: The earlier BF-1 type body cap cannot be used. It may damage the lens mount and electrical contacts around the lens mount of the D40x.

- **DG-2** viewfinder eyepiece magnifier provides an approximate 2x magnification of the central area of the viewfinder field. The eyepiece adapter is required to enable the DG-2 to be fitted to the D40x.
- DK-3 circular rubber eyecup for the Nikon FM/FE-series cameras that can be attached via the square-to-circular DK-22 viewfinder eyepiece adapter, it also requires a viewfinder eyepiece filter for the FM3/FE-series camera to hold it in place. The circular eyecup provides a better light seal when held to the photographer's eye orbit than the DK-16 square eyecup fitted as standard to the D40x.
- **DK-5** cover cap for the viewfinder eyepiece; it is essential to use when the D40x is operated remotely in automatic exposure modes, to prevent light entering the viewfinder and affecting exposure measurement.
- **DK-16** standard square profile rubber eyecup supplied with the D40x.
- **DK-22** a viewfinder eyepiece adapter that allows viewfinder accessories with a round attachment thread, such as the DG-2, to be mounted on the square frame of the viewfinder eyepiece on the D40x
- **DR-6** right angle viewer that can attach directly to the square frame of the D40x viewfinder eyepiece. It is useful when the camera is at a low shooting position, but is disproportionately expensive compared with the D40x camera!

• **EH-5** – multi-voltage AC adapter for powering the D40x; it is ideal for extended periods of shooting (requires the EP-5 DC adapter).

The D40x comes supplied with both the EN-EL9 Li-ion battery and its dedicated MH-23 AC charger. It is a good idea to invest in a spare battery so you have an extra that is charged at all times.

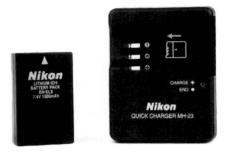

- **EN-EL9** 7.4V, 1000mAh, lithium-ion rechargeable battery for the D40x, which at the time of writing is exclusive to this camera model (one battery is supplied with the camera).
- **EP-5** DC adapter that enables the D40x to be connected to an EH-5 AC adapter to power the camera.
- **MH-23** multi-voltage AC charger for a single EN-EL9 battery (supplied with the camera).
- ML-L3 Remote Control a wireless infrared remote release for the D40x. It requires one CR2025 (3V) battery.

Working Digitally

Workflow

Shooting digitally instead of with film brings new aspects to your photography and provides a high level of user control, especially in processing and enhancing your image files. It is essential to develop a system to make sure you work in an efficient and effective way. The following 7-point workflow is a general guide to establishing a productive routine.

Preparation:

- Familiarize yourself with the camera. The more intuitive you become with your equipment, the more time you can spend concentrating on the scene/subject being photographed.
- Make sure the camera battery is charged and always carry a spare.
- Rather than save all your pictures to a single high capacity memory card, reduce the chance of a catastrophic loss due to card failure/loss by spreading the risk over several memory cards.
- Clean the low-pass filter array in front of the sensor to reduce the level of post-processing work.
- Always format the memory card in the camera in which it will be used each time you insert a card.

Preparation is the key to success in photography. The more you learn about camera control, the better your results will be.

Shooting:

- Adjust camera settings to match the requirements of your shoot; choose an appropriate image quality, size, ISO, color space, and white balance.
- Set other camera controls such as metering and auto focus according to the shooting conditions.
- Use the Image Comment feature (see Setup menu) to assign a note about the authorship/copyright of the images you shoot.
- Review images and make any adjustments you deem necessary. The histogram display is extremely useful for checking on exposure values.
- Do not be in too much of a hurry to delete pictures unless they are obvious failures. It is often better to edit after shooting rather than "on the fly".

Transfer:

- Before transferring images to your computer, designate a specific folder, or folders, in which the images will be stored so you know where to find them.
- Use a card reader rather than connecting the camera directly to the computer. It is much faster, more reliable, and reduces wear and tear on the camera.
- If your browser application permits you to assign general information to the image files during transfer [e.g. DNPR (IPTC) metadata] make sure you complete appropriate fields for image authorship and copyright.
- Consider renaming files and assigning further information and key words to facilitate searching for images at a later date.

Edit and file:

- Use a browsing application to sort through your pictures. Again, do not be in a hurry to edit out pictures. It is often best to take a second look at images a few days or even weeks after they were shot, as your opinions about images will often change.
- Print a contact sheet of small thumbnail images to help you decide which images to retain.

Since a still subject is not going anywhere, take the time to set your D40x properly to produce optimum results. Use features such as the histogram display to review exposure accuracy, and reshoot if necessary.

Processing:

- Make copies of RAW files and save them to a working file format such as TIFF, or PSD (Adobe Photoshop).
- Do not use the JPEG format for processing.
- Make adjustments in an orderly and logical sequence starting with overall brightness, contrast, and color. Then make more local adjustments to correct problems or enhance the image.
- Save your adjusted file as a master copy to which you can then apply a crop, resizing, un-sharp mask, and any other finishing touches appropriate to your output requirements.

Archive:

- Data can become lost or corrupted at any time for a variety of reasons so *always* make multiple back-up copies of your original files and the edited master copies.
- CD's have a limited capacity, so consider DVDs, or an external hard disk drive. No electronic storage medium is guaranteed 100% safe, nor does it have an infinite lifespan, so always check your back-up copies regularly and repeat the back-up process as required.

Display:

- We shoot pictures for others to see and enjoy. Digital technology has expanded the possibilities of image display considerably; we can e-mail pictures to family, friends, colleagues, and clients; prepare digital "slideshows"; or post images to a web site for pleasure or profit.
- Home printing in full color is now reliable, cost effective, and above all, achievable. Spend some time to set up your system properly and work methodically; calibrate your monitor and printer, use an appropriate resolution for the print size you require, and choose paper type and finish accordingly.
- Once you have a high-quality print, be sure to present it in a manner befitting its status: Frame it or mount it securely. This will also help to protect it from the effects of light and atmospheric pollutants.

The D40x is fully compatible with a wide range of SD format memory cards, including the latest SDHC types that have capacities in excess of 2GB.

SanDisk Lock

Using Memory Cards

Nikon has tested and approved only the memory cards listed in the table below for use with the D40x.

Manufacturer	Card Type / Series	Capacity
Lexar	Lexar Media	128MB, 256MB, 512MB and 1GB
Lexar	Platinum II (40x) series	256MB, 512MB and 1GB
Lexar	Platinum II (60x) series	512MB 1GB, and 2GB
Lexar	Professional (133x) series *	1GB and 2GB
Panasonic	Panasonic	64 MB, 128MB, and 256MB
Panasonic	Panasonic High Speed	256MB, 512 MB, 1GB and 2GB
Panasonic	Panasonic Super High Speed *	256MB and 1GB
Panasonic	Panasonic Pro High Speed *	512MB, 1GB, and 2GB
Panasonic	Panasonic SDHC	4GB
SanDisk	Blue	64 MB, 128MB, 256MB, 512MB 1GB, and 2GB
SanDisk	Ultra II *	256MB, 512MB 1GB, and 2GB
SanDisk	Ultra II Plus *	512MB and 1GB
SanDisk	Extreme III *	1GB, and 2GB
SanDisk	SDHC	4GB
Toshiba	Blue	64 MB, 128MB, 256MB, 512MB 1GB, and 2GB
Toshiba	High Speed (White) *	128MB, 256MB, 512MB and 1GB
Toshiba	SDHC	4GB

Nikon Approved Memory Cards For D40x

* These cards have a rated data transfer rate of 10MBs or faster.

Note: If you use a memory card with a capacity of 2GB or more, ensure that your card reader or image storage device supports 2GB memory cards. Also make sure that the card reader or other storage device used with a memory card that has a capacity of 4GB or more supports the SDHC standard. Multi Media cards (MMC) are not recommended and should not be used.

While other brands and capacities of cards may work, Nikon will not guarantee their operation. If you intend to use a memory card not approved by Nikon, it is advisable to check with the manufacturer in respect of its compatibility. Should you experience any problems related to the memory card, use one of the approved cards for the purposes of trouble-shooting.

Memory Card Capacity

This table provides information on the approximate number of images that can be stored on a 1GB memory card at the various image-quality and size settings available on the D40x. All memory cards use a small proportion of their memory capacity to store data required for the card to operate, therefore the amount of memory available for storing image files will be slightly less than the quoted maximum capacity of the card.

Quality	Size	File Size ¹	No. Images ¹	Buffer Capacity ^{1, 2}
NEF (RAW)	-	9.0	79	6
NEF (RAW) + JPEG Basic ³	– / L	10.1	70	6
JPEG Fine	L	4.8	129	100
	М	2.7	225	100
	S	1.2	487	100
JPEG Normal	L	2.4	251	100
	М	1.3	431	100
	S	0.6	888	100
JPEG Basic	L	1.2	487	100
	М	0.7	839	100
	S	0.3	1500	100

- 1. File size will vary according to the scene photographed, and the make of memory card used. Therefore, all figures are approximate.
- 2. This is the maximum number of image files that can be stored in the buffer memory. The number of images that can be stored before the buffer memory reaches capacity may vary with different makes of memory card. Capacity will be reduced if noise reduction is active.
- Image size applies to JPEG file only; size of NEF file cannot be altered. File size is the combined total for NEF and JEPG image files.

Image Information

In addition to image data, the picture files generated by the D40x contain a wealth of additional information that includes shooting parameters and instructions about printing pictures. This information is tagged to the image file using a number of common standards, depending on the sort of information to be saved with the image file.

Supported standards include:

DPOF

Digital Print Order Format (DPOF) is a standard used widely to enable pictures to be printed from print order created and saved on a memory card (see page 263).

PictBridge

A standard that permits an image file stored on a memory card to be output directly to a printer without the need to connect the camera to a computer, or download the image file from a memory card to a computer first (see page 259).

Exchangeable Image File Format (EXIF)

The D40x supports Exchangeable Image File Format for Digital Still cameras, a standard that allows information stored with image files to be read by software and used for ensuring image quality when printed on an EXIF-compliant printer.

The D40x uses the EXIF (2.21) standard to tag information to each image file it records (sometimes this information is referred to as metadata, which is a more generic term). Most popular digital imaging software is able to read, interpret, and display the EXIF tags (though some software is less capable and therefore will not display part or all of the EXIF data values).

The information recorded includes:

- Nikon (the name of the camera manufacturer)
- D40x (the model number)
- Camera firmware version number
- Exposure information, including shutter speed, aperture, exposure mode, ISO, EV value, date/time, exposure compensation, flash mode, and focal length.
- Thumbnail of the main image

Examining EXIF data is a great teaching aid because you can see exactly what the camera settings were for each shot. By comparing pictures and the shooting data, you can learn about the technical aspects of exposure, focusing, metering, and flash exposure control.

International Press Telecommunications Council (IPTC)

Other information (metadata) that can be tagged to an image file includes the use of a standard developed by the International Press Telecommunications Council (IPTC). Known as Digital Newsphoto Parameter Record (DNPR), it can append information about the image including details of the origin, authorship, copyright, caption details, and key words for searching purposes. Any application that is DNPR compliant will show this information and allow you to edit it. If you want to submit pictures you shoot with the D40x for publication, you should make use of DNPR (IPTC) metadata, as most publishing organizations require it to be present before accepting a submission.

Note: DNPR data is often erroneously referred to as IPTC data.

Camera Connections

The upper terminal is used to connect the D40x to a video device, such as a TV or DVR/VCR; the lower terminal is a USB port for connecting the camera to a computer or PictBridge compatible printer.

Connecting to a TV

The D40x can be connected to a television set or DVR/VCR for playback or recording of images. In many countries the camera is supplied with the EG-D2 video cable for this purpose. First, you need to select the appropriate video standard.

Open \forall the Setup menu and navigate to the *Video Mode* item. Press the multi selector to the right and highlight the required option: *NTSC* (used in USA, Canada, and Japan) or *PAL* (most other countries), and press the multi selector to the right again, or press the O button, to confirm your selection.

Before connecting the camera to the video cord, make sure the camera power is switched off. Open the large rubber cover on the left side of the camera body to reveal the ports for Video out (top), and USB (bottom). Connect the narrow jack-pin of the EG-D2 to the camera and the other end to the (yellow) video terminal of the TV/video player. Tune the TV to the video channel, and turn on the camera. The image that would normally be displayed on the LCD monitor will be shown on the television screen or can be recorded on a video recording device.

Note: The LCD monitor will remain blank but all other camera operations will function normally. So, you can take pictures with the camera connected to a TV set and carry out review/playback functions as you would on the LCD monitor. If you intend to use the camera for an extended period for image playback via a TV or DVR/VCR, it is probably best to use the EH-5 AC adapter with the EP-5 connector adapter to power the camera.

Connecting to a Computer

The D40x can be connected directly to a computer via the supplied UC-E4 USB cable. The camera supports the High-speed USB (2.0) interface that offers a maximum transfer rate of 480Mbps. Open the large rubber cover on the left side of the camera body to reveal the ports for Video out (top), and USB (bottom). With the camera turned off, connect the mini-

USB plug of the UC-E4 USB cable to the USB port of the camera, and the other end of the cable to a USB port on a computer. Turn the camera on and you can download images from the camera using the supplied Nikon Picture-Project software. Alternatively, the D40x can be controlled from a computer using the optional Nikon Camera Control Pro software.

Hint: If you use the D40x tethered to a computer for any function, be sure that the EN-EL9 battery is fully charged. Preferably, use the EH-5 AC adapter with the EP-5 connector adapter to prevent interruptions to data transfer by loss of power.

Before connecting the D40x to a computer, appropriate Nikon software must be installed on the computer, and the camera must be configured for one of the two USB connection options, via the Setup menu.

Open the Setup menu and navigate to the USB item. Press the multi selector to the right to right to display the two options: *Mass Storage* and *MTP/PTP*. Highlight the required option (see descriptions below) and press multi selector to the right to right to select it.

• Mass Storage (default) – in this configuration the D40x acts like a card reader and the computer sees the memory card in the camera as an external storage device; it only allows the computer to read the data or the memory card. Use this option if computer is running Windows 2000 Professional, though it can also be selected with Windows Vista (32-bit Home Basic, Home Premium, Business, Enterprise, or Professional), Windows XP (Home or Professional), or Macintosh OS X (10.3.9, or 10.4.x).

Note: When using the *Mass Storage* option, ensure the camera is removed from the computer system in accordance with the correct procedure for the operating system in use, before the camera is switched off and disconnected from the USB cord.

• MTP/PTP (Media Transfer Protocol/ Picture Transfer Protocol) – in this configuration the D40x acts like another device on a computer network and the computer can communicate and control camera operations. Use this option if the computer is running Windows Vista (32-bit Home Basic, Home Premium, Business, Enterprise, or Professional), Windows XP (Home or Professional), or Macintosh OS X (10.3.9, or 10.4.x).

You must select *MTP/PTP* to control the camera using the optional Nikon Camera Control Pro software. When Camera Control Pro software is running the camera will display "PC" in place of the number of exposures remaining.

Card Readers

Although the D40x can be tethered directly to a computer via a USB cord for transferring image data, there are several reasons why you should consider using a memory card reader as an alternative:

- The connected camera drains battery power and lost or corrupted data may occur if the power fails.
- Data transfer from the memory card to the computer will usually be far faster using a card reader.

- A card reader allows you to run software to recover lost or corrupted image files while the card is mounted in the reader, as well as to diagnose problems with the memory card.
- You can leave a card reader permanently attached to your computer, which further reduces the risk of losing or corrupting files as a result of a poor connection due to the wear and tear caused by constantly connecting the camera.

Direct Printing

You can print individual pictures or a group of images directly from your D40x via a USB connection without the aid of a computer. However, this feature is only compatible with JPEG format image files, and a printer that supports the PictBridge standard.

Note: Direct printing from the D40x is only supported for JPEG files. Nikon recommends images destined for direct printing should be recorded in the sRGB color space. Set the D40x to either color Mode Ia or IIIa when using the P, A, S, and M exposure modes via the *Custom* option of the *Optimize image* selection in the Snooting menu.

Linking the D40x with a Printer

The D40x can be connected to a PictBridge compatible printer to print pictures direct from the camera.

First, set the *USB* option in the Setup menu to *MTP/PTP* (printing cannot be performed using the Mass Storage option). Next, turn the printer on and ensure the camera is switched off, and then connect the printer to the camera via the supplied UC-E4 USB lead. Nikon does not recommend connecting via a USB hub.

Note: It is essential that the camera battery is fully charged before starting direct printing from the camera; preferably use the EH-5 AC adapter with the EP-5 connector adapter.

Since the D40x supports the PictBridge standard for use with compatible printers, you do not necessarily have to use a computer to produce prints from your recorded image files.

Turn the camera on and a welcome message shows, followed by the PictBridge playback display on the camera's monitor screen. You can print pictures one-at-time or in multiples.

To scroll through the images saved on the memory card, press the multi selector to left or right. To display an enlarged section of the displayed image, press the button. To view up to six images at a time press the multi selector to select a photograph (a yellow frame bounds the highlighted image) and press the button to display the selected photograph full frame.

Printing Pictures One At A Time

To print the image selected in the PictBridge playback display, press and release the button. The PictBridge printing menu will be displayed. Use the multi selector to highlight the required option by pressing it up or down, and then press right to select the required option.

Option	Description
Start Printing	Select to print the image highlighted in the PictBridge display. To cancel function press button.
Page Size	Press the multi selector up or down to select the appropriate paper size from <i>Printer default</i> item: 3.5 x 5 in, 5 x 7 in, 100 x 150 mm, 4 x 6 in, 8 x 10 in, Letter, A3, or A4. Then press the button to select and return to the print menu.
Number of Copies	Press the multi selector up or down to select the number of copies of the highlighted image to be printed (maximum 99). Then press the button to select and return to the print menu.
Border	Press the multi selector up or down to select <i>Printer Default</i> (uses default setting of current printer), <i>Print with border</i> (white border), or <i>No</i> <i>border</i> . Then press the button to select and return to the print menu.
Time Stamp	Press the multi selector up or down to select Printer Default (uses default setting of current printer), <i>Print time stamp</i> (date and time image was recorded is printed in image area), or <i>No</i> <i>time stamp</i> . Then press the button to select and return to the print menu.
Cropping	Press the multi selector up or down to select <i>Crop</i> (picture can be cropped in-camera), or <i>No crop</i> (printed full frame). The press the button to select and return to the print menu. If <i>Crop</i> is selected, the image is displayed with a frame overlaid. Use the and buttons to determine the size of the crop. To position the cropping frame, use the multi select button. Then press the button to select and return to the print menu.

To print the image once you have selected the required options from the menu, highlight *Start printing* and press \mathfrak{W} ; the PictBridge playback display will be shown when printing is complete

Printing Multiple Images

To print multiple images or an index print (contact sheet), press button when PictBridge is displayed and a menu with three options will show:

- *Print Select* The selected images are printed.
- *Print* (*DPOF*) The current DPOF print order set is printed (DPOF date and information options are not supported). See page 263 for more information.
- Index Print Creates an index print of all images saved in the IPEG format. If the memory card contains more than 256 JPEG images only 256 will be printed. Press the button to display a sub-menu with three further ок options: Page Size, Border, Time Stamp. These have the same options as described in the table above for single image printing. To commence printing highlight Start Printing and press the

Choose Print Select from the PictBridge menu; six thumbnail images will be displayed on the monitor screen. Use the multi selector button to scroll through the images and press 9

to see the highlighted image full frame.

To select the highlighted image, press the multi selector up; the number of copies to be printed is set to one. To specify the number of copies of each image selected for printing. press the multi selector up or down accordingly. To deselect a picture from printing, press the multi selector down until one is displayed as the number of prints, and then press it left or right to highlight another picture. Repeat this process for each image to be printed (each selected image will be marked by a small icon of a printer). Display the print options and set page size, border type, and time stamp according to the instructions above. To print selected images, highlight *Start Printing* and press the button.

Note: Images saved in the NEF format will be displayed in the *Print Selected* menu, but cannot be printed.

Selecting Images For Direct Printing – DPOF

The D40x supports the Digital Print Order Format (DPOF) standard that embeds an instruction set in the appropriate EXIF data fields of an image file, which allows you to insert the memory card into any DPOF compatible home printer or commercial mini-lab printer and automatically print a set of selected images.

To select images for printing, highlight the *Print (DPOF)* option from the playback menu. The *Select/Set* option will be highlighted; press the multi selector to the right to select it.

The camera will display a thumbnail of all the images stored on the inserted memory card, in groups of up to six thumbnails. Use the multi selector to scroll through the images; a yellow frame bounds the highlighted image. To view the highlighted image full frame, press and hold the button.

To select the highlighted image for printing, press the multi selector up. A small icon of a printer and a number will appear in the upper right corner of the thumbnail image; the number of copies to be printed is set to one. To specify the number of copies of each image selected for printing, press the multi selector up to raise the number, and down to lower the number. To deselect a picture from printing, press the multi selector down until *one* is displayed for the number of prints, and then press it left or right to highlight another picture. Repeat this process for of each image required to be printed.

Once all images to be printed have been selected press the button to save the selected group of images. A further two options are now displayed: (1) to imprint shooting data (shutter speed and aperture setting) on all the pictures, highlight *Data Imprint* and press the multi selector button to the right to place a check mark in the option box. (2) To print the date/time of image recording on all the pictures in the print set, highlight *Imprint Date* and press the multi selector to the right to place a check mark in the option box. Finally, to finish and save the *Print Set* order, highlight *Done* and press the **w** button.

To deselect an entire print set, select *Print Set* from the playback menu and highlight *Deselect All?* Highlight the required option either *Yes* or *No* and press the button to confirm the selection.

The Print set option requires sufficient memory on the installed memory card to store the print order data as well as the image files, so the card must have spare capacity before creating a print order. These selections can only be made from JPEG format images stored on the memory card; if an image was shot using a NEF+JPEG option, only the JPEG image can be selected for printing.

Nikon Firmware & Software

The initial firmware version for the D40x is version 1.0 (A and B), for Widows, including Vista 32-bit, and Mac OS X; however, Nikon may choose to release further updates whenever necessary. They are free for download from Nikon websites. I recommend you check the firmware version installed on your camera, compare to available versions, and update it if necessary. If you do not feel confident enough to do this for yourself, the update can be performed at any authorized Nikon service center.

Picture Project

Nikon's PictureProject browser application is designed to facilitate the transfer of images from a memory card, either installed in a camera or via a card reader. The application provides an image browsing capability to display images to review, sort, and edit once they have been transferred to a computer.

PictureProject is designed to be intuitive and accessible to beginners and to experienced users, with the interface presented in an easy-to-understand manner. The program is used to:

- Automatically import image files when a camera is connected to a computer. Thumbnail previews become available to allow pre-selection of images and confirmation of the memory card contents.
- Drag-and-drop images into easy to locate "portfolios" for fast and simple access to pictures.
- Access the most recently imported images with a single click.
- Search features to locate any image quickly by parameters such as the file name, keyword, and date captured or modified.
- Use basic digital editing tools such as crop, rotate, zoom, and red-eye reduction.
- The Photo Enhance menu offers further options, including tools for controlling brightness, D-Lighting, color booster, photo effects, sharpening, and straightening.
- Always preserve the original images after editing, ensuring that important pictures are never lost and the editing process can always be reversed.
- Display a slideshow with user-selectable background music track
- Design templates and make it easy to share images in email and attractive print layouts.

Note: If you have an earlier version of Nikon PictureProject installed on your computer you will need to update it to version 1.7.5 or higher to ensure fully support and compatibility with image files generated by the D40x.

To adjust and enhance image files with any degree of finesse and accuracy, I strongly recommend alternative applications, such as Nikon Capture NX or one of the many third party digital imaging applications.

Nikon Capture NX

Nikon Capture NX is an optional extra that permits a much greater level of image control than PictureProject. It represents a complete re-write of the original Nikon Capture application by Nik Software, an independent software company, and incorporates their unique U-point technology that permits complex selections of an area(s) within an image to be made with an accuracy and speed that is far greater than can be achieved using current digital imaging software, which generally requires the use of complex masking or layering techniques. The user has an extensive toolbox available to enhance and modify any image file regardless of whether it was saved in the NEF, TIFF, or JPEG formats.

Adjustments to the image file data are both independent and completely variable, permitting complete control over all aspects of the image. The original image file data is always preserved, allowing an infinite number of variations to be created and stored without the need to make duplicates of the original data, thus saving considerable amounts of disk space.

Nikon Capture NX (version 1.1.0) offers many features in addition to the unique U-Point technology, including:

- Advanced white balance control with the ability to select a specific color temperature, or sample from a gray point.
- Advanced NEF file control that permits attributes such as exposure compensation, sharpening, contrast, color mode, saturation, and hue to be modified after the exposure has been made, without affecting the original image data.
- The Image Dust Off feature, which compares an NEF file with a reference image taken with the same camera to help reduce the effects of any dust particles on the lowpass filter.
- The D-Lighting tool, which emulates the dodge & burn techniques of traditional photographic printing to control highlight and shadow areas to produce a more balanced exposure.

- A Color Noise Reduction tool, which minimizes the effect of random electronic noise that can occur, especially at high sensitivity settings
- An Edge Noise Reduction tool that accentuates the boundary between areas of the image to make them more distinct.
- The Color Moiré Reduction feature helps remove the effects of moiré, which can occur when an image contains areas with a fine repeating pattern.
- LCH Editor allows for control of Luminosity (overall lightness), Chroma (color saturation), and Hue in separate channels.
- Fisheye Lens tool converts images taken with the AF Fisheye-Nikkor DX 10.5mm f/2.8G lens so they appear as though they were taken using a conventional rectilinear lens with a diagonal angle-of-view equivalent to approximately 120°.

Nikon Camera Control Pro

Nikon Camera Control Pro (version 1.3.0) is an optional, standalone application that allows full remote control of a D40x both prior to and during shooting while the camera is connected to a computer via the supplied UC-E4 USB cable. It also supports the direct transfer of images from the camera to a computer, effectively turning the computer hard drive in to a large volume memory card. It also enables the user to create a custom tone (contrast) curve and upload it to too the D40x using the *Custom* option in the Optimize Image menu.

Troubleshooting

Common Problems

On occasion your D40x may not operate as you expect. This could be due to an alternative setting(s) having been made (often inadvertently), or for some other reason. Many of the causes for these problems are common and the solutions are listed in the table below:

Problem	Solution
Camera takes longer than expected to turn on	Delete files/folders
Viewfinder appears out of focus	Adjust viewfinder focusUse diopter adjustment lens
Viewfinder display is unresponsive and dim	Response time and brightness of viewfinder display can be affected by high or low temperature
Displays turn off unexpectedly	Set longer delay for monitor off/ meter off
Camera is slow to record picture	Turn off noise reduction
Image in viewfinder out of focus	 Camera unable to perform auto focus: use manual focus Lens is not AF-S or AF-I: use manual focus Manual focus selected: set autofocus with AF-S and AF-I lenses
Playback menu cannot be accessed	No memory card inserted
Image size cannot be altered	RAW or RAW+B selected for image quality

If the D40x does not behave in the way you expect, there is probably a simple explanation and a simple solution. The more familiar you become with the camera, the sooner you will be able to resolve problems operating it.

Problem	Solution
Menu item not displayed	Select Full for CSM/Setup menu
Menu item cannot be selected	Turn mode dial to another setting, or insert memory card, or ensure lens set to auto focus (AF-S/AF-I only)
Shutter release will not operate	 CPU lens with aperture ring not set to minimum (highest f/number) value Memory card not installed or full Flash charging Focus not acquired Non-CPU lens attached: rotate mode dial to M Bulb selected in S exposure mode
Metering cannot be changed	 Digital Vari-program mode selected Autoexposure lock active
Unable to select focus area	 Closest subject selected for AF-area mode Camera in stand-by: press shutter release halfway to activate camera
AF-assist lamp does not light	 Camera in M or AF-C focus mode Mode dial set to , or
No picture taken when release button of ML-L3 remote release is pressed	 Replace battery in ML-L3 Select Remote control mode Flash is charging Time selected for remote delay (CS-17) has elapsed; reset Bright light is interfering with remote signal
Range of shutter speeds is limited	Flash in use – sync speed imposed

Problem	Solution
Focus does not lock when shutter release is depressed halfway	 Camera in AF-C focus mode: use AF-L/AE-L button AF-A mode used to photograph a moving subject: use AF-L/AE-L button
Final pictures shows more than viewfinder	Viewfinder coverage is limited to approx. 95% of full frame area
Pictures out of focus	 Select autofocus mode AF unable to operate; use manual focus
Recording time is unusually long	Noise reduction in operation
Random bright pixels appear in image	 Use lower ISO setting Use High ISO noise reduction Shutter speed exceeds 8 seconds; use noise reduction in Shooting menu
Areas with a red tint appear in pictures	Long time exposure used; turn on noise reduction in Shooting menu
Dark spots/blotches appear in pictures	Dirt on lensDirt on low-pass filter
Colors appear unnatural	 Select P, S, A, or M exposure mode: Adjust white balance to match light source. Adjust Optimize Image settings
Continuous shooting mode unavailable	 In P, A, S, and M modes lower built-in flash unit Turn flash off in Digital Vari- program modes
Unable to obtain WB measurement in Preset WB	Illumination of test target too dark or too bright
Source image cannot be selected for setting WB	Image not created with D40x
 Single image review selected: Flashing area appears on image Shooting data appears on image Graph appears on image 	Press multi selector button up or down to scroll through photo information

Problem	Solution
Results with Optimize Image vary from image to image	Use Custom setting. Avoid Auto for Sharpening, Tone Compensation, and Saturation options
Exposure compensation cannot be used	Select P, A, or S exposure modes
Pictures shot in upright orientation (tall) displayed in horizontal (wide) orientation	 Select ON for Rotate Tall OFF selected for Auto Image Rotation Camera orientation was altered while shooting in continuous mode Camera was pointed up/down when shooting
Unable to delete image	Image protection set; remove protection
Not all images displayed in Playback mode, or message stating no images are available in Playback mode	Select All for Playback Folder; note Current will be selected automatically when next picture is taken
NEF image is not played back	Image quality set to NEF + JPEG
Cannot change print order	Memory card is full: delete images
Unable to print direct from camera via USB connection	Set USB to MTP/PTP
Unable to select image for direct printing	Image saved as NEF file
Unable to display image on TV	Select correct video mode
Unable to transfer images to computer	Select correct USB option
Unable to use Camera Control Pro	Set USB to MTP/PTP
Date of recording is incorrect	Set time and date

Error Messages & Displays

The D40x is capable of reporting a range of malfunctions and problems by way of indicators and error messages that appear in the viewfinder and LCD monitor. The following table will assist you in finding a solution should one of these indicators or messages be displayed.

Message	Indicator	Solution
Lock lens aperture ring at minimum aperture (largest f/number)	FE E	Lock ring at minimum aperture (largest f/number)
Lens not attached	F/? (blinks)	Attach a lens to camera; The attached lens is not CPU
Attach a lens	F/\$ (blinks)	Attach a lens to camera
Initialization error. Turn camera off and then on again	(3links)	Turn camera off, remove battery and reinsert, turn camera back on
This battery cannot be used. Choose battery designated for use in this camera	(Elinks)	Insert EN-EL9 battery
Battery level is low. Complete operation and turn camera off immediately	(Bilinks)	Stop low-pass filter cleaning and quickly turn camera off
Shutter release disabled. Recharge battery	(Blinks)	Turn off camera, insert fully charged battery
Clock not set	?	Set clock on camera
NO MEMORY CARD	[- E -]	Insert an SD card
Memory card is locked. Slide lock to "write" position	[HR	Slide protect switch on card to enable writing
This card cannot be used	([H R)	Use memory card approved by Nikon; Damaged card needs replacement; Delete some files or insert new card
This card is not formatted Format the card	(For)	Insert card to camera and format
Card is full	Ful	Use lower image quality or size; Delete image files from card; Insert new SD card

Message	Indicator	Solution
Subject is too bright	н	Select lower ISO setting; Select faster shutter speed; Select smaller aperture (larger f/number; Use Neutral Density (ND) filter
Subject is too dark	10	Select higher ISO setting; Decrease shutter speed; Choose larger aperture (smaller f/num)
	(blinks)	Full-power flash fired; reshoot with adjusted settings if required
	\$/@ (blinks)	Built-in flash is not raised; Flash head on SB-400 Speedlight is in position for bounce flash; SB-400 cannot fully illuminate subject at present lens focal length. Alter subject-to-camera distance
Flash is in TTL mode. choose another setting or use a CPU lens	\$ (blinks)	Change flash control mode for optional Speedlight
No Bulb in S mode	bulb (blinks)	Change shutter speed or select M exposure mode
Unable to measure white balance. Please try again	റാം ലർ (blinks)	Preset white balance cannot be measured by camera. Change exposure settings
Folder contains no images	_	Insert a different SD card Set <i>Playback folder</i> to <i>All</i>
File does not contain image data	_	Delete the file; reformat SD card
check printer		Insert new ink or toner cartridges; check printer status
Error. Press shutter release button again	Err	Press shutter release button. If error message does not go away, contact Nikon-authorized service
Initialization error.	Err	Contact Nikon-authorized service representative

Electrostatic Interference

Operation of the D40x is totally dependent on electrical power. Occasionally, the camera may stop functioning properly, or display unusual characters or unexpected messages in the viewfinder and LCD display. Such behavior is generally due to the effects of a strong external electro-static charge. If this occurs try switching the camera off, disconnecting it from its power supply (remove the EN-EL9 battery, or unplug the EH-5/EP-5 AC adapter), then reconnect the power, and switch the camera on again.

If this procedure fails to rectify the problem, turn the camera off, and open the rubber port cover on the left side of the camera. A small, square, recessed button is located between the video terminal and USB port; this is the reset switch. Press the reset switch but note that this resets the clock to its default time, so you will need to change the date/time settings appropriately. Should the symptoms persist the camera will require inspection by an authorized technician.

Web Support

Nikon offers product support information on-line at the following sites:

http://www.nikon.com–global gateway to Nikon Corporation http://www.nikonusa.com–for continental North America http://www.europe-nikon.com/support–fcr most European countries

http://www.nikon-asia.com-for Asia, Oceania, Middle East, and Africa

Glossary

AA

Auto aperture. Refers to a Nikon flash mode in which the flash level is automatically adjusted for aperture.

aberration

An optical flaw in a lens that causes the image to be distorted or unclear.

AF-D

AF Nikkor lenses that communicate the distance of the focused subject to a compatible camera body in order to improve the accuracy of exposure calculations for both ambient light and flash. (AF-G, AF-I, and AF-S lenses also perform this function.) AF-D lenses are focused by a motor mounted in the camera body.

AF-G

AF Nikkor lenses that lack a conventional aperture ring. They are only compatible with those cameras that permit the aperture to be set from the camera body.

AF-I

The first series of AF Nikkor lenses to have an internal focusing motor.

AF-S

AF Nikkor lenses that use a silent wave focusing motor mounted within the lens. The technology used in AF-S lenses permits faster and more responsive automatic focusing as compared to the AF-I and AF-D lenses.

AI

Automatic Indexing.

AI-S

Nikon F-mount lens bayonet for manual focus Nikkor lenses. They have a small notch milled out of the bayonet ring.

ambient light

See available light.

angle of view

The area seen by a lens, usually measured in degrees across the diagonal of the film frame.

anti-aliasing

A technique that reduces or eliminates the jagged appearance of lines or edges in an image.

aperture

The opening in the lens that allows light to enter the camera. Aperture is usually described as an f/number. The higher the f/number, the smaller the aperture; and the lower the f/number, the larger the aperture.

Aperture-priority mode

A type of automatic exposure in which you manually select the aperture and the camera automatically selects the shutter speed.

artifact

Information that is not part of the scene but appears in the image due to technology. Artifacts can occur in film or digital images and include increased grain, flare, static marks, color flaws, noise, etc.

artificial light

Usually refers to any light source that doesn't exist in nature, such as

incandescent, fluorescent, and other manufactured lighting.

automatic exposure

When the camera measures light and makes the adjustments necessary to create proper image density on sensitized media.

automatic flash

An electronic flash unit that reads light reflected off a subject (from either a preflash or the actual flash exposure), then shuts itself off as soon as ample light has reached the sensitized medium.

automatic focus

When the camera automatically adjusts the lens elements to sharply render the subject.

available light

The amount of illumination at a given location that applies to natural and artificial light sources but not those supplied specifically for photography. It is also called existing light or ambient light.

backlight

Light that projects toward the camera from behind the subject.

bounce light

Light that reflects off of another surface before illuminating the subject.

brightness

A subjective measure of illumination. See also, luminance.

buffer

Temporarily stores data so that other programs, on the camera or the computer, can continue to run while data is in transition.

built-in flash

A flash that is permanently attached to the camera body. The built-in flash will pop up and fire in low-light situations when using the camera's automated exposure settings.

built-in meter

A light measuring device that is incorporated into the camera body.

bulb

A camera setting that allows the shutter to stay open as long as the shutter release is depressed.

card reader

Device that connects to your computer and enables quick and easy download of images from memory card to computer.

CCD

Charge Coupled Device. This is a common digital camera sensor type that is sensitized by applying an electrical charge to the sensor prior to its exposure to light. It converts light energy into an electrical impulse.

close-up

A general term used to describe an image created by closely focusing on a subject. Often involves the use of special lenses or extension tubes. Also, an automated exposure setting that automatically selects a large aperture (not available with all cameras).

CLS

Creative Lighting System. This is a flash control system that Nikon introduced with its SB-800 and SB-600 Speed'ights. See also, Speedlight.

color cast

A colored hue over the image often caused by improper lighting or incorrect white balance settings. Can be produced intentionally for creative effect.

color space

A mapped relationship between colors and computer data about the colors.

compression

Method of reducing file size through removal of redundant data, as with the JPEG file format.

contrast

The difference between two or more tones in terms of luminance, density, or darkness.

critical focus

The most sharply focused plane within an image.

cropping

The process of extracting a portion of the image area. If this portion of the image is enlarged, resolution is subsequently lowered.

dedicated flash

An electronic flash unit that talks with the camera, communicating things such as flash illumination, lens focal length, subject distance, and sometimes flash status.

default

Refers to various factory-set attributes or features, in this case of a camera, that can be changed by the user but can, as desired, be reset to the original factory settings.

depth of field

The image space in front of and behind the plane of focus that appears acceptably sharp in the photograph.

diopter

A measurement of the refractive power of a lens. Also, it may be a supplementary lens that is defined by its focal length and power of magnification.

dpi

Dots per inch. Used to define the resolution of a printer, this term refers to the number of dots of ink that a printer can lay down in an inch.

DPOF

Digital Print Order Format. A feature that enables the camera to supply data about the printing order of image files and the supplementary data contained within them. This feature can only be used in conjunction with a DPOF compatible printer.

D-TTL

A flash control system that relies on a series of pre-flashes to determine the output required from a Nikon Speedlight. The system does not monitor the flash output during actual exposure. See also, Speedlight.

D-type Nikkor

A series of lenses that have a built-in CPU that is used to communicate the focus distance information to the camera body, improving the accuracy of exposure measurement.

DX

Nikkor lenses designed specifically for the Nikon DX format sensor.

ED glass

Extra-low Dispersion glass. Developed by Nikon, this glass was incorporated into many of their camera lenses to reduce the effects of chromatic aberration. See also, chromatic aberration.

electronic flash

A device with a glass or plastic tube filled with gas that, when electrified, creates an intense flash of light. Also called a strobe. Unlike a flash bulb, it is reusable.

electronic rangefinder

A system that utilizes the AF technology built into a camera to provide a visual confirmation that focus has been achieved. It can operate in either manual or AF focus modes.

EV

Exposure Value. A number that quantifies the amount of light within an scene, allowing you to determine the relative combinations of aperture and shutter speed to accurately reproduce the light levels of that exposure.

EXIF

Exchangeable Image File Format. This format is used for storing an image file's interchange information.

exposure

When light enters the camera and reacts with the sensitized medium. The term can also refer to the amount of light that strikes the light sensitive medium.

exposure meter

See light meter.

file format

The form in which digital images

are stored and recorded, e.g., JPEG, NEF, RAW, TIFF, etc.

filter

Usually a piece of plastic or glass used to control how certain wavelengths of light are recorded. A filter absorbs selected wavelengths, preventing them from reaching the light sensitive medium. Also, software available in image-processing computer programs can produce special filter effects.

FireWire

A high speed data transfer standard that allows outlying accessories to be plugged and unplugged from the computer while it is turned on.

firmware

Software that is permanently incorporated into a hardware chip. All computer-based equipment, including digital cameras, use firmware of some kind.

f/number

See f/stop.

focal length

When the lens is focused on infinity, it is the distance from the optical center of the lens to the focal plane.

focal plane

The plane on which a lens forms a sharp image. Also, it may be the film plane or sensor plane.

focus

An optimum sharpness or image clarity that occurs when a lens creates a sharp image by converging light rays to specific points at the focal plane. The word also refers to the act of adjusting the lens to achieve optimal image sharpness.

FP high-speed sync

Focal Plane high-speed sync. Some digital cameras emulate high shutter speeds by switching the camera sensor on and off rather than moving the shutter blades or curtains that cover it. This allows flash units to be synchronized at shutter speeds higher than the standard sync speed. In this flash mode, the level of flash output is reduced and, consequently, the shooting range is reduced.

f/stop

The size of the aperture or diaphragm opening of a lens, also referred to as f/number or stop. The term stands for the ratio of the focal length (f) of the lens to the width of its aperture opening. (f/1.4 = wide opening and f/22 = narrow opening.) Each stop up (lower f/number) doubles the amount of light reaching the sensitized medium. Each stop down (higher f/number) halves the amount of light reaching the sensitized medium.

full-frame

The maximum area covered by the sensitized medium.

full-sized sensor

A sensor in a digital camera that has the same dimensions as a 35mm film frame (24 x 36 mm).

GB

See gigabyte.

gigabyte

Just over one billion bytes.

GN

See guide number.

gray scale

A successive series of tones ranging between black and white, which have no color.

guide number

A number used to quantify the output of a flash unit. It is derived by using this formula: GN = aperture x distance. Guide numbers are expressed for a given ISO film speed in either feet or meters.

histogram

A graphic representation of image tones.

hot shoe

An electronically connected flash mount on the camera body. It enables direct connection between the camera and an external flash, and synchronizes the shutter release with the firing of the flash.

IF

Internal Focusing. This Nikkor lens system shifts a group of elements within the lens to acquire focus more quickly without changing the overall length of the lens (as occurs with conventional, helical focusing mechanisms).

image-processing program

Software that allows for image alteration and enhancement.

infinity

In photographic terms, the theoretical most distant point of focus.

interpolation

Process used to increase image resolution by creating new pixels based on existing pixels. The software intelligently looks at existing pixels and creates new pixels to fill the gaps and achieve a higher resolution.

ISO

From ISOS (Greek for equal), a term for industry standards from the International Organization for Standardization. When an ISO number is applied to film, it indicates the relative light sensitivity of the recording medium. Digital sensors use film ISO equivalents, which are based on enhancing the data stream or boosting the signal.

i-TTL

A Nikon TTL flash control system that has a refined monitor pre-flash sequence and offers improved flash exposure control. See also, TTL.

JPEG

Joint Photographic Experts Group. This is a lossy compression file format that works with any computer and photo software. IPEG examines an image for redundant information and then removes it. It is a variable compression format because the amount of leftover data depends on the detail in the photo and the amount of compression. At low compression/high guality, the loss of data has a negligible effect on the photo. However, JPEG should not be used as a working format-the file should be reopened and saved in a format such as TIFF, which does not compress the image.

KB

See kilobyte.

kilobyte

Just over one thousand bytes.

LCD

Liquid Crystal Display, which is a flat screen with two clear polarizing sheets on either side of a liquid crystal solution. When activated by an electric current, the LCD causes the crystals to either pass through or block light in order to create a colored image display.

lens

A piece of optical glass on the front of a camera that has been precisely calibrated to allow focus.

lens hood

Also called a lens shade. This is a short tube that can be attached to the front of a lens to reduce flare. It keeps undesirable light from reaching the front of the lens and also protects the front of the lens.

light meter

Also called an exposure meter, it is a device that measures light levels and calculates the correct aperture and shutter speed.

lithium-ion

A popular battery technology (sometimes abbreviated to Li-ion) that is not prone to the charge memory effects of nickel-cadmium (Ni-Cd) batteries, or the low temperature performance problems of alkaline batteries.

low-pass filter

A filter designed to remove elements of an image that correspond to high-frequency data, such as sharp edges and fine detail, to reduce the effect of moiré. See also, moiré.

luminance

A term used to describe directional brightness. It can also be used as luminance noise, which is a form of noise that appears as a sprinkling of black "grain." See also, brightness, chrominance, and noise.

macro lens

A lens designed to be at top sharpness over a flat field when focused at close distances and reproduction ratios up to 1:1.

Manual exposure mode

A camera operating mode that requires the user to determine and set both the aperture and shutter speed. This is the opposite of automatic exposure.

MB

See megabyte.

megabyte

Just over one million bytes.

megapixel

A million pixels.

memory

The storage capacity of a hard drive or other recording media.

memory card

A solid state removable storage medium used in digital devices. They can store still images, moving images, or sound, as well as related file data. There are several different types.

midtone

The tone that appears as medium brightness, or medium gray tone, in a photographic print.

moiré

Occurs when the subject has more detail than the resolution of the digital camera can capture. Moiré appears as a wavy pattern over the image.

NEF

Nikon Electronic File. This is Nikon's proprietary RAW file format, used by Nikon digital cameras. In order to process and view NEF files in your computer, you will need Nikon View (version 6.1 or newer) and Nikon Capture (version 4.1 or newer).

Nikkor

The brand name for lenses manufactured by Nikon Corporation.

noise

The digital equivalent of grain. It is often caused by a number of different factors, such as a high ISO setting, heat, sensor design, etc. Though usually undesirable, it may be added for creative effect using an image-processing program. See also, chrominance noise and luminance.

normal lens

See standard lens.

overexposed

When too much light is recorded with the image, causing the photo to be too light in tone.

pan

Moving the camera to follow a moving subject. When a slow shutter speed is used, this creates an image in which the subject appears sharp and the background is blurred.

perspective

The effect of the distance between the camera and image elements upon the perceived size of objects in an image. It is also an expression of this three-dimensional relationship in two dimensions.

pixel

Derived from picture element. A pixel is the base component of a digital image. Every individual pixel can have a distinct color and tone.

pre-flashes

A series of short duration, low intensity flash pulses emitted by a flash unit immediately prior to the shutter opening. These flashes help the TTL light meter assess the reflectivity of the subject. See also, TTL.

Program mode

In Program exposure mode, the camera selects a combination of shutter speed and aperture automatically.

RAW

An image file format that has little or no internal processing applied by the camera. It contains 12-bit color information, a wider range of data than 8-bit formats such as JPEG.

RAW+JPEG

An image file format that records two files per capture; one RAW file and one JPEG file.

rear curtain sync

A feature that causes the flash unit to fire just prior to the shutter closing. It is used for creative effect when mixing flash and ambient light.

red-eye reduction

A feature that causes the flash to emit a brief pulse of light just before the main flash fires. This helps to reduce the effect of retinal reflection.

resolution

The amount of data available for an image as applied to image size. It is expressed in pixels or megapixels, or sometimes as lines per inch on a monitor or dots per inch on a printed image.

RGB mode

Red, Green, and Blue. This is the color model most commonly used to display color images on video systems, film recorders, and computer monitors. It displays all visible colors as combinations of red, green, and blue. RGB mode is the most common color mode for viewing and working with digital files onscreen.

saturation

The intensity or richness of a hue or color.

SD

Secure Digital, a format of memory card compatible for use with the Nikon D40x

SDHC

Secure Digital High Capacity, a format of memory card compatible for use with the Nikon D40x that is capable of recording 4GB or more of data.

sharp

A term used to describe the quality of an image as clear, crisp, and perfectly focused, as opposed to fuzzy, obscure, or unfocused.

shutter

The apparatus that controls the amount of time during which light is allowed to reach the sensitized medium.

Shutter-priority mode

An automatic exposure mode in which you manually select the shutter speed and the camera automatically selects the aperture.

slow sync

A flash mode in which a slow shutter speed is used with the flash in order to allow low-level ambient light to be recorded by the sensitized medium.

SLR

Single-lens reflex. A camera with a mirror that reflects the image entering the lens through a pentaprism or pentamirror onto the viewfinder screen. When you take the picture, the mirror reflexes out of the way, the focal plane shutter opens, and the image is recorded.

small-format sensor

In a digital camera, this sensor is physically smaller than a 35mm frame of film. The result is that standard 35mm focal lengths act like longer lenses because the sensor sees an angle of view smaller than that of the lens.

Speedlight

The brand name of flash units produced by Nikon Corporation.

standard lens

Also known as a normal lens, this is a fixed-focal-length lens usually in the range of 45 to 55mm for 35mm format (or the equivalent range for small-format sensors). In contrast to wide-angle or telephoto lenses, a standard lens views a realistically proportionate perspective of a scene.

stop down

To reduce the size of the diaphragm opening by using a higher f/number.

stop up

To increase the size of the diaphragm opening by using a lower f/number.

synchronize

Causing a flash unit to fire simultaneously with the complete opening of the camera's shutter.

telephoto effect

When objects in an image appear closer than they really are through the use of a telephoto lens.

thumbnail

A miniaturized representation of an image file.

tripod

A three-legged stand that stabilizes the camera and eliminates camera shake caused by body movement or vibration. Tripods are usually adjustable for height and angle.

TTL

Through-the-Lens, i.e. TTL metering.

USB

Universal Serial Bus. This interface standard allows outlying accessories to be plugged and unplugged from the computer while it is turned on. USB 2.0 enables high-speed data transfer.

vignetting

A reduction in light at the edge of an image due to use of a filter or an inappropriate lens hood for the particular lens.

VR

Vibration Reduction. This technology is used in such photographic accessories as a VR lens.

wide-angle lens

A lens that produces a greater angle of view than you would see with your eyes, often causing the image to appear stretched. See also, short lens.

Index

3D Color Matrix Metering (see matrix metering)

AE-L

(AE-lock, see autoexposure lock)

AF-A mode 34, 62, **136**, 143, 148, 190, 193, 271

AF-area modes 34, 64, 119, **140–141**, 148, 191, 270

AF-assist illuminator 34, 56, 70, 72, 127, 132, **142–143**, **193**, 206, 224, 225, 231, 270

- AF-C mode 34, 63, 130, 136, **137–139**, 141, 142, **190**, 270, 271
- AF-L (see focus lock)

AF-S mode 34, 127, **136–139**, 141, 142, 143, **190**, 193, 196

- anti-aliasing filter (see low-pass filter)
- Aperture-priority mode (A) 35, 36, 102, 114, 119, **121**
- auto aperture (AA) 221
- Auto Image Rotation (see image rotation)

auto-servo focus (see AF-A mode)

- autoexposure lock 123-124, 196
- autofocus system 19, 20, **33–34**, 53, 64, 116, 118, 119, 126, 127, 131, **134–144**, **190**, **191**, **195–196**, 231, 233, 236–237, 240

- batteries **24–25**, 47, **49–50**, **79–84**, 163, 173, 193, 202, 212, 229, 245, 247, 257, 259, 273, 275
- black and white 105, 178, 183–184

blur 59, 74, 122

- bounce flash 210, 215, 230, 274
- buffer 41, 80, 127, 130, 149, 253
- built-in Speedlight 35, **43–45**, 65, 66, 182, 193, 197, 205, 206, 207, **211–212**, 216, 222–223, **225–228**, 274 see also flash
- bulb mode 40, 134, 270, 274

camera care (see cleaning)

- card reader 86, 202, 248, 252, **258–259**
- CCD (see sensor)
- center-weighted metering 38, 115, **118**, 123, 192, 243
- cleaning 45-47, 173, 175
- color space 76, **107**, 111, 173, 184, 248, 259
- color temperature 39, **95–97**, 99–103, 178, 226, 266
- command dial 26, 98, 113, 120, 121, 122, 124, 125, 156, 161, 181, 195, 223
- composing 63, 70, 122, 123, 131, 135, 139, 142, 144, 150, 196, 211, 235

compression 28, 29, 62, 87, 88, 91–93, 182 see also image quality

- continuous-servo autofocus (see AF-C mode)
- Continuous shooting mode 127, 128, **130**, 149, 271
- CSM/Setup menu **161–162**, 171, 178, 180, 188, 200, 270
- Custom Setting menu 41, 136, 140, 148, 159, 160, 162, **187–199**
- deleting images 16, 43, 77, 86, **156–157**, 163, **200–201**, 273

depth of field 151–154

- Digital Vari-Program modes 35, 39, 43, **60–77**, 148, 165, 191, 211, 225, 270, 271
- direct printing from camera 105, 107, 109, 169, **259–264**, 272

DPOF 203, 253, 262-263

drive modes (see shooting modes)

Dust Off Ref 47, 175–177, 266

DX-format sensor (see sensor)

error messages 273–274

EXIF 88, 254, 263

exposure compensation 35, 36, **124–126**, 272

exposure modes 35, 38, 44, 53, 62–77, 119–123

file formats 28, **87–92**, 249 see also JPEG, NEF, and RAW fill flash 44, 148, 205, **216–217**, 218–220, 226, 227, 230

filters 46, 235, 241, 242-244

filter effects 180, 181, 184-185

firmware 90, 170, **175**, 254, 257, 258, 264

flash compensation 148, 193, 205, **226**

flash modes 197, 216-226, 231

flash photography 205–231

Flexible program mode 35, 120

focus lock 142, 144, 196, 271

- focus tracking (see Predictive Focus Tracking)
- formatting memory card 57-58, 86-87, 162-164

hand holding 59, 122

histogram 43, 117, 149, 151, 152–155, 165, 148

Highlights page 151

image overlay 181, 182, **186–187**

image processing 70, 87, 89, 90, 108, 109, 110, 115, 117, 264–267

image quality 58, 62, 88, 89, 93–95, 106, 148, 178, 182, 195, 251, 253, 273

image review 42, **77**, **149–150**, 167, 181, **192**, 198, 271

image rotation 150, **177**, **202**, 265, 272

- image size 62, **93–95**, 148, **178**, 185, 195, 253, 269
- Info Display 164
- IPTC 248, 255
- ISO sensitivity 36, **112–115**, 128, 148, **179**, 194–195, 228
- JPEG 26–29, 62, 87, 88, **89–90**, 92–94, 109, 148, 173, 178, 182, 249, 253, 262, 264
- LCD monitor 20, 33, **42–43**, 77, 83, 150, 156, 157, 159, 166, 192–193, 198
- lenses 54, 233–245, 256 compatibility 53, 228, 236–239 non-CPU lenses 38, 53, 61, 116, 120, 144, 238, 240, 270
- low-pass filter 27–28, 45, 46–47, 173, 175, 177, 247, 271, 273
- Manual exposure mode 20, 35, 38, 114, 119, 122–123, 125, 130, 131, 134, 144, 218, 238
- Manual focus 38, 53, 64–65, 68, 70, 72, 74, 75, 131, 133, 136, **137**, 144, 176, 190, 269
- matrix metering 20, **38**, 53, 115, **116**, 117, 118, 205, 209, 240, 243
- memory cards 16, 20, **56–59**, 84–87, 94, 127, 130, 157, **162**, 170, 180, 192, 203, 247, **251**, **252**, 253, 273 see also SD and SDHC cards
- metering 36-38, 115-119, 192

- mirror lock-up 46, 47, 82, 173–175
- mode dial 36, 61, 66, 119, 120, 270
- monochrome 105, 180, 181, 183
- multi selector42, 43, 77
- My menu 43, **161–162**, 171, 178, 180, 188, 200
- NEF 28–29, 87, 88, **90–91**, 92–94, 109, 172, 175, 178, 182, 253, 263, 266, 272
- Nikon Camera Control Pro 17, 82, 110, 169, 170, 257, 258, **267**
- Nikon Capture NX 17, 29, 47, 91, 92, 169, 172, 175, 176, 177, 265, **266**
- noise 40, 113, 114, 153, 179, 194
- noise reduction 36, 40, 112, 128, 134, **179–180**, 267, 269, 271
- optimize images **39**, 76, **104–112**, 178, 180, 183, 259, 267, 271, 272
- Photo Information Pages 115, 150–151, 165, 169, 193, 194
- PictBridge 169, **254**, 259, 260, 261, 262
- Picture Project 169, 177, 257, 264
- Playback menu 157, 159, 160, **200–203**, 263, 269
- Predictive Focus Tracking 72, 136, 137, **138–139**

Printing 45, 93, 203, 250, 253, 259–263 see also direct printing

Programmed Auto exposure mode (P) 35, 114, 120 see also Flexible program mode

protecting images 43, 77, 84, **156–157**, 163, 200, 272

- RAW 28, 87, 88, 90, 94, 249, 253, 269
- red-eye reduction 65, 128, **182–183**, 215, 224, 225, 265
- Remote release **42**, 128, **133**, 190, 199, 245
- reset to default 24, 25, 63, 120, **148**
- resolution (see image size)
- Retouch menu 42, 43, 151, 159, 160, **180–187**
- SD Secure Digital (SD) cards 20, **56–59**, **84–86**, 149, 190, 191, 195, **199**
- SDHC (Secure Digital High Capacity) cards 20, **85–87**
- Self-timer **41**, 76, 128, **130–132**

sensor 14, 19, **25–27**, 46–47 87–89, 93, 95, 113, 179, 215, **233–235**

- Setup menu 33, 43, 159, 160, **161–177**
- Shooting Information Display 20, **32–33**, 43, 164
- shooting modes 41, 127, **128–134**, 149, 160, 191, 195, 271

Shooting menu 94, 159, 160, **178–179**

- Shutter-priority mode 35, 114, 119, **121**
- Single frame shooting mode 41, 127, 128, **130**, 148, 149, 191
- single-servo autofocus (see AF-S mode)
- spot metering 28, 44, **118–119**, 121, 123, 237, 243
- two-button reset (see reset to default)

trap focus **139**, 196

tripod 66, 74, 114, 131, 147

USB 45, **169–170**, 256–257, 258, 267, 272

viewfinder **30–31**, 34, **55–56**, 63, 131, 176, 244, 269, 271, 273

wireless flash 44, 206, 207, 208, 213, 231

- white balance 39, 61, 91, **95–104**, 148, 178, 184, 195, 226, 242, 248, 266, 271, 274
- workflow 247